THE ART OF FORGERY

THE MINDS, MOTIVES AND METHODS OF MASTER FORGERS

NOAH CHARNEY

To Eleonora, who is a hundred percent original

Bad artists copy, good artists steal
– PICASSO

INTRODUCTION

THE WORLD WISHES TO BE DECEIVED...

Hold! You crafty ones, strangers to work, and pilferers of other men's brains! Think not rashly to lay your thievish hands upon my works. Beware! Know you not that I have a grant from the most glorious Emperor Maximilian that not one throughout the imperial dominion shall be allowed to print or sell fictitious imitations of these engravings? Listen! And bear in mind that if you do so, through spite or through covetousness, not only will your goods be confiscated, but your bodies also placed in mortal danger.
– Albrecht Dürer

This may well be the most belligerent property notice ever penned. It appeared in the colophon to an edition of an engraving series called *Life of the Virgin,* published in Nuremberg in 1511. Its author and the creator of the engravings, the great painter and printmaker Albrecht Dürer, had good reason to fear forgers.

Dürer's prints were wildly popular throughout Europe, highly collectible and a more affordable alternative to a painting. Dürer was perhaps the first internationally self-promoting artist in history, more akin to Jeff Koons or Damien Hirst than the solitary, morose likes of contemporaries such as Giorgione or Pontormo. He even created what some consider the first artist's trademark: a stylized monogram signature featuring a small upper-case 'D' between the legs of a large upper-case 'A', the inclusion of which assured the authenticity of his prints.

In 1506 a concerned friend from Venice sent Dürer a print from the original 1502 *Life of the Virgin* series.[1] In his Nuremberg studio, surrounded by pots of pigment, coal to make ink, quill pens and sheets of vellum, Dürer examined this woodcut engraving. It looked nearly identical, but it was not his handiwork. It was the work of a master forger.

A quick investigation led to the artist behind the copies, a printmaker (and sometime pornographer) named Marcantonio Raimondi.[2] The unquestionably skilful Raimondi had created woodcut plates from scratch, including the famous 'AD' monogram. The Dal Jesus family of printers then sold prints made from these plates as Dürer originals. However, while Raimondi had copied every detail of Dürer's intricate prints, he had also included three alterations to the original that distinguished his creations as copies, and which would eventually be used as his escape clause when he was brought to court.

He included his own monogram, an intertwined 'MAF'; he added the device of the Dal Jesus publishing house, the 'YHS' of Christ placed inside a squared quatrefoil; and he included two triangles arranged in the shape of an hourglass, taken from the sign on the Dal Jesus print shop. It took close examination to notice these additions, but they were there. They raised the question as to whether Raimondi intended his prints to be passed off as Dürer originals or if he merely intended them to be an homage to the original artist.

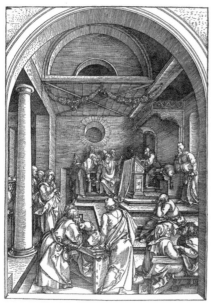 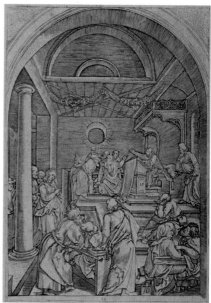

Albrecht Dürer, *Christ Among the Doctors in the Temple*, plate 15 in *Life of the Virgin*, 1503, woodcut print, 29.3 × 20.4 cm (11 ½ × 8 in)

Marcantonio Raimondi, after Dürer, *Christ Among the Doctors in the Temple*, c. 1506, woodcut print, 29.3 × 20.4 cm (11 ½ × 8 in)

But Dürer had had quite enough of forgers profiting from his work and brought a lawsuit in Venice against Raimondi and the Dal Jesus family. It was the first-known case of art-specific intellectual property law brought to trial, but the suit proved only partially successful. The Venetian authorities declared that the prints were not exact copies but merely excellent imitations. They ruled that Raimondi should not be blamed for being as skilled an artist as Dürer and that Dürer should be flattered that his work was considered important enough to copy. Raimondi was required to remove Dürer's signature from the plates and the Dal Jesus family was forced to sell Raimondi's versions as explicit copies, not as Dürer originals.

Dürer stormed off back to Nuremberg, unhappy with the result. He had heard the argument before that he should be flattered that his work was so famous as to draw copyists, so when he came to publish his 1511 edition of *Life of the Virgin*, Dürer was careful to include his warning to potential thieves.

The history of forgery is filled with similar anecdotes that are still relevant today. Arguments over brand-name authenticity, copyright and trademark are staples of contemporary intellectual property law. Had Dürer's case been brought to court today, Columbia University Law Professor Jane Ginsburg notes that contemporary copyright law would see Raimondi's work as an infringement because it substantially copied the original image. The inclusion of the AD monogram would be considered 'passing off' copies as originals, thereby violating trademark law.[3] That the origins of artistic copyright law date back to a legal brawl between one of history's first self-promoting celebrity artists and a renegade Venetian pornographic printmaker-turned-forger does not detract from its contemporary application.

WHY DOES FORGERY FASCINATE?

Any given forgery case brings together an intriguing amalgam of the desire for fame, money, revenge, power and the expression of genius. Art forgery explores and exploits the art trade, and involves remarkable talent, treachery, detection, forensic science and a measure of mysticism – for the art world still relies, to a great extent, on the word of individual experts, connoisseurs whose personal opinion can change an artwork's value by millions. The undeniable technical skill of many forgers likewise impresses the public, as does the ingenuity of the confidence tricks that make forgeries of varying quality convincing.

This book will examine the adventures and misadventures of master forgers throughout history and consider the many different motivations that drove them, allowing a glimpse into both their minds and their methods. We will examine how and why these artful tricksters – often ingenious, skilful, quirky and charming – succeeded in deceiving the art world and how they were eventually caught, through shrewd detective work, scientific examination or a good measure of luck. These prominent historical and contemporary true-crime stories are fascinating, illuminating and often bizarre.

INSIDE THE FORGER'S MIND

Art thieves tend to be mercenary, have no specialized knowledge, skills or interest in art, rarely steal art on more than one occasion and do not fit any consistent psychological profile. In contrast, in the world of forgery, there are consistent generalizations that can be widely applied to the character and motivations of forgers. In addition, unlike art theft and antiquities looting, art forgery generally does not involve organized crime. It damages reputations but rarely wreaks the sort of widespread, frightening harm of other types of art crime, with its links to mafia activity and even terrorism.[4] In forgery schemes, original works are not destroyed or damaged, as in acts of iconoclasm, antiquities looting or theft.

We might assume that money is the primary motivation for art forgery, but we see again and again that this is rarely true – although profit might be a welcome bonus. Forgers are complex psychological characters, driven by many different impulses to a life of crime. We will examine the complexity of these motivations by addressing the primary impetuses of select master forgers, one in each chapter. There is a decided lack of female forgers in this book; there are female accomplices and con men, but I know of no notable female forgers in the history of forgery.

The first chapter, Genius, will consider the legacy of the tradition of artists learning their skill by legitimate forms of copying their masters. This is linked to the overarching search for the expression of genius – wanting to show the world one's technical skill and creativity, and demonstrate the ability of a pupil to match, or surpass, his master.

The next chapter, Pride, explores how a collector, connoisseur or dealer's sense of pride might cause them to wilfully misattribute a work in order save face (or finance).

In Revenge, we consider the true cliché that many art forgers are artists whose original works were dismissed, prompting them to concoct a passive–aggressive method of vengeance against the art world that spurned them, proving their ability and superiority while at the same time demonstrating how easily the so-called art experts can be fooled.

Fame follows. Having proven their superiority over the art world, many forgers are not satisfied with private glory and seek public

acknowledgement for their success. When art forgers are found out, many are greeted as heroes of a sort and go on to lucrative careers post-conviction. The reasons for this remarkably regular phenomenon are complex. The wider public often considers art forgers to be rather loveable Robin Hood-types. The popular interest in art crime in general, and forgery in particular, results in an audience for forgers willing to expose themselves to the public eye upon leaving prison.

The fifth chapter, Crime, examines cases in which a forgery was used as a tool to commit a different crime, such as theft, as well as some of the rare cases of forgers linked to organized crime.

Chapter six looks at confidence tricks and con men who lead amateur artists into careers as criminals, showing how a talented artist may be manipulated by a con man into an art forgery scheme. These partnerships tend to be between two people, the criminal mastermind and con man behind the fraud and a technically skilled copyist.

The seventh chapter, Money, explores the few cases in which financial greed was a forger's primary motivation.

Lastly, while deception in the art world is the primary focus of this book, the chapter on Power considers the broader sphere of cultural forgery and investigates how forgers have sought to establish their power and influence by rewriting history – from politics to scientific discoveries, and from religious relics to literature.

Along the way, we will peer into the forger's mind, motivation and methods. We will learn the tricks of their trade, how they fooled the art world, what ultimately led to their capture, and how the art world is, in many ways, complicit, stepping eagerly into the traps that clever criminals lay. Welcome to the world of forgery and remember your Petronius: *Mundus vult decipi, ergo decipiatur.* 'The world wishes to be deceived, so let it be deceived.'

COPY OR CRIME?

Art has been copied, misattributed and forged since before biblical times. Indeed, the authenticity of artworks was already a concern in ancient Rome, where Greek vases and sculptures were prized above Roman copies of them. In the Middle Ages, a lively trade in fake religious relics flourished along pilgrimage trails. The history of art forgery is as old as the art trade.

Although the terms 'fakes' and 'forgeries' are often used inter-changeably to define artworks that are passed off as a work of greater value, they have distinct definitions. In the simplest terms, a forgery is an object made in a wholesale, fraudulent imitation of something else, while a fake is an original object that has somehow been altered or 'doctored' – a painting, for example, to which a spurious signature has been added. However, for either fakes or forgeries to be tried in court, a crime must be committed. If a forger is charged, it is usually with the crime of fraud.

Beyond deliberate fraud, there are many noncriminal reasons why a work of art might be misattributed, sometimes to the benefit of the owner. Keep in mind that copying art has always been the way young artists learned their trade – copying or imitating another artist's style is only a crime if someone tries to pass off the copy as an original.

The *Mona Lisa* copy at the Museo del Prado is an example: recent forensic tests show that it has under-drawings that are similar to those beneath the original, showing that the layout of the copy was developed piecemeal – something that would not have been the case if the copy had been painted directly from the finished original. This suggests that the copy was painted at the same time as, and in the presence of, the Leonardo original, and is therefore almost certainly the work of someone in Leonardo's studio. Renaissance studios were populated by apprentices and assistants, and commissions were frequently fulfilled largely by the studio, with the master designing and supervising the final product and often tackling the most difficult portions, such as hands and faces, while relegating backgrounds, still lifes or architectural elements to his pupils.

Similarly, there have been long-standing debates about how many works attributed to Rembrandt were actually touched by him, for many of his pupils painted works that are barely distinguishable from his own. In the contemporary workshops of artists like Takashi Murakami, Hirst or Koons, the artist designs and supervises the process while studio assistants produce most of the work. The idea that an 'authentic' work of art should be made by a single artist, alone, is a relatively new one. As Thierry Lenain describes in *Art Forgery: The History of a Modern Obsession*, it was only in the Romantic era that the concept took hold of the sole creator of a great work of art as a solitary, often struggling artist, painting by flickering candlelight in a draughty garret.

There is an illusionism to art – and to its authenticity. Sometimes the line between masterpiece and forgery is slender or even invisible. For a crime to be committed, someone or something must be victimized or damaged, whether that is someone specific – a buyer who was duped, for example – or a more abstract harm, such as to an artist's reputation. From a forensic perspective, based on police files and historical studies, forgery and deception may be broken down into four basic categories.

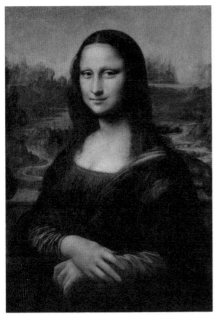 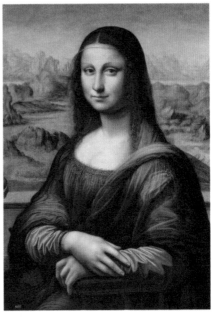

Leonardo da Vinci, *Mona Lisa*, 1503–1506, oil on poplar panel, 77 × 53 cm (30 ¼ × 21 in), Louvre, Paris

Studio of Leonardo da Vinci, *Mona Lisa*, 1503–19, oil on panel, 76.3 × 57 cm (30 × 22 in), Museo del Prado, Madrid

The first category is forgery: the wholesale creation of a fraudulent work. This is the manufacture of a new work of art that professes to have been made by someone whose authorship would result in a greater sale value of the object. This method requires the most industry and skill in order to produce something that will fool expert analysis.

The second category is fakes: the alteration of, or addition to, an authentic work of art in order to suggest a different authorship or subject matter that results in a greater sale value of the object. This is somewhat simpler than forgery, but it does require the acquisition of something authentic in the first place.

The third category consists of provenance traps: confidence tricks in which an altered documented history of an object, rather than the object itself, results in its greater value. An object must fit somewhere into the documented history of an artist's oeuvre in order to be convincing. Four types of provenance trap are most often applied to wholesale forgeries. A fake or forgery can be prepared to match the existing, real provenance for a lost artwork; forged or fake provenance may be inserted in real archives, to be 'discovered' by investigating scholars; a forgery may be made that appears to be a preparatory work, such as a drawing, for a known original; or finally, an authentic work with authentic provenance may be purchased, a copy of the work made and the real provenance used to authenticate it.

The last category of forgery and deception is the misattribution of authentic work: a confidence trick in which an 'expert' convinces a potential buyer that a work is of greater value than it actually is, or inversely, convinces a potential seller that a work is of lesser value. This last example is only a crime if a prior intent to deceive can be proven.

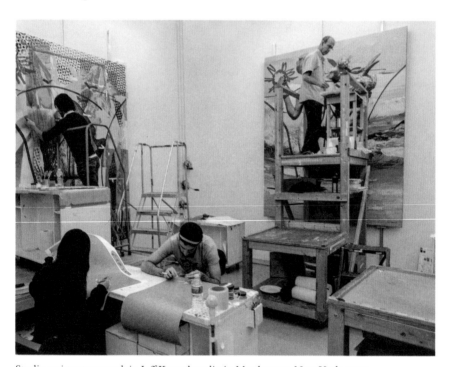

Studio assistants at work in Jeff Koons' studio in Manhattan, New York, 2010

THE PERCEPTION OF VALUE

The value of art is linked to its authenticity, or at least the perception of it. But perceived value is amorphous and sharklike: it moves constantly and changes with the times, even from one day to the next.

By art, we mean objects that are prized significantly more for their non-intrinsic value than for their intrinsic worth. If you break down the components of a diamond ring, its value would be similar to that of the assembled ring: its primary value (gold, diamonds) is intrinsic to it. A Leonardo painting, on the other hand, consists of a piece of wood with a variety of pigments, binders and varnish. Break it down into its component parts and it has no value at all; combine these humble ingredients in the hands of a master, and its value is tremendous. Art is really the definition of the idiom 'greater than the sum of its parts'. For our purposes, art consists of objects most of the value of which is non-intrinsic, due to the skill of their creator and their historical and cultural significance.

In the world of art, perception is all. If the world believes that a work is authentic, then its value is that of an authentic work, whatever the truth may be. The concept of perception has three main components: authenticity, demand and rarity.

We have considered authenticity already. Demand asks if there is a market for the object. The key in the art trade is not the quantity of potential buyers but the quality – if two wealthy collectors are determined to buy a work at auction, they will bid against each other, driving up the price. Rarity may seem obvious for a work of art, as most of the works we think of are unique. But it is important to understand that it is the very fact that most art *is* unique that gives it such a high value. For some works, multiple authentic versions exist, such as the two versions of Leonardo's *Madonna of the Yarnwinder*, Ribera's *La Barbuta* or Bronzino's *Pala of Eleonora di Toledo*. In such cases, whichever version was painted first is considered more valuable. But reflect on prints: these were always intended to be reproducible and affordable. Rarity also takes into account the total number of extant works by an artist. Dürer prints are more valuable than Picasso prints because fewer were produced and fewer remain in circulation. Art and cultural/historical objects of any category must be considered authentic in order to have their full value. This brings us back to perception, for all the components of value are nested within the concept of perception rather than actuality.

THE HISTORY OF FORGERY:
FROM ANTIQUITY TO THE TWENTIETH CENTURY

From antiquity until the twentieth century, the reliance on the malleable and easily mistaken conviction of experts made it difficult to distinguish truth from myth, hearsay and wilful deception. The traditions, legends and stories that surrounded objects, often passed down orally and with no means of checking their veracity, coloured the way that people viewed those objects.

Before one could train in the study of art history, which was established as a scholarly discipline in Germany during the nineteenth century; before there existed a more rigorous qualification by which to call oneself 'expert'; and long before forensics and provenance research were regularly applied to determine authenticity and authorship, optimistic belief outweighed doubt. The history of forgery begins in this setting, in which it was far easier to pass off forgeries than it can be today. But while the pre-modern era had fewer weapons available to identify fraudulent objects, suspicion of forgeries is almost as old as art itself.

The ancient Greeks had no shortage of forgery issues. The scientist and mathematician Archimedes exposed a supposedly gold crown as a fake as he recounted in his treatise 'On Floating Bodies', which used the displacement of water as a calculator of density. The crown did not possess the same density as an equal amount of gold and must, therefore, have been made of gold mixed with a lighter metal – its maker was thus caught in an attempt to defraud King Hiero II of Siracusa (270–216 BC). The famous Greek painter Apelles and his counterpart in sculpture, Phidias – considered during the Renaissance to be the first true masters of their respective media – lent a helping (and disingenuous) hand to their protégés, Protogenes and Agaracritus, by signing some of their students' works as their own, thereby allowing them to sell them to collectors at a higher rate.

When the Romans fell in love with Hellenic art after about 212 BC, their ravenous collecting sprees were accompanied by genuine concern over authenticity.[5] Phaedrus wrote a verse about forgeries made by contemporary Roman artists to satisfy the demand for Greek antiquities during the reign of Augustus. Forgeries during the ancient Roman Empire were largely concerned with creating new works that looked like older Greek vases and sculptures to feed the insatiable market for all things Hellenic.

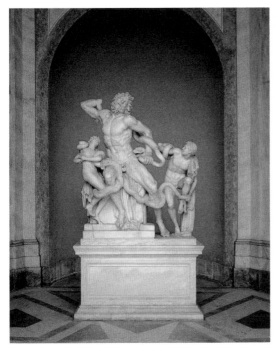

Hagesandros, Athenedoros
and Polydoros of Rhodes
(attrib.), *Laocoön*, copy
after Hellenistic original,
c. 42–20 BC, marble,
1.84 m (6 ft 12 in) high,
Musei Vaticani, Rome

From the fall of Rome in the fifth century AD until the dawn of the
Renaissance at the start of the fifteenth, the most visible phenomenon
was that of forged religious relics and documents. These included
objects of questionable authenticity, such as the Crown of Thorns,
which one must take on faith, as well as those that have since been
proved to be forgeries, such as the Shroud of Turin (see p. 231) or the
Donation of Constantine (see p. 210). The Crown of Thorns was
among the religious relics brought back from the Holy Land in 1238
by King Louis IX of France, later dubbed Saint Louis. If this warped
and dried tangle of brambles was believed by scores of Byzantine
emperors, countless worshippers and a canonized French king to be
the biblical Crown of Thorns, who was to argue?[6] Faith in objects that
had a plausible story behind them was all that was needed, and often
all that was available, to authenticate an artwork or object. This
meant that a great deal of art was misattributed, either inadvertently
or intentionally. For all the relics that were accompanied by centuries
of belief in their authenticity, there were innumerable bone fragments
that charlatans claimed had come from various saints but which
certainly had not: some bones of saints, caged in rock crystal and
gilded silver reliquaries, have been shown to have come from animals.[7]

In this period, often referred to as the Dark Ages, art collecting largely ceased. With much of Europe torn by war, disintegrating empire and plague, the arts that flourished were those with a high intrinsic value (jewellery, gold and silverwork) and architecture. There were highlights in illuminated manuscripts and religious sculpture, to be sure, but it was not until the late fourteenth century that art, and its collection, matched and then surpassed the level enjoyed during the Roman Empire.

Art production and collection escalated during the Renaissance. Running from around 1390 to 1600, the Renaissance was characterized by the adulation of specific artists, whereas past eras tended to admire objects and pay little attention to those who created them. The period saw the launch of art collecting in the modern sense, with princes, popes, kings and wealthy merchants actively accumulating elaborate collections of art and cultural objects, paying huge sums for the creations of famous artists and competing with one another for particularly desirable works. King Francis I of France wrote to his favourite Italian artists – including Raphael, Leonardo, Michelangelo and Cellini – requesting *any* work by their hand.[8] It was new to offer to buy *anything*, even by a favourite artist. Francis even sought to 'collect' the artists, inviting them to live and work at his court in France (Raphael and Michelangelo passed, but Rosso Fiorentino and Leonardo both accepted and lived for extensive periods there). This greater interest in, and value of, art by acknowledged masters led to a parallel rise in forgeries.

An obsession over authenticity grew more widespread in the seventeenth century. This obsession did not only encompass artworks but also a wider fear of disingenuity. This is evident in a number of illustrated books that identified known confidence tricks used to appeal to one's Christian charity: how a healthy beggar could simulate being a legless war veteran, or how an old woman might feign a seizure in order to attract attention and assistance, while an accomplice picked the pockets of those who rushed to her aid. While this broader concern over deception was in the air, it was most obvious in the art world. Such was the concern that the collector Prince Johann Adam Andreas of Liechtenstein placed a stamp on each of the works in his collection as a caution against originals being swapped for fakes during an upcoming move. The painter Sebastien Bourdon (1616–1671) made a career in Paris selling forged paintings in the style of contemporary Italian artists. A *Madonna*,

which he signed 'Annibale Carracci', sold for 1,500 sovereigns, even though Carracci never signed his works – a detail that experts at the time failed to note.

With the new-money wealth of the nineteenth-century 'robber baron' era, when American industrialists in particular had inordinate riches and wished to acquire the trappings of the aristocracy they lacked (the Rothschild family famously bought a baronet, and thus nobility), there was a strong demand for art and ample cash with which to purchase it. But the collectors often relied on field agents to seek out objects for them to acquire, which left plenty of room for forgeries to be acquired as originals or for questionable works to be over-optimistically attributed by middlemen, who might be combing Europe for art while their patrons sent over cheques from Chicago, New York, Buenos Aires or Tokyo.

The tradition of middlemen buying for collectors was nothing new. In ancient Rome, Cicero had employed agents to search for the Greek art he enthusiastically collected. Artists like Rubens and Velázquez were sent to Italy on buying sprees on behalf of their patrons. But this system was particularly advanced during the second half of the nineteenth century and early twentieth century, heightened by the fact that so much wealth was in the hands of American collectors who wanted European art but did not have the know-how or desire to hunt through the scattered shops, dilapidated manor houses, markets and galleries of Tuscany, Swabia, Murcia or Burgundy to acquire it.

This extended period from antiquity through to the twentieth century laid the foundation for modern forgery. It was characterized by faith in objects that had a plausible story behind them, the concept of the value of art and cultural objects and the tradition that, in the world of art, perception is more important than truth. In addition, art authentication during this period was reigned over by the connoisseur.

THE ART OF THE CONNOISSEUR

Connoisseurship relies on stylistic analysis. An expert develops an intrinsic familiarity with an artist's oeuvre by seeing and studying his or her extant works. Connoisseurs (a term largely synonymous with 'expert') examine brushstrokes, the application and thickness

of paint, the way artists painted certain recurring themes, the content of the work – and a more evasive 'feeling' that one gets from a work.

One of the issues with connoisseurship is that there has never been a national or international standard that determines who can be called an expert. Like many other academic disciplines, before art history was first studied in an academic setting in mid-nineteenth-century German universities, art expertise was generally passed down from artist to pupil, from collector to inheritor – and only later from professor to student. Certificates of authenticity could feasibly be written by anyone proclaiming to be an expert. Famous experts could guarantee a lucrative sale on the provision of a certificate, though there has never been a quantifiable way to determine whether an art expert really knew what he was talking about. Despite this, connoisseurship was the primary, and often only, determination of a work's authenticity and authorship from ancient times until about 1900.

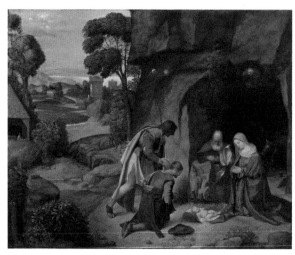

Giorgione (previously attributed to Titian), *Adoration of the Shepherds* or *Allendale Nativity*, c. 1505/1510, oil on panel, 90.8 × 110.5 cm (35 ¾ × 43 ½ in) National Gallery of Art, Washington, DC

The connoisseur of connoisseurs was arguably the art historian Bernard Berenson (1865–1959), who became a world-famous expert on Italian Old Masters and advised leading dealers including Colnaghi and Wildenstein, brokered purchases for collectors such as Isabella Stewart Gardner and worked as a professional authenticator. A signed certificate of authenticity by Berenson was as close as a dealer could get to an iron-clad guarantee of an artwork's authorship. While his talents were undoubted, however, even Berenson was involved in more

than one authentication scandal, and his story is a case in point of why reliance on connoisseurship alone can lead even the well-intentioned astray.

Berenson worked most closely with Sir Joseph Duveen, the leading art dealer in Europe in the first decades of the twentieth century. Berenson provided certificates of authenticity to works acquired by Duveen in order to solidify (or in some cases drive up) the resale price. Duveen would acquire high-quality Renaissance works that were unattributed and Berenson would, more often than not, attribute the works to a renowned artist, thereby making Duveen a significant profit.

Berenson and Duveen eventually fell out over an authenticity debate in which Berenson's expertise outweighed his desire for profit, much to Duveen's dismay. The work in question was the *Allendale Nativity*, or *Adoration of the Shepherds* (circa 1505, now in the National Gallery of Art in Washington, DC), which was acquired by Duveen in the hope that it was by Giorgione; Berenson thought it was by Titian.

Both Giorgione's and Titian's works are of high value. Both were pupils of Giovanni Bellini in Venice, and their early works are not easily distinguishable: though not widely accepted, some historians have even gone as far as to suggest that Giorgione might never have existed, and was merely a pseudonym for the young Titian.[9] But while Titian lived into his eighties and created well over a hundred paintings, Giorgione died of plague at the age of thirty-two, having produced only a handful of known works – twelve paintings, of which five survive, and one drawing. As valuable as a Titian may be, a Giorgione is far more valuable due to its exceptional rarity.

Duveen wanted Berenson to sign a certificate of authenticity stating that the *Allendale Nativity* was by Giorgione, so he could sell it to the collector Samuel Kress. Berenson refused, attributing it to Titian. This argument ended their long-standing relationship. Ironically, the painting has since been attributed to Giorgione. Duveen had been right, but for the wrong reasons.

The mystique of the connoisseur, and a preference to rely on the word of an expert (often self-proclaimed, without further bona fides), pervaded the art world until the twentieth century and, to some extent, continues to play a vital role in art authentication. Millions of dollars, as well as professional reputations, still ride on the word of these pseudo-mystics.

AUTHENTICATION SINCE THE TWENTIETH CENTURY: CONNOISSEURSHIP, SCIENCE AND PROVENANCE

After millennia of precedence, it is only in the last hundred years that connoisseurship has been demoted from its perch as the definitive method for authenticating art. Two significant advances of the twentieth century have caused this, making forgeries more difficult to pass off as authentic works: forensic scientific investigation and research into provenance, the documented history of an object. These advances shifted the onus from passively accepting the word of an 'expert' to proactively proving the authenticity of an object, in order for it to be accepted.

The first port of call to identify a work's authorship is still to show the work to an expert, an art historian or dealer with extensive experience of the field in question. Scientific tests and provenance research are secondary measures, only employed when experts disagree or if suspicions have been otherwise raised.

The turning point toward rigorous scientific investigation was marked by the 1932 trial of Otto Wacker (1898–1970). It was the first trial that used science to authenticate art, and it was concluded by what is considered the first police investigation of a suspected art forger in the modern era (earlier cases investigated money counterfeiters).

Wacker claimed to be a dealer representing a Russian collector who had escaped the Communists and who needed to sell his collection of some thirty Van Goghs to save his family. Wacker refused to reveal the name of the collector. He was brought to trial in 1932 for fraud, falsification of documents and breach of contract when a number of the buyers of his 'Van Goghs' discovered that they had been sold forgeries.

Debate over the authenticity of works by Vincent van Gogh began within a few years of the artist's death.[10] Art experts tend to specialize in the work of one period or, in many cases, one artist. Rivalry often develops among the small number of experts as each tries to stake out territory in their specialist world, racing one another to new discoveries and often trying to discredit their rivals if there is a point of disagreement. At the Wacker trial two renowned Van Gogh experts disagreed as to which paintings should be included in the catalogue raisonné, the definitive list of works by the Dutch master – and both turned out to be wrong.

On one side stood Jacob Baart de la Faille, author of Van Gogh's first major catalogue raisonné. On the other was his rival, the supercilious H. P. Bremmer, an art expert who once said of an Odilon Redon drawing that even if Redon himself declared the drawing one of his best, Bremmer would still know that it was a forgery, because declaring authenticity was Bremmer's job not the artist's.[11] The two experts could not agree on which, if any, of Wacker's Van Goghs were genuine. De la Faille vacillated, changing his mind five different times over his career. The police investigation led to the discovery that Wacker's brother, Leonhard, was the forger who had painted the 'Van Goghs' in question. Unfinished 'Van Goghs' were found in his studio, and it was later revealed that both Otto and their father, Hans Wacker, were forgers of Old Master paintings. Otto was sentenced to a year in prison. He appealed – but with the result that his sentence was *raised* to a year and seven months.

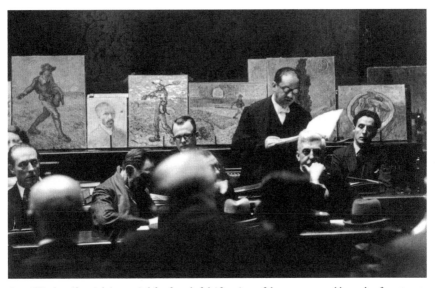

Otto Wacker (far right) on trial for fraud, falsification of documents and breach of contract, with the suspected Van Gogh forgeries displayed in the background, 1932

Martin de Wild (1899–1969), a distinguished chemist and perhaps the first forensic investigator into art authenticity, was called upon to test the oil paint that had been used in Wacker's Van Goghs. He found resin and lead mixed into the paint – chemicals that made the oil dry faster, and which Van Gogh never used.[12] This was the definitive evidence that convicted Otto Wacker.

De Wild's use of pigment analysis led to the dismissal of a very expensive 'Van Gogh' acquired from Wacker by the renowned American collector Chester Dale. Although his painting was found to contain resin, which does not appear in any authentic Van Goghs, Dale stubbornly insisted that his painting was an original: 'I know of course that this is a controversial painting, but as long as I am alive, it will be genuine.'[13] Even the suspicion of inauthenticity can damage the value of an artwork. This damage spreads to personal, financial and even collective, national cultural spheres. In the end, Chester Dale *chose* to believe that his Van Gogh was authentic. He also allegedly hid scientific evidence and falsified provenance in order to trick the National Gallery of Art in Washington, DC, into accepting and displaying his forged Wacker original.

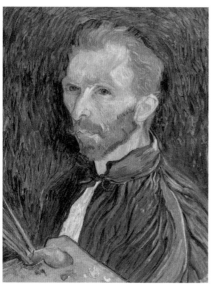

Vincent van Gogh, *Self-portrait*, 1889, oil on canvas, 57.8 × 44.5 cm (22 ¼ × 17 ½ in), National Gallery of Art, Washington, DC

Anonymous, *Portrait of Vincent van Gogh*, 1925/1928, oil on canvas, 59.4 × 47.5 cm (23 ¼ × 18 ¾ in), Chester Dale Collection, National Gallery of Art, Washington, DC

The precedents set by the Wacker trial and Martin de Wild's involvement in bringing science to the study of art would have resounding consequences. They showed that, even in a courtroom, authenticity was difficult to determine when the world's leading experts could not agree. The solution was to turn to science, which was considered an objective arbiter (and is still widely considered

so, although scientific findings and data can, of course, be misread or manipulated).

Scientific analysis can be expensive and sometimes destructive (carbon dating, for instance, requires the obliteration of a tiny portion of a work). But the larger problem is that while science may be more objective, it can often only exclude possibilities and yield 'maybes' rather than definitive answers: tests can rarely prove without a doubt that x object is the artwork entitled y by artist z. Forgers are aware of the tests to which their handiwork will be subject – and some conjure ways to defeat even the most advanced forensic tests. Some forgers have manipulated or planted evidence in schemes that run parallel to provenance traps, but which are 'forensic traps': crumbs meant for a scientist to discover, leap upon and interpret as the criminal intends.

Some scientific tests merely reveal the date or origination of the raw material, not the artwork itself, so forgers might acquire period-specific materials. Many forgers have a background in conservation, so they know the tests their forgeries will need to overcome, manipulating evidence and data to their own ends.[14]

The increasing reliance on scientific analysis coincided with a parallel rise in the art world's confidence in provenance (usually an ownership history) as reassurance of a work's legitimacy. The problem with provenance, however, is that it relies on a paper trail of historical documents that rarely survive intact over the centuries.

It is estimated that perhaps one-half to two-thirds of all artworks by pre-modern artists that we know existed – from references in contemporary documents, contracts, diaries, biographies and so on – are considered 'lost', a piece of optimistic art historical terminology that suggests that some of these missing works might be found.[15] The re-emergence of works by great artists is therefore entirely plausible. On the other hand, it is rare indeed that a work that is not mentioned in any extant document should suddenly appear. Of Michelangelo's extensive oeuvre in sculpture, for example, only a few works are considered lost – so we already have almost everything that Michelangelo was documented as having sculpted.

Despite this, a history of optimistic attribution continues, and apparently lost works with no traceable provenance do occasionally appear. In 2008 the Italian state purchased a $4.2 million carved linden-wood crucifix attributed to Michelangelo that few experts think could possibly be his work.[16] The crucifix (the cross of which

Attributed to Michelangelo,
Crucifix, c. 1495,
linden wood,
41.3 cm (16 ¼ in) high,
Museo del Bargello,
Florence

is missing) is dated to around 1495, when Michelangelo would have been only twenty. Some experts say that the delicacy of the crucifix is distinctive and bears a likeness to Christ in Michelangelo's Vatican *Pietà,* made when the artist was twenty-four. Other scholars worldwide cite a number of concerns regarding the attribution to Michelangelo.

Firstly, there is no known wooden sculpture by Michelangelo in existence. A 1492 crucifix at Santo Spirito in Florence may have been one of Michelangelo's earliest works, but this is unconfirmed and is far from the general consensus among experts. Secondly, not one of Michelangelo's many biographers mentions either this specific crucifix nor, indeed, any work by Michelangelo in wood. Thus, the sculpture fails to be backed by provenance.

When the expensive purchase was announced, most scholars and the international media felt it was a suspicious deal in which Italian government funds had been used to buy an object from friends of those in power. The personal opinion of the few experts who assigned this sculpture to Michelangelo was preferred over the vast majority of connoisseurs who disagreed. As for scientific examination, in this case it is unlikely that forensic tests would be definitive, because the crucifix does indeed date to Michelangelo's lifetime. Such optimistic attributions by select connoisseurs occur regularly throughout history. It is sometimes generations before authenticities are questioned and corrected.[17]

AUTHENTICATION IN PRACTICE

It may be useful to consider the role of a conservator, whose position is more objective than that of experts, dealers and collectors. Conservators are taught to look at art as physical objects, paying less attention to its content – for example, an Annunciation or an allegory – which is the role of the art historian. For conservators, the work of art is a fragile object that must be preserved.

The initial examination is a visual one, often accompanied by magnification. For a painting, the painted surface will be scrutinized, looking at the craquelure (the natural web of cracks that occur on the surface of paint as it expands and contracts due to changes in humidity) to see if it is consistent with the work's age. The conservator checks the back and sides of the works for markings, inscriptions, labels and other identifiers that could provide clues to its provenance, and scans for signs of potential damage (wormholes in wood, fungus, patches of moisture, places where the pigment is peeling from the support). Some of these clues are less obvious than others. Wood panels used for painting prior to the eighteenth century were planed and carved by hand, and would therefore show some traces of the tools that built them. From the eighteenth century, panels were honed by mechanical saws and therefore have a distinctive, more regular appearance.[18] Likewise, old works on canvas almost inevitably need to be reinforced at some point, as the canvas can deteriorate. If a purportedly old canvas painting has never been reinforced, that would also be cause for concern. This is how any trained professional would approach a new work of art, whether a conservator or a connoisseur. But conservators have scientific instruments at their disposal and can therefore look deeper.

To take a closer look, conservators use a handheld 'loupe' or magnifying glass, or a powerful microscope that may provide up to 50x magnification. Through this level of magnification, conservators can see, for example, whether the craquelure was painted on – a known forger's trick. A connoisseur is likely to stop at this point, whereas a conservator can apply any number of forensic tests to a work (see glossary, p 271). Collectors and dealers are only likely to order further tests if a work still seems suspicious after an initial thorough visual examination. Conservators are more apt to run a battery of tests to get as complete a picture as possible.

Take, for example, *Virgin and Child* by Jan Gossaert. The painting was cleaned by conservators and an ultraviolet (UV) photograph was taken. It revealed a pink fluorescence on portions of the panel, suggesting that a nineteenth-century pigment (red madder) had been used in these sections of a painting which, if it was indeed by Gossaert, would have been painted in 1527.[19] But this did not mean it was a nineteenth-century forgery – rather it meant that the sixteenth-century work had been damaged, and a slightly heavy-handed restoration had taken place on that section of the painting during the nineteenth century.

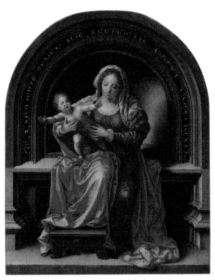 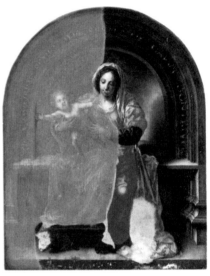

Jan Gossaert, *Virgin and Child*, 1527, oil on oak, 30.5 × 23.5 cm (12 × 9 ¼ in), National Gallery, London

Virgin and Child under ultraviolet light during cleaning. Prior to its removal, you can see the the old varnish (left) has a fluorescence

When irregularities are found, the initial assumption is not always that a crime has taken place. Instead, the reasonable conclusion would be that the conservator is facing a copy (without the intent of fraud) or that a portion of the work has been restored. This default conclusion, that there is a non-criminal explanation for irregularities, works to the advantage of the criminal prowling the art world.

A combination of scientific analysis and provenance provides the strongest argument for authenticity. But there are ways to beat any system, and the art world still relies to an astonishing degree on expertise, which remains unregulated.

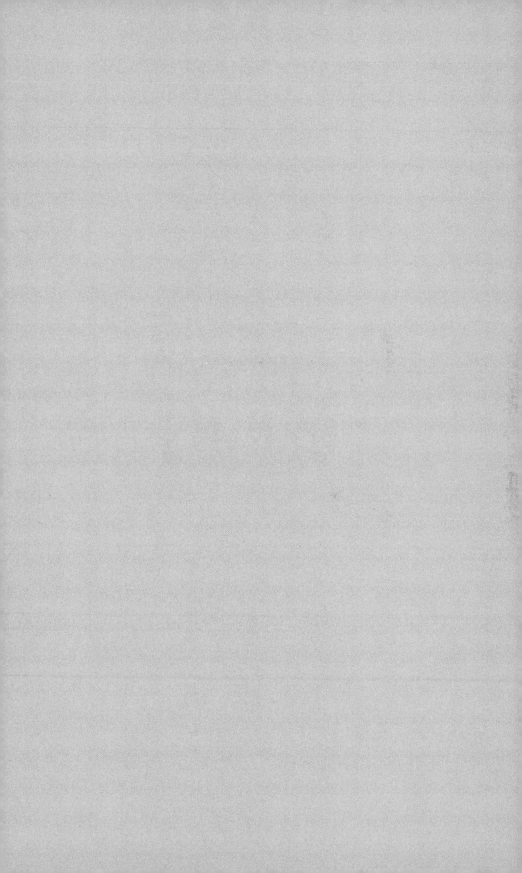

GENIUS

Renaissance apprentices learned by copying the works of their master, with the goal of making their work indistinguishable from his. It was only after a pupil produced his 'masterpiece' and became a master himself that it became possible to develop his own distinctive style. In China, the greatest praise for an artist's work was that it was identical to the work of past masters: the intentional ageing of objects to suggest that they came from a past era was considered praiseworthy, rather than disingenuous.

The ability to ape the technique of someone established and admired is, likewise, the forger's goal. Although rarely articulated, there is an element of master–pupil relationship in all art forgery. Forgers function as self-taught apprentices, attempting to mimic the technique of one or more masters. If a forger can teach himself to create works that are indistinguishable from those of the acknowledged geniuses of the past, that forger might reasonably claim to be as good as the master. But this achievement must necessarily be a private one, for the moment the forger is exposed, he can no longer practice his dark art.

This chapter examines some of the most renowned artists who forged to flatter themselves, for whom the act of aping another's work was an artistic exercise in itself. While forgers' psychological motivations can be as complex as that of any other criminal, some clearly practiced art fraud largely for the game of it, the challenge – the test of how they measured up to geniuses of the past. For the forgers in this chapter, to demonstrate their ability to mimic past masters was an end unto itself. They forged to show that they were artistic geniuses – and many of them were.

—

A MASTER'S EARLY CAREER:
MICHELANGELO BUONAROTTI AS FORGER

While Albrecht Dürer was resorting to litigation and ornery warning notices to prevent forgers profiting from his name, another Renaissance giant began his career as a forger. Before anyone had heard of Michelangelo Buonarotti (1475–1564), the most valuable sculptures on the Renaissance Italian art market were ancient Roman marble statues. Several biographical accounts demonstrate that even an artist as great as Michelangelo could be involved in wilful forgery, setting out to create an ancient Roman marble of his own. It did nothing to impede his reputation. Indeed, having successfully passed off his work as a Roman marble helped add lustre to the start of a glistening career, by showing Michelangelo had the technical skill and creative genius to match his forebears.

The first biography of Michelangelo, written by renowned historian Paolo Giovio (1483–1552), describes the artist as having 'great genius … in contrast to a character so rude and savage as to make his private life one of unbelievable pettiness'. Michelangelo carved the marble statue *Sleeping Eros* in 1496, when he was only twenty-one and, according to Giovio, doctored it in order to make it appear to be ancient. The statue was passed off as such when it was sold to Cardinal Raffaele Riario, grandnephew of Pope Sixtus IV and a great collector of early Roman antiquities (who perhaps should have known better). When Riario later found out that he had bought a forgery, he returned the statue to the dealer from whom he had bought it, Baldassarre del Milanese. However, between Riario buying the work and realizing he had been duped, Michelangelo had gone from being an unknown twenty-one-year-old to Rome's hottest commodity, thanks largely to the fame of his *Pietà* (1498–99), which proudly stood in the Basilica of Saint Peter's in Rome. Del Milanese was thus happy to take it back, and had no trouble selling it on, now under the authorship of the suddenly-famous Michelangelo. It was acquired by Cesare Borgia, and then passed on to the Duke of Urbino, Guidobaldo da Montefeltro. When Cesare Borgia took over Urbino in 1502, he also 're-acquired' the statue, which he then sent as a gift to Isabella d'Este in Mantova, where it took pride of place in her grotto, where she displayed works by the leading artists of the time. The *Sleeping Eros* remained in Mantova until King Charles I of England purchased it in 1631. It has not been seen

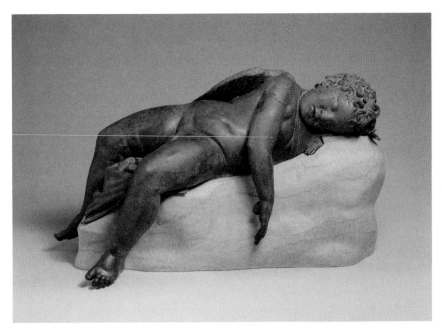

Statue of Eros sleeping, c. 3rd century BC – early 1st century AD, bronze, Metropolitan Museum of Art, New York. Michelangelo's marble *Sleeping Eros* sculpture, 1496, now lost, would have taken inspiration from the Hellenistic tradition of this kind

since, and it was likely destroyed in a fire at Whitehall Palace in 1698.[1]

Whether undertaken as a practical joke, to show that his work was as good as that of the ancients or for reasons of more criminal intent, Michelangelo's deception does not seem to have angered the original owner of the *Sleeping Eros*. Cardinal Riario became Michelangelo's first patron in Rome, commissioning two other works in 1496 and 1497: another Eros statue entitled *Standing Eros* (also lost) and the *Bacchus* now displayed at the Bargello Museum in Florence, both made shortly after *Sleeping Eros*. This is an early example of a recurring narrative: successfully fooling those who consider themselves experts does not always cause rage – it can also endear the forger to the expert.

That Riario bought the original *Sleeping Eros* believing it to be an ancient Roman marble is not in question. But we cannot be sure of the artist's ultimate motivations, because various sixteenth-century biographies shift the guilt of having concocted the deception between Michelangelo and the slippery art dealer, Baldassarre del Milanese. The renowned biographer Giorgio Vasari does not mention the story in his canonical *Lives of the Artists* (first edition in 1550), but Vasari's wonderful history is clearly slanted in favour of Tuscan art, and

Vasari was a disciple of Michelangelo's painting style and a close friend of the artist – indeed, the work reads like a publicity campaign in favour of crowning Michelangelo the greatest artist of all time.

Another contemporary biographer, Ascanio Condivi (1525–1574), does tell the story of Michelangelo's forgery – but with a twist. He blames Del Milanese, suggesting that Michelangelo sculpted the *Eros* in Florence but the dealer persuaded him that he could set himself up in Rome by selling the statue there as an ancient Roman sculpture. According to Condivi, it was thus the *Sleeping Eros* that led Michelangelo to Rome and into the service of Cardinal Riario in the first place.[2] It is worth bearing in mind, however, that Condivi's biography is an 'authorized' account – Michelangelo cooperated with the author in return for control over what was included in it – and it would have been in Michelangelo's interest to shift the blame for the deception away from himself and onto an unscrupulous art dealer.

While Michelangelo's possible complicity in a forgery scandal may be surprising, the *Sleeping Eros* was not the only work he faked – far from it. Vasari noted that: 'He also copied drawings of the Old Masters so perfectly that his copies could not be distinguished from the originals, since he smoked and tinted the paper to give it an appearance of age. He was often able to keep the originals and return his copies in their place.'[3] Alas, no more is known of which drawings were involved in this Renaissance bait-and-switch, but the story provides insight into the mind of a great artist who was also, it seems, a great forger and art thief, demonstrating how thin is the line between artistic genius and criminality.

WHEN A MASTER FAKES A MASTER: LUCA GIORDANO'S DÜRERS

Michelangelo was far from the only great artist to dabble in the darker arts. The Italian Luca Giordano (1634–1705) was one of the most famous painters in Europe when he was lured to Spain in 1692 by a lucrative financial offer, accompanied by political promises, to paint for the Habsburg king, Charles II. Giordano created a series of astonishing frescoes at El Escorial, the great monastery and palace complex outside of Madrid. Before his invitation to Spain, Giordano had made his reputation in Spanish-ruled Naples. However, while Giordano was a world-class artist in his own right, he was also an inveterate practical

joker who took pride in his ability to mimic the work of others.

Giordano was the son of a humble Neapolitan painter and had the good fortune to be apprenticed to Jusepe di Ribera. Ribera ran a large, lucrative studio in Naples, where he produced work inspired by Caravaggio, which featured dramatic spot-lighting, the *chiaroscuro* emergence of figures from shadow into light and striking realism. Ribera took the seed of Caravaggio's inspiration and made of it his own, instantly-identifiable art form. Of all of the so-called *Caravaggisti*, emulators of Caravaggio's style, only Ribera can be considered the master's equal. Giordano was Ribera's favourite pupil, given every opportunity to learn from his master and to benefit from his important connections within Spanish Naples.

While it is not clear whether Giordano was playing a prank or trying to cash in by making works in the style of other artists, one case did come to trial. In 1653, Giordano sold a painting he had done in the style of Albrecht Dürer, *Christ Healing the Cripple*, as a Dürer original. The collector who acquired it eventually grew suspicious, and decided to consult an expert. The expert he summoned was none other than Luca Giordano himself. Giordano pointed out his own signature hidden on the back of the painting and revealed that he had painted it.

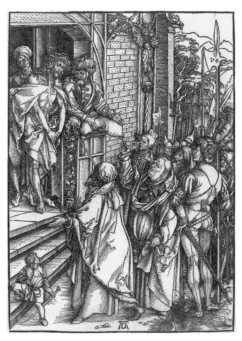

Albrecht Dürer, *Ecce Homo*, sixth plate from the series *The Large Passion*, c. 1498/1499, woodcut, 38.7 × 27.3 cm (15 ¼ × 10 ¾ in), National Gallery of Art, Washington, DC

Luca Giordano, in the style of Dürer, *Ecce Homo,* 1650-1659, oil on wood panel, 45.1 × 69.7 cm (17 ¾ × 27 ½ in), Walters Art Museum, Baltimore. An example of Giordano's paintings in the style of Dürer (see previous page), of which *Christ Healing the Cripple* was the most famous

The collector did not find this as funny as Giordano, and took him to court. When Giordano proudly revealed his signature, the judges seemed to find it as amusing as he did. They acquitted Giordano, declaring that he should not be punished for painting as well as Dürer. Whether Giordano explicitly told the collector that the work was by Dürer, which would imply active fraud, or whether he simply did not correct the collector's assumption that the work was a Dürer, is unknown.[4]

Giordano's story highlights the fine line that exists between artists copying the work or style of more famous practitioners – a long and rich tradition that still continues in art academies, where students hone their abilities by copying masters – and attempting to defraud someone by passing off work as the work of another. Giordano's motivation seems to have been part-prank, part-test of his own abilities. The money he pocketed from the sale was unlikely to have been more than he, a famous artist in his own right, would have received for painting a Giordano original.

The trial does not seem to have affected Giordano's reputation. The previous Spanish king, Philip IV, was a great admirer of Giordano's work, but despite several attempts had been unable to

entice him to Spain. Philip's son, Charles II, had more success by using guile. Giordano's son had a position in the Spanish Habsburg-run government of Naples. When Giordano petitioned Charles II to renew his son's position, Charles agreed – on condition that Giordano come to Spain as the official court painter. When Giordano remained unconvinced, Charles agreed to give lucrative royal appointments to a number of Giordano's family members (including his father-in-law, a well-known smuggler). The lengths to which Charles II went to attract Giordano show the king's determination to establish his legacy as a great patron of the arts. Giordano proved a worthy investment, and would live and work for the Spanish court in Madrid from 1692 until 1702, after Charles II died.

THE 'RENAISSANCE' JEWELLER: REINHOLD VASTERS

The German master goldsmith and restorer, Reinhold Vasters (1827–1909), created Renaissance-style jewellery in his workshop that was purchased by scores of collectors who believed it originated in the Renaissance. Vasters was a quietly skilful artist who realized that he could make more money through fraud than through his own original creations and, more importantly, was confident that his impressive technical and creative skill set him in the same league as, if not a league above, the Renaissance masters he sought to emulate.

The true extent of Vasters' abilities, and the scale of his operation, only came to light in 1979, when more than 1,000 drawings by Vasters and his studio were found by scholar Charles Truman in the archives of the Victoria and Albert Museum, London. Many of the exquisitely-drafted drawings were preparatory sketches for objects that were still being displayed by major world museums as Renaissance originals. The sketches include highly-specific instructions for assembling the works they depict, including the *Saint Hubert Tazza* and a gold belt pendant, both stars of the Rothschild family collection. Vasters' highest-profile forgery was the *Rospigliosi Cup*, also called the 'Cellini Cup'.

The *Rospigliosi Cup* is a masterwork in gold and enamel. It was acquired by the Metropolitan Museum of Art, New York, as part of a bequest in 1913, and was thought to be a work by Benvenuto Cellini, the greatest of Renaissance goldsmiths. In 1969 Met curator Yvonne Hackenbroch published an article in which she noted that

the cup was stylistically too modern to be by Cellini, but that she did not think it a modern forgery. She attributed it to a late-sixteenth century Delft goldsmith working for the Medici, Jacopo Bilivert, and the cup was renamed *Rospigliosi*, after the Roman family from which it supposedly came. It remained one of the Met's most significant treasures and continued to fool the world's experts. It was only when Vasters' preliminary sketches for it were found at the V&A that its authenticity was again called into question. Since 1984 it has been considered a Vasters forgery of the highest quality.[5]

Vasters grew up near Aachen and was appointed restorer at the Aachen Cathedral Treasury in 1853. He began his career producing silver in an antique style for church use, clearly labelling the works 'R. Vasters'. By the 1860s he had turned to making Gothic and Renaissance-style secular pieces, which he did not sign. In 1865 the Cathedral asked him to replace the clasp of an early sixteenth-century pax. While doing so, Vasters made about a dozen copies of the clasp, one of which found its way into a private art collection in Paris.[6] From the 1860s to the 1880s Vasters' wealth increased to the point where he had bought enough art to have an exhibition of his

Reinhold Vasters, after Benvenuto Cellini, cup known as the *Rospigliosi Cup*, c. 1840–1850 or before, gold, partly enameled; pearls, 19.7 × 21.6 × 22.9 cm (7 ¾ × 8 ½ × 9 in), Metropolitan Museum of Art, New York

own collection in Dusseldorf in 1902, featuring 500 pieces. How many of these were purchased originals and how many were 'Vasters originals' remains unknown.

A businessman, art dealer and antiques collector who lived in Aachen and Paris, Frederic Spitzer (1815–1890), seems to have encouraged Vasters to create forgeries, and worked in partnership with him. Vasters restored many works in Spitzer's collection, which was displayed in an eponymous museum in Paris. Spitzer appears to have introduced Vasters' forgeries into the art market. Spitzer also worked with two other highly-skilled art forgers: an enamel specialist from Cologne, Gabriel Hermeling (active 1860–1904), and a Parisian goldsmith, Alfred André (1839–1919). André's renown as a restorer was such that he was hired to work at El Escorial in Spain and in 1885 was awarded the Order of Charles III by the Spanish royal family, in thanks for his service. It was only after André's death that his work as a forger was discovered, as his studio was packed with sketches and moulds for enamel and jewellery pieces that were in collections as Renaissance originals.

Vasters' success raises the question of whether he was any less talented than Benvenuto Cellini. So many decades later, no one

Drawings of various designs for gold mounts by Reinhold Vasters, c.1870, Victoria and Albert Museum, London

can claim to have been harmed by Vasters' forgery of the *Rospigliosi Cup*. The original owner who bequeathed it to the Met in 1913 went to his grave believing he owned a Cellini masterpiece. The Met received the cup as a gift, and so no one's reputation was harmed by authenticating it, when all the world thought it was one of Cellini's finest pieces. When the Met discovered that it was a Vasters forgery, the general mood was bemusement, although Met director, Philippe de Montebello, did not find it so funny. He said: 'Most likely every major repository of Renaissance jewellery, metalwork and mounted crystals will find that a disturbing portion of their holdings date from the nineteenth and not the sixteenth and seventeenth century. It is irrefutable because we have the actual drawings created by the master [Vasters].'[8] One had to hand it to the forger, De Montebello continued: '[Vasters] captured the style of the Renaissance so well that even today, if you were to put side by side two pieces, one by Vasters and one from the Renaissance, very few curators could tell by eye alone. He was that good, which is why all the collections were fooled.' That Vasters chose to invest his time in creating something meant to be passed off as a work far more valuable than his own does not lessen the quality of the work. He made enough money as a restorer and jeweller under his own name to assemble an art collection 500 pieces strong, so finance was not the primary motivation for his dip into fraud.

Vasters did not suffer from the common inferiority complex that may be identified in many forgers in this book. He seems to have been satisfied with his abilities, his wealth and his art collection, and it was only a century after his death that his forgeries came to light. But such a confident, assured artist/forger is something of a rarity. The nineteenth century was a rich time for artists capable of creating Old Masters, and few were more skilful, and successful, than Reinhold Vasters.

BERENSON'S FRIENDLY NEMESIS: ICILIO JONI AND THE SIENESE SCHOOL OF FORGERS

The American art historian Bernard Berenson (see p. 24) prided himself on his expertise, but he was not so proud as to refuse to acknowledge when he had made a mistake. One story – possibly apocryphal – describes how Berenson met his nemesis, master forger Icilio Joni. Joni had done the unthinkable: he had created a painting that had fooled Berenson.

Icilio Federico Joni (1866–1946) was a painter from Siena who specialized in forging thirteenth- to fifteenth-century Sienese School paintings. Joni was also head of a small ring of art forgers who all operated in the city in the first decades of the twentieth century, including Igino Gottardi, Gino Nelli, Umberto Giunti, Bruno Marzi and Arturo 'Pinturicchio' Rinaldi.[9]

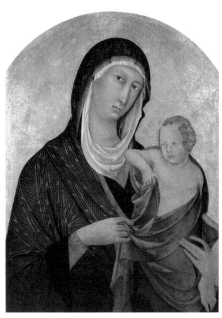 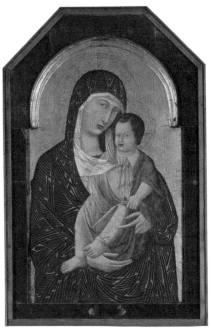

Segna di Bonaventura, *Madonna and Child*, c. 1325–1330, tempera and gold on panel, 85 × 52 cm (33 ½ × 20 ½ in), Chiesa di Santa Maria dei Servi, Siena

Icilio Joni, in the style of the Sienese School, *Madonna and Child*, gilded work on panel, early 1900s, tempera and gold on wood, 89.9 × 54 cm (35 ⅜ × 21 ¼ in), Indianapolis Museum of Art

Joni was raised at the orphanage of Santa Maria alla Scala in Siena. He studied art and was apprenticed to a gilder, restoring antique frames. There he developed an interest in creating Sienese School-style paintings, which enjoyed a retro popularity in the late nineteenth century. He began by making stylistic copies, both for his own practice as a painter and also on commission from collectors who could not afford an original. It was only when he began to artificially age the paintings and introduced them onto the market as originals that his criminal career began.

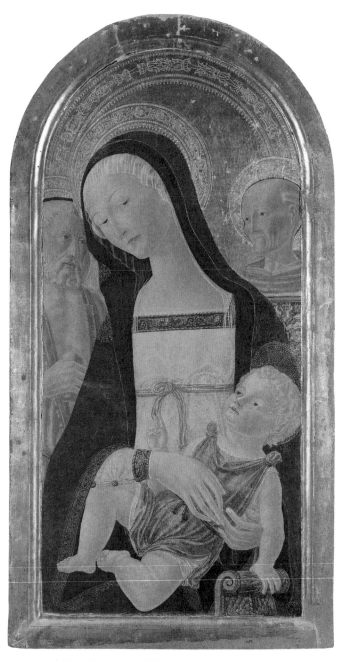

Neroccio de' Landi, *Virgin and Child with Saints Jerome and Bernardine*, 1476, tempera on panel, 98 × 52 cm (38 ½ × 20 ½ in) Pinacoteca Nazionale, Siena

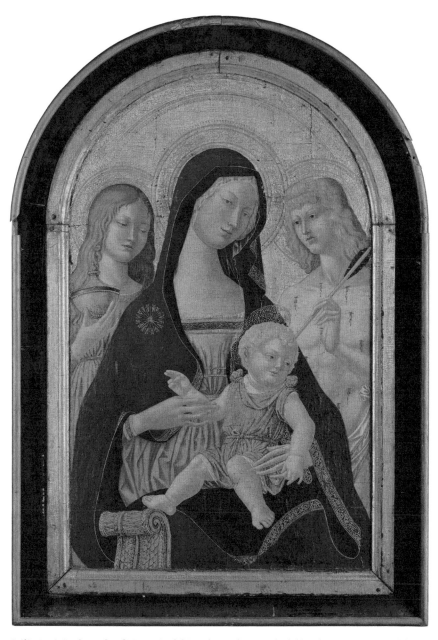

Icilio Joni, in the style of Neroccio de' Landi, *Madonna and Child with Saints Mary Magdalene and Sebastian,* date unknown, tempera on wood, gold ground, 109.5 × 72.4 cm (43 × 28 ½ in), Metropolitan Museum of Art, New York

Joni created new works in the style of Sienese masters, rather than copying existing works or re-creating lost works documented in existing provenance. His favourite artists to emulate were Duccio, Pietro Lorenzetti and Fra Angelico. His *Madonna and Child with Saints Mary Magdalene and Sebastian,* in the style of Neroccio di Bartolomeo de' Landi, is in the Metropolitan Museum of Art, New York.

The work of Joni and his collaborators was first brought into question in 1930. British collector Viscount Lee of Fareham had purchased a Botticelli, entitled *Madonna of the Veil,* from a young Italian dealer, Luigi Albrighi. The Viscount brought in experts who confirmed the authenticity of the work, and he purchased it for $25,000. It was not until the 1950s, when advances in scientific analysis and x-rays permitted closer examination of paintings, that celebrated art historian and television personality Kenneth Clark expressed doubts about its authenticity.

It was the first glimpse into what would prove to be a lively and productive forgery ring. It would transpire that *Madonna of the Veil* was not the work of Botticelli but the 'masterpiece' of forger Umberto Giunti (1886–1970), a pupil of Joni's forgery academy in Siena. The face of the Madonna was modelled on Giunti's granddaughter. Another work by Giunti, a fresco fragment, is in the National Gallery of Ireland, Dublin.

Joni was proud of his abilities, both his stylistic mimicry of the great masters and his technical skill in artificially ageing his paintings and integrating them into the market. For him, forgery was more of a practical joke and a demonstration of his abilities than a source of income. He published a memoir in 1932, *Le Memorie di un Pittore di Quadri Antichi*, in which he detailed the forgeries he had created.[10] The memoir drew a great deal of attention in the Italian art world, and immediately prompted collectors of Sienese School works to worry that their own collections might be populated by Joni forgeries. It is said that a consortium of local collectors even pooled their resources and offered to pay Joni *not* to publish his memoir.

Joni's memoir proudly described how Bernard Berenson purchased one of his works, believing it was a Sienese School original. Berenson had the work in his home for many weeks, staring at it, before he realized that he had been duped. Instead of being furious, however, he was fascinated. He simply had to meet the forger who had managed to fool him. He tracked down Joni through the dealer from whom he had purchased the painting, and travelled to Siena to meet Joni in person.

An unlikely friendship developed in which Joni played the role of the merry prankster. On more than one occasion, he would slip one of his creations into an inconspicuous location, like the sacristy of a small church, and arrange for Berenson to be called out to authenticate it, with Joni eagerly listening in to see if he had fooled his friend.[11] A testament to his vibrant but rather crass sense of humour, Joni liked to sign certain works with a hidden acronym, PAICAP, which stands for *Per Andare in Culo Al Prossimo* – 'To Stick it in the Ass of the Future'.

A now-anonymous Italian *Portrait Group* at the National Gallery in London was thought for centuries to be by an accomplished late-fifteenth-century painter, perhaps Melozzo da Forli. It was acquired

Anonymous (Italian), *Portrait Group*, early twentieth century, oil and tempera on wood, 40.6 × 36.5 cm (16 × 14⅜ in), National Gallery, London

in 1923 by the National Gallery and was thought to portray members of the Montefeltro family, dukes of Urbino. Suspicions began to grow, however, and it was only in 1960 that the work was found to be a forgery. A costume historian, Stella Mary Newton, noted that the clothing worn by the three figures in the painting was not authentic to the late fifteenth century. Male and female garments were mixed, with a man wearing what appeared to be a lady-specific sleeve, and an odd checkered hat that was popularized in women's fashion magazines circa 1913. After these anachronisms in the painted costumes, subsequent scientific analysis led to the discovery of modern pigments in the painting, none of which was available before the nineteenth century. Many suspect that Icilio Federico Joni was ultimately behind the work.[12]

As with a small group of other master forgers (see Fame p. 123), Joni's work has become valuable in its own right. A high-profile exhibition of his fakes took place in 2004 at the Palazzo Squarcialupi in Siena, a city proud of its native son.[13]

CONSERVATOR OR FORGER?
THE HEAVY HAND OF JEF VAN DER VEKEN

Before World War II, restorers tended to paint with a free hand, bringing back a damaged work to the most complete state possible and sometimes adjusting the artist's intended design to match the values of the time. Victorian conservators, for instance, painted over a tongue, nipple, groin and buttocks in Bronzino's *An Allegory of Love and Lust* in London's National Gallery, deeming the details too sexy for the viewing public.

Today, conservators seek to prevent deterioration while touching up works of art as little as possible. When they do add to paintings in order to fill in damaged portions of the composition, they do so in a way that is true to the original – but that does not try to trick viewers into thinking that the work has not been restored. The restoration efforts are rigorously photographed and documented, and the paints used are chemically divergent from the original paints, so that they can be removed by future conservators if necessary without damaging the original. For a restorer, the ability to mimic the work of the masters in order to preserve it is a critical component of professional success.

Little wonder, then, that conservators – schooled in the technical analysis, tools and historical methods of past artists – have, on a number

 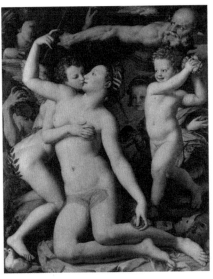

Bronzino, *An Allegory of Love and Lust*, c. 1545, oil on wood, 146.1 × 116.2 cm (57 ½ × 45 ¾ in), National Gallery, London

Bronzino's *An Allegory of Love and Lust*, photographed before restoration, showing the Victorian conservation work covering the tongue, nipple, groin and buttocks

of occasions, been behind forgery schemes. Prominent among them was the conservator to the Royal Fine Arts Museum of Belgium, Jozef (Jef) van der Veken (1872–1964).

Born in Antwerp, Van der Veken was an amateur Surrealist painter and a conservator of the highest repute. Specializing in the fifteenth-century Flemish masters, he was entrusted with the restoration of some of Belgium's greatest masterpieces, including Jan van Eyck's *Madonna with Canon van der Paele* and Rogier van der Weyden's *Madonna and Child*, the latter of which was tested through x-rays and infrared spectrometry in 1999 and found to be primarily the work of Van der Veken rather than Van der Weyden. Van der Veken's incredibly skilful but heavy hand in restoration prompted an exhibition in 2004 and 2005 at the Groeningemuseum in Bruges, called 'Fake or Not Fake', exploring the limits of acceptable restoration practices.

The great restorer's expertise and connoisseurship made him the preferred consultant of Emile Renders, a wealthy Belgian banker who, before World War II, assembled an important private collection of fifteenth-century Flemish painting. Several paintings in the collection were found to be largely, or exclusively, the work of Van der Veken. The paintings include a *Saint Mary Magdalene,* originally

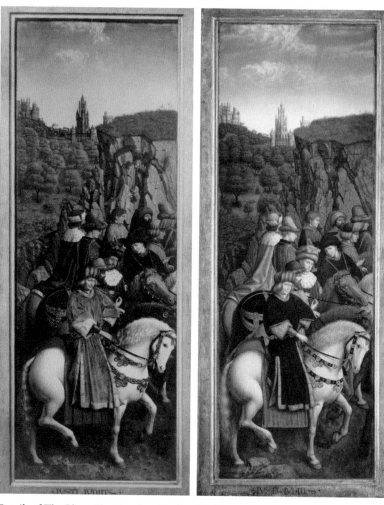

Details of *The Ghent Altarpiece* showing Van Eyck's original 'Righteous Judges' panel (left) before it was stolen in 1934, and Jef van der Veken's copy (right)

thought to have been a copy by a fifteenth-century painter after Rogier van der Weyden's *Braque Triptych*.[14] That ravenous collector of stolen art, Hermann Göring, bought the entire Renders collection in 1941 for 300 kg of gold (about $4–5 million today), with the help of the Schmidt–Staehler organization, the Netherlands-based equivalent of the ERR, the Nazi art theft unit run by Alfred Rosenberg. The collection included a forged Hans Memling painting, actually by Van der Veken, which Göring loved so much that it was one of only a handful of works he took with him when he attempted to flee the Allies at the end of the war.

Van der Veken enjoyed a sideline in making 'new' Flemish Primitives, copies of famous paintings or portions of them, using centuries-old panels as the support. He would then artificially age the works to give them the appropriate craquelure and patina. What distinguished this restorer–forger from a forger proper is that he never claimed his own work as a Renaissance original. Nevertheless, both Renders and Göring were fooled – and they were not alone.

In 1939 Van der Veken began to paint a copy of a panel that had been stolen from Van Eyck's *The Ghent Altarpiece* five years earlier. The panel, called the 'Righteous Judges', depicted a group of elegant men on horseback approaching the central subject of the enormous altarpiece, the 'Adoration of the Mystic Lamb', a lamb representing Christ bleeding into the Holy Grail on a sacrificial altar in a heavenly field, surrounded by hundreds of prophets, saints, hermits, pilgrims and knights.[15]

The Ghent Altarpiece, completed in 1432, is one of the most influential works in the history of art. It was the first large-scale oil painting to achieve international acclaim, demonstrating the capabilities of what was then a relatively new medium. It drew artists and admirers from across Europe and prompted other artists to choose oil as the preferred medium for painting over the next five centuries. It had an unprecedented level of realism, from the reflection of sunlight in a horse's eye to dozens of botanically identifiable plants painted with delicate, microscopic care on a twelve-panel altarpiece. It also has the dubious distinction of having been stolen more frequently than any other artwork, the target of at least thirteen different crimes over its six-hundred-year existence. In 1934, one of the twelve panels disappeared from the altarpiece, which was housed in the cathedral of Saint Bavo in Ghent. A series of ransom demands to the bishopric for the return of the two-sided panel led nowhere. The verso of the panel, depicting Saint John the Baptist, was returned by the thief as a sign of goodwill, but the recto side, depicting the Righteous Judges, was still missing. The police had no leads.

Several months after the ransom demands ceased, a middle-aged stockbroker named Arsène Goedertier suffered a heart attack and, with his dying words, whispered that he was the last man on earth who knew the location of the stolen panel – but he died before he could reveal anything more to his lawyer. The panel has never been found. The whole case – including the death-bed confession – struck many as suspicious, and evidence pointed to Goedertier himself as the

Jan and Hubert van Eyck, *Adoration of the Mystic Lamb*,
or *The Ghent Altarpiece*, 1423–1432, oil on panel, 3.5 × 4.6 m
(11 ft 5 ¾ × 15 ft 1 ½ in), Cathedral of Saint Bavo, Ghent

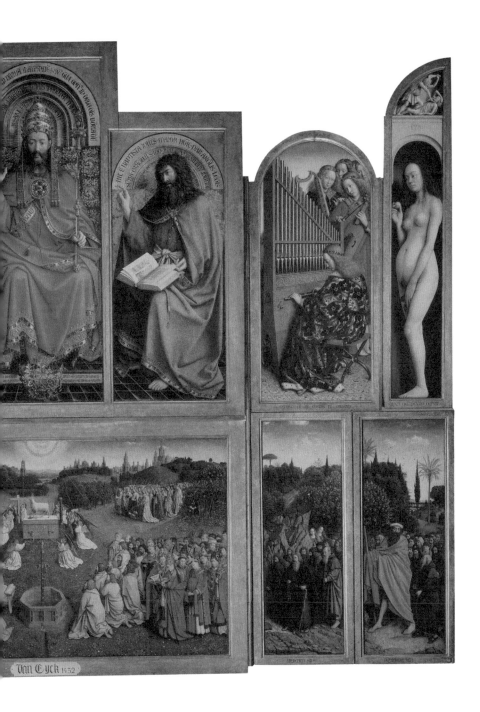

thief and ransomer. Later, however, further evidence came to light to suggest that something far more complicated was afoot.[16]

The case was officially closed, unsolved, by the Ghent police before World War II. Van der Veken, as Belgium's leading conservator, volunteered to paint a replacement copy of the missing panel – indeed, he had already started work. He used a 200-year-old cupboard door of the precise dimensions for his support, and painted with the aid of photographs and a copy of the panel that had been made in the sixteenth century by Michel Coxcie. He made only three alterations to distinguish his copy from the original panel: he added a profile portrait of the new Belgian king, Leopold III, to one of the judges in the painting; he removed a ring from the finger of another of the judges; and he moved the head of one of the judges so that his face was no longer hidden behind a fur hat.

Van der Veken finished his copy of Van Eyck's panel in 1945. It was placed in the elaborate framework of the original triptych, along with the recovered Saint John the Baptist and the other authentic panels, in 1950. His copy is still displayed with the eleven original panels today.

It has been suggested that Van der Veken was somehow involved in the original theft of the 'Righteous Judges' panel. It was odd that he began to make the replacement copy on his own initiative, and there is a touch of dark humour in his decision to work on a copy of a panel that was still missing, and that only a year before had been the subject of a renewed ransom attempt.

Oddest of all, on the back of the replacement panel is a confusing inscription. Van der Veken wrote, in Flemish rhyming poetry:

I did it for love
And for duty.
And for vengeance
Sly strokes
Have not disappeared.[17]

It is signed 'Jef van der Veken, October 1945'.

Van der Veken was interviewed on multiple occasions, but each time replied that he knew no more than anyone else about the 1934 theft. His reticence, together with the inscription – the meaning of which he refused to explain – led people to believe that he knew more than he let on, but there was never any concrete proof.

Conservator Jef van der Veken at work in his studio

In 1974 another conservator, Jos Trotteyn, made a striking accusation. He was convinced that the Judges panel had, over the course of a few months since his last visit, aged by several centuries. It no longer looked decades old, but had the craquelure and patina of centuries. Other conservators concurred, triggering uproar in the media. Many now wondered whether Van der Veken had been party to the 1934 theft and had somehow painted *over* the original panel as a way to surreptitiously insert it back into the altarpiece. Members of the bishopric of Saint Bavo had also been implicated in the 1934 theft. Was this their way of undoing a crime that had proven unsuccessful in extracting a ransom?

The question of whether the altarpiece might, in fact, be whole after all was put to rest in 2010. The Getty Conservation Institute and the Flemish government embarked on a thorough analysis and restoration of *The Ghent Altarpiece* that confirmed that the 'Righteous Judges' panel is, indeed, the copy by Van der Veken and not the stolen, painted-over, original, which is still waiting to be found.

PRIDE

All art historians dream of finding a lost masterpiece. Art history can be like a treasure hunt for grown-ups, accompanied by ravenous hunger, adrenaline and expertise. Collective wishful thinking plagues and pleasures the art community. The spark of hope that one is on the trail of a lost artwork produces such a momentum that contradictory clues may be ignored and incongruous details overlooked.

Sometimes, the success of forgeries depends not on the forger – who may not even be involved in the case – but on the wishful thinking of owners or discoverers whose enthusiasm leads to the misattribution of good copies of famous works or works in the style of famous artists. Pride plays a forceful role in driving such wilful misattributions, when collectors, academics or even institutions have a vested interest in the work being original – and therefore valuable. On the flip side, pride might also drive authentication boards and artists' estates to discredit what is considered an authentic work for reputational reasons. This chapter examines a range of cases in which pride – on the part of owners, artists, dealers or experts – may have driven misattributions.

—

THE HUNT FOR OVERLOOKED TREASURES

The promise of discovering a long lost masterpiece tempts the ego of many a collector or connoisseur – and it does happen. Works of art that have been dismissed as inferior have been found, through the sharp eye of connoisseurs and subsequent scientific testing, to be authentic and of enormous value. A Caravaggio expert, Sergio Benedetti, once spotted a grimy painting hanging in a shadowy corner of a Jesuit seminary in Dublin. It turned out to be a lost Caravaggio, *The Taking of Christ*, which is now the star of the National Gallery in Dublin. In the same way, Raphael's *Madonna of the Pinks*, purchased by the British nation for £22 million and on display at the National Gallery in London, was long thought to be only a copy after Raphael's lost original. In 1991 an investigation of provenance and scientific tests proved its authenticity. An infrared reflectogram, which allows scientists to peek beneath the surface of the paint, showed underdrawing beneath the finished painting. This initial drawing revealed an evolution of the positioning of the figure of the Madonna as Raphael's composition developed. A copy would not have an underdrawing, as it would simply reproduce what could be seen in the final, original painting. The discovery

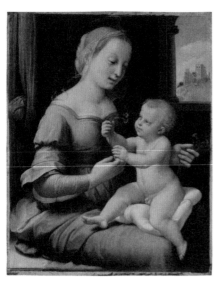 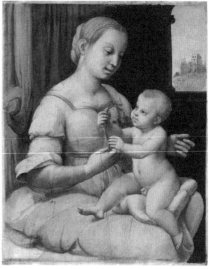

Raphael, *Madonna of the Pinks*, c. 1506–1507, oil on yew, 27.9 × 22.4 cm (11 × 8⅞ in) National Gallery, London

An infrared reflectogram image of *Madonna of the Pinks* reveals the metalpoint underdrawings

turned the tiny painting from a copy after Raphael, worth in the mid-six figures, into an original Raphael worth eight figures.[1]

Identifying a lost original does not only satisfy pride – it can be immensely lucrative. Works such as the mysterious *Salvator Mundi*, authenticated as being by Leonardo da Vinci in 2010, rise dramatically in value, perhaps by as much as a million percent. In 1958 *Salvator Mundi* was thought to be a school of Leonardo painting, meaning that the artist was probably one of Leonardo's pupils, perhaps Boltraffio. It sold for $125. This was around the time that Caravaggios could be picked up for a similarly negligible amount, and was probably the last period in which major artists could be considered 'hidden' talents. In the digital age, the worldwide availability of information makes it highly unlikely that such bargains will be had in the future. Now, with the cult of Leonardo in full bloom and no works by the master on the market, the same painting would sell for over $100 million.[2] All that has changed is the perception of who created it.

While *Salvator Mundi* has been universally acclaimed as a Leonardo, another work, discovered at the same time and likewise supported by compelling evidence, has not been accepted as authentic – at least not by everyone.

In 2010 both *Salvator Mundi* and another painting, called *La Bella Principessa,* were authenticated by Dr Martin Kemp of Oxford University as lost Leonardos. *Salvator Mundi* was displayed at the National Gallery of London's sold-out 2011 exhibition, 'Leonardo: Painter at the Court of Milan'. *Salvator Mundi* not only looked like a Leonardo, but it had a compelling provenance: it had last been seen in the royal collection of King Charles I of England, but had disappeared from view for centuries. But *La Bella Principessa*, a painting on vellum that was once part of a bound book, still divides scholars.

Kemp champions *La Bella Principessa* as a great lost Leonardo. One of his books details his argument, including the fact that he located the very book from which the vellum page seems to have been removed.[3] Kemp believes the painting to be a portrait of Bianca Sforza, painted circa 1495, and that it was cut from a book known as the *Sforziad*, a volume of wedding poetry, which is currently part of the collection of the National Library of Warsaw.

But other Leonardo experts feel that *La Bella Principessa* is not by Leonardo. It was sold at Christie's in 1988 as a nineteenth-century German painting in the style of Leonardo, and was sold again in 2007 as a portrait that was 'based on a number of paintings by Leonardo da Vinci

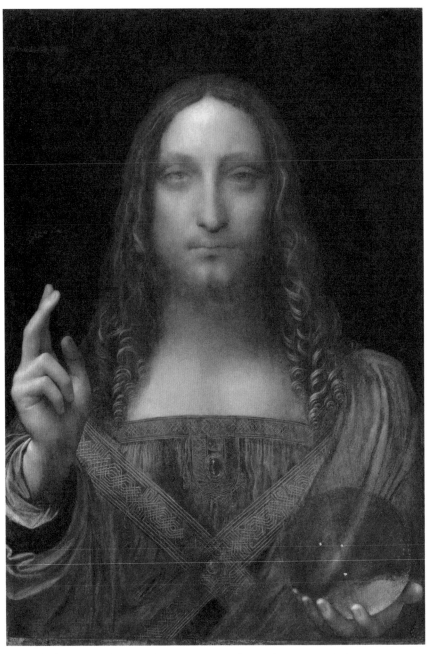

Leonardo da Vinci, *Salvator Mundi*, c. 1490–1519, oil on walnut, 45.5 × 65.6 cm
(18 × 25 ⅞ in), private collection

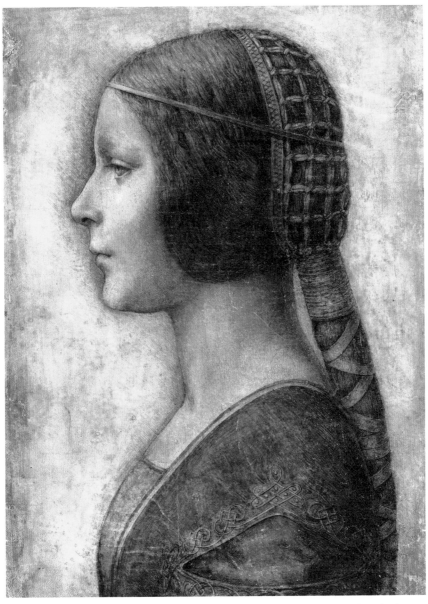

Attributed to Leonardo da Vinci, *La Bella Principessa*, dated 15th century, chalk and ink on vellum, 33 × 22 cm (13 × 8 ⅝ in), private collection

and may have been made by a German artist studying in Italy', as the auction catalogue related. It was not included in the National Gallery's Leonardo 2011 exhibition and continues to provoke debate.[4]

If the work is indeed by Leonardo, it becomes an important element of the limited oeuvre of the artist, who completed precious few paintings during his career – and is also worth millions to its current owners. When respected scholars are divided on a work such as this, and technology is unable to sway the determination one way or the other, the work remains in an attribution limbo. It is up to each viewer to decide whether they think the work is authentic or not, and it can therefore be neither wholly integrated into the canon nor comfortably dismissed.

Shifts in the perception of authorship may lead to a rise in a work's value – or less frequently to a drop in value. Art is a sound investment, provided its authorship is established and unchallenged. During a recession, art tends to keep its value far better than other commodities – unless it is proven to be a forgery. *La Bella Principessa* and *Salvator Mundi* were both under-attributed as paintings 'after Leonardo' rather than 'by Leonardo'. Therefore their values could only go up. For *Salvator Mundi,* the potential price skyrocketed; for *La Bella Principessa,* the final outcome is still undetermined.

THE COLLECTOR'S PRIDE VS. THE CONNOISSEUR'S PRIDE: THE AMERICAN LEONARDO

La Belle Ferronnière, a portrait by Leonardo da Vinci, has hung in the Louvre Museum in Paris for centuries. It is thought to portray Beatrice d'Este, wife of Leonardo's patron, Ludovico Sforza, and to have been painted by Leonardo while he was in Milan, circa 1493–1496. But in the early twentieth century Harry Hahn, an American soldier from Kansas, insisted that the Louvre version was a copy – and that he owned the original.

Harry and Andrée Hahn claimed to have received their – admittedly very good – version of *La Belle Ferronnière* as a wedding gift from a relative, whom they would not name. In 1919 they tried to sell the painting as an original Leonardo for $225,000, but the sale fell through when, without having seen the work in person, the influential British art dealer Sir Joseph Duveen declared that the Kansas *La Belle Ferronnière* was a copy that was certainly not by Leonardo. In retaliation

for having effectively slashed the value of their possession, the Hahns sued Duveen for $500,000.[5] The legal case was less an argument about forgery than about the power of experts to determine authenticity. Duveen was one of the great experts and in his employ was Bernard Berenson, the connoisseur of connoisseurs (see p. 24).

The courtroom battle between the Hahns and the world's art experts was a major media event. Berenson claimed a 'sixth sense' for authenticity, while *The New York Times* assured its readership that an expert like Berenson 'has a special gift for remembering his feelings'.[6] The general sense was that connoisseurs have an almost supernatural sensibility, in which authentic works 'speak' to them. Their word was law. To a significant extent, this holds true today: it is relatively unusual for a work of art to be subjected to rigorous scientific examination prior to sale, and most works are sold based only on the pronouncements of experts.

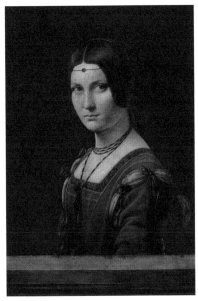 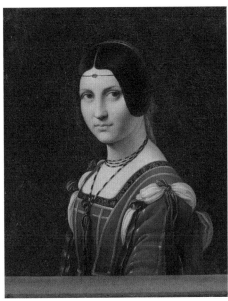

Leonardo da Vinci, *La Belle Ferronnière*, 1495–1499, oil on wood, 63 × 45 cm (24 ¾ × 17 ¾ in), Musée du Louvre, Paris

Follower of Leonardo da Vinci, *La Belle Ferronnière*, c. before 1750, oil on canvas, 55 × 43.5 cm (21 ⅝ × 17 ⅛ in), private collection

The trial took place in 1920, at a time prior to reliable forensic analysis (or, frankly, any forensic analysis at all) and before the idea of provenance was seen as a key component to authenticating art; neither forensic analysis nor provenance would come to the fore until the Wacker trial of 1932. Before the era of quality colour photographs,

it took significant effort to view a work, so experts who had examined an object personally had to be relied upon. It added insult to injury that Duveen should call the 'American Leonardo' a forgery without seeing it in person: a black-and-white photograph and Berenson's opinion were enough for him to dismiss it. The first time he saw the painting in person was during the trial.

The trial itself was a duel of egos. The Hahn family sought compensation for damages related to the devaluation of their property, but their reputation and sense of self-importance had likewise been compromised. They went from a working-class family who had struck gold by owning a Leonardo to appearing fools for falling for a forgery. Duveen and Berenson, likewise, stood their ground, both because of their pride and because their professional reputations depended on them never being wrong.

The Hahns sued Duveen, as he had the most money, but Berenson was also called to testify. He suggested that most likely the painting was a very good sixteenth-century copy of Leonardo's *La Belle Ferronnière*, perhaps even by someone in Leonardo's studio. As an authenticated Leonardo, the Hahns' painting would have been worth a fortune; without an authentication, it was a situation of *caveat emptor,* 'buyer beware': it was up to the potential buyer to decide whether to take the risk. Now an expert as renowned as Duveen had actively declared the painting a forgery, a buyer would be very hard to come by.

There was also a class element to the dispute. At the time, Duveen and Berenson were seen as the social elite, with the implication that they and their peers were the only ones who could understand great art and who 'deserved' to own such masterpieces. In contrast, Hahn represented the common man, whom the media framed as ignorant and money-hungry.

By the end of the trial, no verdict had been reached. The jury sympathized with the Hahns, but without expertise of their own they could not make a judgement one way or the other. The Hahns hoped for a retrial, but Duveen did not wish such an affair to drag out. He settled with the Hahns for $60,000.

If the 'American Leonardo' is by Leonardo, then it is a copy of the Louvre original. Today, few scholars think it is anything more than a very good copy. Yet this in itself should not be dismissed: very good copies can have great value. Berenson himself originally thought that the Louvre *La Belle Ferronnière* was by the sixteenth-century Pavian artist, Bernardino de' Conti.

On 29 January 2010, the Hahn version of *La Belle Ferronnière* was sold at auction, listed as by a 'follower of Leonardo' made 'probably before 1750'.[7] Its buyer chose to remain anonymous, but is thought to be a private collector in Omaha. Its estimated value was $500,000 and yet it sold for $1,300,000, doubtless because of the fascinating story of its trial. The Hahns' pride would doubtless have been satisfied, as owning even a *possible* Leonardo would have raised their social status – although most of all they were in it for the money. The 2010 sale price would prove a bargain if the work should turn out to be truly by Leonardo; but even if it is not, it remains a captivating piece of history.

THE ARTIST'S PRIDE: SALVADOR DALÍ AND THE OTHER DALÍ, ANTONI PITXOT

When *The Persistence of Memory*, Salvador Dalí's famous 'soft clock' painting, was displayed in New York City in 1934, it caused a huge stir. Dalí (1904–1989) was the talk of the town, hugely popular and in-demand among the literati and the Manhattan art world. A ball was held in his honour to which the inimitable Dalí arrived wearing a glass case around his chest containing a brassiere. Two years later, at the International Surrealist Exhibition, Dalí arrived to give a lecture leading a pair of giant Russian wolfhounds, wearing a deep-sea diving suit and helmet and carrying a billiard cue. Such acts were the bread and butter of the Surrealists. Anything that would turn heads, force double-takes, confuse and induce a sense of wonder was par for the course. And no one lived a Surreal existence better than Dalí.

When Dalí and his wife Gala dressed as the Lindbergh baby and his kidnapper at a social event in New York in 1934, the outraged press demanded a public apology. Dalí duly apologized, but was consequently kicked out of the Surrealist group on the grounds that one didn't apologize for a Surrealist act. Dalí quit, stating simply 'I am surrealism'.

Dalí produced a staggering number of works in many media. The number of projects to which he attached his name increased with his age – and his desire for more and more money – but his lifestyle and declining mental competence seemed at odds with his prodigious output. And no wonder. The Belgian crime writer Stan Lauryssens published a memoir in 2008 of his early career as a dealer in fake Dalí prints, in which he reveals that there were whole industries producing fraudulent works by Dalí, whose lithographs in particular rank alongside those 'by'

Picasso, Miró and Chagall as the most-faked of all artworks.[8] Around 12,000 fake Dalí prints were seized in a single investigation.[9] Dalí is the second most frequently forged artist (behind only Picasso),[10] and is known to have signed blank canvases to be filled in later by other artists. He also authenticated forgeries in his style by other artists (it seems that he genuinely believed them to be his), and he may have sanctioned forgeries of his own work in exchange for a share in the profits.[11] Dalí had become an industry – he even designed, among many other products, the wrapping and display stands for Chupa Chups lollipops.

Salvador Dalí photographed in 1973

The life of Antoni Pitxot (born 1934) is inseparable from that of his great friend Dalí. Both he and Dalí were born in Figueres in Catalonia, Pitxot a generation after Dalí, and both owned property in Cadaques. Their families were close friends and Dalí was the earliest supporter of the young Pitxot's work. Pitxot was an award-winning artist himself whose work often features surreal allegories of memory, as does Dalí's. Pitxot would go on to co-design the Dalí Museum, which was built in 1968, and became the museum's director after Dalí's death.

Pitxot received the Gold Medal of Merit in Fine Arts from the King of Spain in 2004 for work produced under his own name. However, a conspiracy theory begins in 1966, when Pitxot moved in to Dalí's villa full-time. Their close personal, artistic and geographical relationship

led some individuals familiar with Dalí to believe that Pitxot began painting *as* Dalí around the same time, sanctioned by Dalí as his own artistic powers started to wane.

There is a clear financial motivation for an artist to keep producing saleable work, especially someone like Dalí who was well-known to be obsessed with money. Fellow Surrealist André Breton jokingly noted that an anagram of Salvador Dalí is 'Avida Dollars' ('crazy for dollars'), and Dalí developed carpal tunnel syndrome from signing his autograph so often, knowing that each autograph could be sold.[12] But Dalí was already wealthy, with a steady income from prints of his work, so any decision to secretly allow a pupil to produce works in his name was surely as much about pride – refusing to admit that he had lost his artistic mojo – as it was about money.

But this raises the question: if Pitxot was working on behalf of Dalí, making 'Dalí' paintings, are these paintings still forgeries? Or are they fakes, since Dalí may have signed the canvas, thereby making authentic a painting by someone else? Certainly the artist is not losing out, as in most forgery cases. But does this action become criminal when a collector or museum buys a painting under the belief that it is a Dalí original?

In principle, such a piece has been offered under false pretences and its value is decreased. But throughout the history of art most artists have kept – and continue to keep – studios. The master artist would supervise all works produced by the studio but there have always been paintings made 'by' an artist – produced from their design and in their studio – that the artist himself has never actually touched. This was not something that artists sought to hide or cover up. It was understood that the master artist would be actively involved in the actual painting only in proportion to what a commissioner was willing to pay. Isn't the situation with Dalí merely an extended example of the studio system at work? Pitxot was simply acting as Dalí's assistant, with Dalí's studio producing paintings that were labelled as 'by Dalí', even though the actual amount of time he spent painting them may have been negligible.

The main objection to such an interpretation is the question of deceit – which in itself may be a case of pride. Perhaps Dalí was reluctant to admit that he was painting less and assigning his projects to his assistant, preferring to maintain the illusion of continued prolificacy even as his skills deteriorated. But although these works may have a tint of disingenuity about them, it is difficult to claim that they are either fakes or forgeries.

Antoni Pitxot, *The Allegory of Memory*, 1979, oil on canvas,
180.3 × 90.4 cm (71 × 35 ½ in) Dalí Theatre-Museum, Figueres

Salvador Dalí, *Untitled. After 'Moses' by Michelangelo*, 1982, oil on canvas, 100.5 × 100 cm (39 ½ × 39 ⅜ in), Fundació Gala-Salvador Dalí. A late Dalí work that some experts believe was painted by Pitxot

THE ARTIST'S LEGACY: THE BASQUIAT DOOR
AND BRUNO B VS. THE WARHOL FOUNDATION

The estates of great artists are often managed by a foundation set up in the artist's name in order to authenticate and protect the artist's legacy. Foundations typically rely on a board of experts to consider questionable artworks and to determine whether – in their expert but ultimately subjective opinions – the work is truly by that artist. If the board deems a work to be inauthentic, there is no real chance for an appeal or a second opinion. Likewise, if the committee deems a work legitimate, it enters the canon with as much authority as possible. The whole point of a committee – comprised of major art dealers, curators, scholars or former acquaintances or assistants of the artist – is to guard against the subjectivity of an individual, like that of the former one-man authentication committee, Bernard Berenson. However these boards sometimes refuse to authenticate what appear to be legitimate works for reasons beyond the mere preservation of an artist's legacy.

Jean-Michel Basquiat
at work, 1983

The New York artist Jean-Michel Basquiat (1960–1988) died at the age of just twenty-eight from a heroin overdose. A few months earlier, he had asked a Brooklyn-based drug dealer with whom he had become friendly if he could paint on the steel door in the alley leading to the dealer's rooms.[13] The dealer agreed, so long as Basquiat locked the door when he finished. The result was an unsigned, hastily-painted figure with devilish horns. Basquiat died of an overdose mere months later, on 12 August 1988.

In the years after Basquiat's death, passers-by sometimes asked if they could buy the door – for up to $7,000 – but the dealer did not sell. Eventually, however, the drug dealer became a middle-aged family man who knew the potential value of the door at a time when Basquiat paintings sold for eight-figure sums. In 2009 he sent photographs of the door to the committee that represented Basquiat's estate, which was run by the artist's father, Gerard.

Basquiat had been forged before. In 1994 the FBI investigated the dealer Vrej Baghoomian, who represented Basquiat when he died, and who was accused but never convicted of having sold five fake Basquiats.[14] In a separate case, Alfredo Martinez forged numerous 'Basquiats' and was imprisoned in 2002.[15] He used a version of the provenance trap: he obtained original certificates of authenticity from the Basquiat estate from an owner of authentic works by the artist, and then matched them to his forgeries.[16]

From photographs of the painted steel door alone, the Basquiat committee determined that the door was *not* painted by Basquiat. They argued was that it was not signed, and it lacked symbols, including a crown and a copyright trademark, which Basquiat often placed in his paintings. It did, however, contain a piece of text that other experts think sounds like the sort of thing that Basquiat liked to write into paintings: 'Yell an eye for an eye'. But the committee sent the former dealer a letter stating that they had determined that the door was not by Basquiat. That meant that an object potentially worth a million was now worth a few thousand dollars, depending on whether the owner could find a buyer who disagreed with the committee.

In official terms, this ended the debate. There was no formal way to reverse the committee's decree. But numerous experts disagree with the committee's decision and think that it may have had more to do with not wanting to place millions of dollars in the hands of a former heroin dealer who, in the eyes of some, contributed to Basquiat's death by overdose.[17] The committee chose not to examine the door in person. Saying 'no' based only on photographs, as Sir Joseph Duveen had done regarding the 'American Leonardo' nearly a century earlier, smacked to some of an overt dismissal, in this case perhaps for personal or moral reasons that are beyond the question of the art itself.[18]

A second case that reveals what seems to be even more of a battle of wills between committee and collector involves a print ostensibly by Andy Warhol, *Red Self-Portrait*, signed 'To Bruno B, Andy Warhol 1969'.[19]

It was one of ten silk-screened self-portraits made in 1965, and the Bruno B in question was Warhol's business partner, art dealer Bruno Bischofberger. The signed print was even used as the cover of a catalogue raisonné of Warhol's work by Rainer Crone, published in 1970,[20] and was then acquired by art collector Anthony d'Offay.

Catalogues raisonnés attempt to list every known work by a particular artist, whether the work is lost or extant. The catalogue raisonné becomes the document against which all works by the artist are checked. Such books are the usual starting point for a researcher investigating an artwork; they will consult the catalogue raisonné to see if a description of a lost work matches the object they are trying to identify. A catalogue raisonné of Warhol's work, including photographs, should really have settled the Bruno B debate.

However, the Warhol authentication board declared that none of the ten silk-screened self-portraits, including the one signed for Bischofberger, were authentic. The committee, which was set up in 1995 to protect the artist's estate and legacy, even went so far as to stamp 'DENIED' on the back of the prints when they were presented for authentication in 2003.

The board's rationale was that Warhol was not physically present when the silk-screens were printed. But if that were the criterion, then many prints by Old Masters such as Schongauer, Goltzius, Dürer and Rembrandt might likewise be labelled 'inauthentic', for who is to say that these masters were physically present at the moment when the prints were made? Artists from Rubens to Koons, from Joshua Reynolds to Damien Hirst, designed their artworks but did not make all of them, in some cases merely supervising their creation. A Piranesi print, printed after Piranesi's death, is worth less than one printed during his life, but is still considered to be a Piranesi print. There is even an extant photograph of Bischofberger standing beside Warhol, holding up the print in question. To confuse matters, the Warhol committee *did* authenticate the signature and dedication – just not the print itself.

When asked to explain their decision, the committee replied that they knew of no verifiable document from the period in question (1964–1965) that suggested that Warhol 'sanctioned or authorized anyone to make the work'. The art critic Richard Dorment, in an article in the *New York Review of Books*, noted that this did not make a lot of sense: 'Decisions like the one about the Bruno B *Self-Portrait* at best raise doubts about this [authentication] board's

One of the series of *Red Self-Portraits* (left) denied authentication by the Andy Warhol Foundation in 2003, and the authenticated signature by Andy Warhol to Bruno Bischofberger on the back of the Bruno B self-portrait

competence, and at worst about its integrity.'[21] Many experts outside the committee seem to disagree with its decision. In 2008 the print was included when d'Offay sold his collection to the British nation (for £28 million, when the collection was valued at £125 million). Like the Basquiat case, the episode underscores just how subjective, and occasionally morally complex, the authentication of art can be.

THE PRIDE OF NATIONS: VAN GOGH DEBATES REVISITED

Not even countries are free from forgery scandals, accusations and attempts to save face. In 1948 William Goetz, the American head of the Universal Studios film company, bought *Study by Candlelight*, a newly-discovered work that the Van Gogh connoisseur, Bart de la Faille, championed as a Van Gogh masterpiece but which was considered a forgery by Willem Sandberg, director of Amsterdam's Stedelijk Museum. Enraged, Goetz sent his lawyer to Amsterdam, demanding expert examination of the painting and a symbolic payment of 10 cents in libel damages. The city of Amsterdam, which runs the Stedelijk, steadfastly refused to participate in the discussion, claiming that it was a matter of personal opinion between Sandberg and Goetz. The city was nervous that a souring of Dutch–American relations might threaten a proposed blockbuster

Van Gogh retrospective exhibition that was to tour the United States. During the furore, the American press declared Sandberg a communist for daring to denounce a work in an American collection.[22] The Dutch government meanwhile asked Sandberg to refrain from going public with his personal opinions on art, for the sake of international relations. From a personal to a national level, the unspoken rule of the art trade is the same: in questions of authenticity, one should remain non-committal.

Hollywood producer William Goetz and his wife Edith in their living room in Beverly Hills, with the suspected Van Gogh forgery, *Study by Candlelight*, hanging on the wall, 1953

Still the property of the Goetz family, *Study by Candlelight* continues to divide scholars over whether or not it is a Van Gogh. In 2013 the Nevada Museum of Art displayed the painting as part of a small exhibition entitled 'A Real Van Gogh? An Unsolved Art World Mystery'. It is an example of those works made more famous by the debate surrounding its authenticity than it might otherwise have been. Were it simply one of the hundreds of authentic Van Gogh paintings, it might have gone overlooked in favour of the artist's more important and impressive works. But the story behind the painting adds a morbid curiosity to its aesthetic interest and possible historical importance. The suspicion of forgery does indeed cut down the value of art, but not all the way. Like the Hahn 'Leonardo', *Study by Candlelight* remains in limbo – and thus remains fascinating.

THE INSTITUTION'S PRIDE: FORGERIES IN MAJOR MUSEUMS

No museum in the world can safely say it has correctly attributed every object in its collection; there is no shame for a museum to own some forgeries. Some even have a sense of humour about it, as in the National Gallery in London's 2010 exhibition entitled 'Close Examination: Fakes, Mistakes and Discoveries'. More often, however, museums are touchy when objects they vouch for are questioned, sometimes turning aggressive and destructive in the process of protecting their reputations and pride. Usually, when a museum appears to block its ears to compelling evidence, it is the institution that winds up looking the fool.

For all the great art, scholarship and funding provided by the J. Paul Getty Museum in Malibu, California, and its related research institutions and trust, the museum has been the subject of a few too many scandals about forged or looted artworks. One reason is the Getty's wealth. It is the wealthiest museum in the world, since J. Paul Getty bequeathed a trust of \$1.2 billion in 1982. At one point the Getty was said to have had a \$100 million acquisitions budget, in stark contrast to, say, the British Museum, which in the same year had a mere £100,000 for acquisitions. The Getty therefore can and does acquire new and exciting objects, but sometimes with an air of new-money panic.[23] The collection began as a 'small and mediocre collection of ancient and European art', as *The New York Times* art critic Michael Kimmelman wrote, and the purpose of the trust and the new museum was to make the collection world class – and fast.[24] Curators combed the market for big buys, sometimes making them too quickly or with insufficient due diligence. They have – both subconsciously and also knowingly – overlooked questionable attributes of these exciting acquisitions. Former Metropolitan Museum of Art director, Thomas Hoving, called the Getty on this in his memoir, and in a series of articles in *Connoisseur* magazine (which he edited). Among others, Hoving pointed to the Getty's purchase of a marble head thought to be by the ancient Greek sculptor, Skopas, but which was found to be a forgery; the \$20 million purchase of what was called a giant statue of Aphrodite (the goddess portrayed has been questioned) and which the book *Chasing Aphrodite* demonstrates was illegally excavated from Italy; a likewise looted *kylix* by the Euphronios; and others.[25] Hoving turned out to be correct – the works he suggested were problematic, either looted or forged, for the most part turned out to be as he suspected. However, it felt as though there was a classist element

to the accusations made by Hoving – nothing if not blue blood, old money, just like the Metropolitan Museum of Art he ran – against the upstart Getty. But the Getty did buy looted and forged art on multiple occasions, sometimes knowingly but even when it only discovered the fact later on, refusing to admit fault. It was a play of pride.

One of the problems with high-profile, very expensive art purchases by renowned institutions is that the occasional mistake results in high-profile embarrassment. The Getty made headlines when it purchased the infamous Getty kouros, bought in 1985 for between $7 and $12 million, a huge sum at the time for an antiquity.[26] However, most experts think the kouros is not an antique marble statue from the Archaic Hellenistic period, but a modern forgery.[27] Before the purchase went through, many of the museum's own staff thought it was a forgery. One Getty art adviser, Federico Zeri, even resigned in protest when the acquisition was announced.[28]

Kouroi (the plural of kouros) were most likely memorial statues, idealized life-sized versions of young men used as grave markers. They date from the Archaic Hellenistic period, circa 500 BC, and are all of a set type: nude, muscled, left foot slightly forward, erect posture, arms at their sides, a half-smile (called an 'archaic smile') and a braided hairstyle that is tied back in preparation for sport.

There are only eleven kouroi in existence. The Getty kouros would be the twelfth – if it were authentic.[29] Its origins are murky and begin with an infamous and allegedly criminal art dealer, Gianfranco Becchina.[30] In 1983 Becchina offered the kouros to the Getty curator of antiquities, Jiri Frel.[31] At the time the statue was in seven pieces (apparently having been excavated in this damaged state) and was accompanied by provenance suggesting that a Geneva-based collector had purchased it in 1930 from a Greek dealer. The export date was important because the UNESCO Convention of 1970 stated that, from 1970 on, antiquities exportation regulations would be strictly enforced, and no object of 'cultural heritage' could be excavated or exported without extensive permissions and paperwork. Due to the haphazardly enforced laws of various constituent nations prior to 1970, however, an effective amnesty was given on objects excavated and exported prior to the Convention. So this kouros, with documentation that it was exported back in 1930, was fair game for museums and collectors to acquire.

But the provenance was suspicious and should have raised alarms. Among the papers was a 1952 letter that appeared to have been written by Ernst Langlotz, a leading expert in Hellenistic art, comparing the

Greek kouros from Volomandra, Archaic era Getty kouros, dated c. 530 BC, dolomitic marble,
(650-500 BC), 560 BC, 179 cm (70 ½ in) high, 206 cm (81 in) high, J. Paul Getty Museum,
National Archaeological Museum, Athens Los Angeles. Suspected to be a modern forgery

Getty kouros to another renowned kouros on display in Athens. The only problem was that the postcode in the letter did not exist until 1972. Likewise, a bank account mentioned in another letter from the provenance documents, dated 1955, was not opened until 1963. Although these two highly suspicious letters do not mean, in themselves, that the kouros was inauthentic, they should have raised concerns. But it is not clear whether anyone at the Getty checked the provenance thoroughly enough to catch these two anachronisms prior to the statue's acquisition.

Some details of the Getty kouros also struck scholars as odd. Its braided hair is rigid in a way that is unlike the eleven extant kouroi. Kouroi have been found from the late seventh century BC through to the early sixth, but the Getty kouros seemed to combine hybrid elements of several periods during which kouroi were made, while adhering wholly to none of them. The material – Thasian marble – and the proportions of the figure were both correct, but there are a number of very subtle flaws in the sculpture, such as fractures in the marble. This again raises suspicions because it is known for Hellenistic sculptures to have been abandoned midway through carving because such flaws were found.

The Getty commissioned two scientific studies of the kouros. Norman Herz at the University of Georgia geology department used x-ray defraction to measure the carbon and oxygen isotope in the stone, and determined that the marble used in the kouros – 88 percent dolomite marble and 12 percent calcite – had come, with 90 percent certainty, from the Greek island of Thasos. Stanley Margolis at the University of California at Davis meanwhile determined that the marble had gone through a process called de-dolomitization, in which magnesium leaches out of the stone, a process Margolis concluded could only have taken place over many centuries and under natural conditions. Armed with positive scientific results to back up its abundant funds and desire to acquire, the Getty went ahead with the purchase.

Doubts soon resurfaced, however. In the early 1990s, chemist Miriam Kastner demonstrated that de-dolomitization could be artificially induced in a laboratory – a result since confirmed by Margolis – although it seems implausible that a forger would be capable of the time-consuming, complicated process required. Still, many scholars continued to believe that the kouros just 'feels' wrong. Thomas Hoving, for example, felt immediately upon seeing the Getty kouros that it was fake.[32]

In 1990, meanwhile, Dr Jeffrey Spier published the discovery of the torso from a kouros that is considered definitively to be a forgery. This torso is made from the same marble as the Getty kouros and exhibits some of the same sculpting techniques, making it likely that the same forger carved it. However it was clearly aged artificially, bathed in acid to give the impression of age-related damage, and it is clear that some of the sculpting was done using power tools. The Getty later purchased the torso for study purposes, which is in line with their role as an educational institution, and may indicate a willingness to acknowledge that they had inadvertently bought a forgery by later knowingly buying one for didactic reasons.[33]

The combination of connoisseurs suspicious of the Getty kouros' appearance, evidence that de-dolomitization could be artificially induced and the clearly forged provenance all add up to suggest that the Getty kouros is not what it appears to be. The disgraced former curator of antiquities, Marion True, who was tried in Italy for having knowingly purchased looted antiquities, said, 'Everything about the kouros is problematic.'[34] But the wall sign beside the kouros still refuses to admit defeat. It reads: 'Circa 530 BC or Modern Forgery'.

Another major scandal at the Getty involved drawings and illustrates a duel of egos between the institution and one of its own curators. The story was revealed in a 2001 *The New York Times Magazine* feature by Peter Landesman called 'A Crisis of Fakes'.[35] Landesman recounted how, in 1993, the soon-to-become curator of European drawings of the Getty, Nicholas Turner, was looking through a selection of the museum's Old Master drawings. He pulled out an ink sketch entitled *Female Figure with a Tibia*, attributed to Raphael. Something did not look right. Turner suspected that the drawing was a forgery, and he suspected he knew the culprit: the British master forger Eric Hebborn (see p. 100).

Turner was appointed to the curatorship the following year and, in time, he uncovered a total of six drawings in the museum's Old Master collection that he suspected were forgeries. All, he believed, were by Eric Hebborn. The six drawings were attributed to Raphael, Desiderio da Settignano, Fra Bartolommeo, Martin Schongauer and two anonymous artists, and had been purchased by his predecessor between 1988 and 1992 for a total of over $1 million. The Desiderio da Settignano drawing had been acquired most recently, in 1994, for $349,000.[36]

Like most connoisseurs, Turner initially felt that the drawings simply did not 'feel' right. But he also pointed to specific elements that seemed incorrect: the paper appeared 'over-washed' and 'unnaturally aged', and the ink looked too faded for its age – iron-gall ink usually darkens over time, rather than fading. Turner also thought that the six paintings had stylistic similarities that they should not have possessed. Forgers tend to copy an artist's style slowly and carefully, while an original artist uses a smooth flowing line that comes naturally, resulting in lighter, wispier, less concentrated lines. These 'weighty' lines were tell-tale signs of forgery. Moreover, four of the six drawings had the same general feel, which included what Turner considered to be surprisingly poor cross-hatching in the shadows.

There was also the baby's head in the drawing ostensibly by Fra Bartolommeo. Turner had seen the same baby's head facing to the right in an authenticated Fra Bartolommeo drawing in a German museum. The Getty drawing had the exact same face, but it was reversed, now facing left. In the drawing by an unnamed 'Northern Italian', Turner thought he found a simple reverse of a self-portrait by Gentile Bellini that he had seen in the Kupferstich-Kabinett Museum in Berlin.

Raphael, *Mercury Offering the Cup of Immortality to Psyche*, 1517/18, red chalk and metalpoint, 26.9 × 22.7 cm (10 ⅝ × 9 in), Staatliche Graphische Sammlung, Munich

Attributed to Raphael, *Female Figure with a Tibia*, dated c. 1504-1509, pen and brown ink, 30.5 × 44.5 cm (12 × 17 ½ in), J. Paul Getty Museum, Los Angeles. Suspected to be a forgery by Eric Hebborn

Turner also noticed several discoloured patches along the right edge of the 'Fra Bartolommeo' drawing, which he suspected could have been from wax or grease used to prevent the ink from being absorbed by the paper, a technique which the scrupulous Fra Bartolommeo would never have used. Turner used a common trick among experts and collectors, turning the pictures upside-down in order to better examine the component parts of the drawings rather than being swayed by the picture as a whole. This highlighted what Turner saw as sloppy lines in the 'Raphael' drawing in both the female figure's armpit and foot. As Turner told Landesman: 'A drawing, like a person, takes a long time to get to know. If the work is authentic, it all hangs together as a statement – there are no oddities about it, and it is organic and coherent. If something on closer inspection lets you down, it will continue to let you down. The more you go back to it, the more it reveals its weaknesses.'[37]

When Turner began to investigate provenances for the six suspect drawings, he found that none had any documented history prior to the twentieth century. It might be acceptable for any one or more of these drawings to have irregular documentation, but it was odd that it should affect all six.

Workshop of, or by Desiderio da Settignano, *Studies of the Virgin and Child*, dated c. 1455–1460, pen and brown ink over stylus underdrawing (recto); pen and brown ink and black chalk (verso), 19.4 × 27.9 cm (7⅝ × 11 in), J. Paul Getty Museum, Los Angeles. One of the drawings suspected to be by Eric Hebborn

Turner asked permission to present his concerns to the Getty trustees in order to proceed with the next step, scientific analysis. The directorship first acquiesced, but then told him to say nothing. The administration wanted to avoid appearing the fools, preferring to remain ignorant of whether the suspect drawings were indeed forgeries. If they allowed scientific testing and the drawings were found to be authentic, they would have publically disgraced their own former curator and merely proved what they already had declared – that the drawings were genuine. If the tests proved that the new curator was correct, then the Getty looked foolish for having purchased forgeries, wasted money and demonstrated their own ignorance. It was a lose–lose situation that could only have been salvaged if, from the start, the Getty administration had been willing to accept their possible mistakes. With a handful of scandals already on their books, however, the directorship battened down the hatches and prepared to fight.

There is something of a parallel in the rationale *not* to test for authenticity in the story of the bones of Saint Peter, which were discovered in September 1941 buried beneath the Basilica of Saint Peter in Rome, where Christian tradition had long claimed the founder of Christianity was buried.[38] The bones were found directly beneath the main altar, adjacent to an enormous Roman burial ground. On tours of the Vatican, guides are careful not to claim that these bones are, without doubt, those of Saint Peter, as they have never been tested. Were they tested scientifically and proven to be authentically of the period, from the first century AD, then we still would not know that they were Saint Peter's, merely that they *could* be. If tests revealed that the bones were not from the first century, then a faith-based institution, the admiration of millions of pilgrims and 2,000 years of tradition, might come crumbling down.

The Getty's refusal to test the drawings was just the start of Turner's problems. He began to complain that his department was under-funded and given insufficient gallery space, which he claimed was a punishment for voicing his suspicions. He went so far as to sue the museum but settled out of court in 1998, agreeing to resign in return for a mid-six-figure payment and a promise that the Getty would publish a book disclosing his suspicions about the drawings.

The rift between Turner and the Getty was clearly irreversible, but still no one knew about the authenticity of the drawings. When the Getty sought the opinions of two independent scholars, Paul Joannides of Cambridge University agreed with some of Turner's suspicions but

not others, and called Turner's analysis a 'magnificent piece of work by an expert of worldwide reputation'. William W. Robinson of Harvard's Fogg Art Museum chose not to offer any professional opinion but, having only seen photocopies of the drawings, confirmed that there was 'something questionable about them' and that Turner 'was onto something'.

Gentile Bellini, *Portrait of a Man (Self-Portrait?)*, c. 1496, charcoal on paper, 23 × 19.4 cm (9 × 7 ⅝ in), Kupferstich-Kabinett Museum, Berlin

North Italian, *Portrait of a Man*, dated c. 1490, pen and brown ink, 21 × 16 cm (8 ¼ × 6 ¼ in) J. Paul Getty Museum, Los Angeles. Suspected to be a forgery by Eric Hebborn

If Turner was correct, as seemed likely, it would damage not just the Getty as an institution but also his predecessor, George Goldner – by that time curator of drawings at the Metropolitan Museum of Art in New York – who had rubberstamped the purchase of the six drawings. In the art world, authenticating a forgery is a sin far greater than misattributing a work of art.

Goldner had a response to some of Turner's concerns. The reversed face of the baby in the 'Fra Bartolommeo' could have been the stock face for *putti*, baby angels, which the artist was planning to use en masse in an altarpiece. Goldner agreed that aspects of the 'Raphael' drawing struck him as suspicious, but went on to say, 'Not every drawing I bought was wonderful, but there is a difference between unexceptional drawings and fakes by Eric Hebborn.'[39]

In June 2001 Turner sued the Getty again, this time for having gagged his right to reveal the alleged forgeries in a published book. The affair was very messy. Sara Hyde, a former curator of drawings at the Courtauld Institute, told Landesman: 'Experts see what they want to see ... They want to see fakes when they want to discredit their predecessor, and they want to see real when they want to believe.'[40] The majority of experts interviewed about the six drawings chose not to comment, so as not to damage a colleague's reputation – or their own, if they said something that later proved incorrect. Those who did comment tended to think that the drawings were of a poor standard at best, even if they were authentic.

A forgery scandal like the Getty drawings affair can ruin careers, lose millions, pay criminals and harm reputations. But it also damages our understanding of the past and skews the study of history beyond its immediate sphere of influence, because it prompts us to doubt the expertise of experts.

The Getty is not the only institution that has fought an uphill battle against the evidence in order not to lose face. The Metropolitan Museum of Art in New York entered into a similar debate over a small Cycladic sculpture of a harp player.

In the late 1940s a Greek shepherd named Angelos Koutsoupis told John Craxton, a British artist writing for *The Times of London*, that he had forged an 11.5-inch-tall stone statue displayed at the Metropolitan Museum of Art, which has been praised as one of the finest examples of Cycladic art, making it approximately 4,000 years old. Koutsoupis described how he had created the statue based on a work in an Athens museum, then buried his fake in a riverbed for six months until it was covered in limescale and looked appropriately aged. Oscar White Muscarella of the Met told Peter Landesman for his 'Crisis of Fakes' article in *The New York Times Magazine* that he had long considered the statue to be a forgery, for the initial reason that the harp being played by the figure is not an ancient harp.[41]

The Met, meanwhile, claimed to have scientific test results that proved the statue's authenticity, but they refused to release them, arguing that doing so might assist future forgers. The gallery's curator of Greek and Roman art, Joan Mertens, pointed to a portion of the statue that was slightly brighter than the rest, and said that it was a remnant of paint that had once covered the whole figurine. It was only discovered in the 1970s that Cycladic figurines – one of the most

frequently forged types of art due to their relatively simple form – were once covered in paint, something the shepherd could not have known in the 1940s, meaning he would not have added the hint of paint. Others have countered this argument, noting that nineteenth-century art history texts state that ancient Greek statuary was painted and therefore the paint argument it is not sufficient proof of the *Harp Player's* authenticity. In fact, a painted Cycladic sculptural head was found in Greece as early as the 1890s.

Marble seated harp player,
Late Early Cycladic I-
Early Cycladic II,
dated c. 2800-2700 BC,
marble,
29.2 cm (11 ½ in) high,
Metropolitan Museum
of Art, New York

Scholars remain divided, and the work remains in the museum's collection, labelled as 'Seated harp player, circa 2800–2700 BC, Early Cycladic'. Whether or not you believe it is original is largely a matter of whose arguments you find most convincing. The very suspicion of inauthenticity, however, can taint an object forever, just as it is a cardinal sin for an expert to claim a work is authentic that turns out not to be. That can be a career-ending error, which is why experts as well as institutions tend to stick to whatever their first public utterance was regarding the authenticity of an artwork. With pride and reputation on the line, the art world tends to go to war rather than admit a mistake.

REVENGE

Unsuccessful artists often see the art world as being exclusive and snobbish. In some cases, these rejected artists plot creative ways to get back at whatever institution they feel dismissed their work or wronged them in whatever way. By creating forgeries that fool the same so-called 'experts' who dismissed their original work, artists-turned-forgers can exact a kind of passive–aggressive revenge against the art world, which they tend to view as a collective 'other', a club to which they are not invited and which therefore deserves to be the target of their connivances. This revenge is twofold. First, by creating works that are mistaken for the art of great masters, the forger demonstrates that he is as good as that great master. Second, the forger demonstrates the foolishness of the 'experts' who dismissed him or her, by showing that they cannot even tell the difference between an authentic work and a forgery.

Many of the forgers detailed in this book first turned to forgery for revenge, with a combination of other motivations following this initial impetus. Part prank, part raising of two fingers to the establishment, part test of one's own prowess, revenge, for these forgers, is a dish best served at auction.

—

HAN VAN MEEGEREN FORGES FOR HIS LIFE

The great Vermeer forger, Henricus Anthonius van Meegeren (1899–1947), set out to paint Vermeers to take revenge against the art world – but his Vermeers nearly took revenge on him.

Van Meegeren had ambitions as an artist, but his original paintings never found critical or popular acclaim. They were technically well-executed but heavy-handed, and his preferred subject matter, a cross between Surrealism and softcore erotica, was not of the highest levels of taste. In response to the failure of his career, Han van Meegeren, as he was known, pitted himself against the art world. His success has proved inspirational to later forgers in the twentieth century.[1]

We know an inordinate amount about Van Meegeren because he was publicly tried for high treason after World War II. He was accused of selling a piece of Dutch cultural heritage, a painting by Vermeer entitled *Christ with the Woman Taken in Adultery*, to the ravenous collector of largely stolen masterpieces, Hermann Göring. The head of the Luftwaffe and Adolf Hitler's number two, Göring assembled a collection of thousands of masterpieces which had been either stolen by his agents or appropriated from the Nazi art theft unit, the ERR, after it had stolen the works, or which had been purchased at a steep discount from desperate individuals during the war.[2] Göring favoured Teutonic or Scandinavian artists and subject matter, such as Memling, Van Eyck and Vermeer (recall that he had also acquired a Jef van der Veken, thinking it was a Hans Memling, see. p 52). To Göring, as well as to others among the Nazi elite, Vermeer was an ideal artist and his works were of inordinate value. But the Dutch considered Vermeer's works part of their cultural heritage, so when the Allied Art Commission found records of Göring's purchase of *Christ with the Woman Taken in Adultery* from Van Meegeren, the artist was put on trial for treason – punishable by execution. His defence was that he was in fact an art forger, and that the Vermeer (and another that had been purchased before the war by the Museum Boijmans van Beuningen in Rotterdam) was his own handiwork.

Van Meegeren had tasted some success with his original art, with several exhibitions between 1917 and 1922, but he had a far higher estimation of his talents than the critics did. He determined to prove the critics wrong by creating a forgery that would reveal their ignorance while simultaneously demonstrating his prowess.

Han van Meegeren, after Vermeer, *Christ with the Woman Taken in Adultery*, 1942, oil on canvas, 100 × 90 cm (39 ⅜ × 35 ½ in), Netherlands Institute for Cultural Heritage

Van Meegeren was something of a megalomaniac, who used his fortune to buy multiple properties, developed a morphine addiction and hoarded cash, hiding it in random places.[3] Living as a recluse in a villa in Provence, he first produced *The Supper at Emmaus* in the style of a young Vermeer, intentionally damaging the painting to make it appear older. Abraham Bredius, the leading authority on seventeenth-century Dutch painting, immediately hailed the painting as not only a great lost work of Vermeer's early art but also the most important painting of Vermeer's oeuvre. When the painting was unveiled at the Museum Boijmans in 1938, it was a major media event. This early success prompted Van Meegeren to forge other works in the loose style of Vermeer and other Dutch masters, such as Pieter de Hooch. In total, his forgeries earned him the equivalent of around $60 million today.[4]

Johannes Vermeer, *Girl Reading a Letter at an Open Window*, 1657–1659, oil on canvas, 83 × 64.5 cm (33 × 25 ½ in), Gemäldegalerie, Dresden

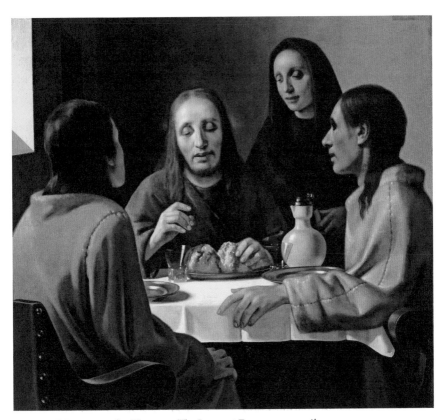

Han van Meegeren, after Vermeer, *The Supper at Emmaus*, 1937, oil on canvas,
118 × 130.5 cm (46 ½ × 51 ⅜ in), Museum Boijmans Van Beuningen, Rotterdam

The first thing that strikes most people who see Van Meegeren's 'Vermeers' is that they look nothing like paintings by Vermeer. The only thing they have in common with real Vermeers is the effect of light emanating from the painted windows. Van Meegeren's pictures are too large, too painterly and too clunky to match Vermeer's style. They also show religious scenes, of which there are none now extant by Vermeer. However Bredius – and others in the 1930s – supported a theory that Vermeer went through an early period of religious painting inspired by Caravaggio. Bredius was particularly pleased to suddenly find on the market a work by Vermeer that ostensibly proved the theory correct – and authenticated Van Meegeren's work.

The very man who had sealed Van Meegeren's success as a forger proved a deadly nemesis in the courtroom. Called as a witness at the trial, Bredius fervently denied the possibility that anyone could have forged the 'Vermeer' he had authenticated. After all, his reputation was at stake. In the art historical periodical the *Burlington Magazine*, Bredius had written of *The Supper at Emmaus*: 'It is a wonderful moment in the life of a lover of art when he finds himself suddenly confronted with a hitherto unknown painting by a great master ... And what a picture! We have here a – I am inclined

Han van Meegeren painting *Christ Among the Doctors*, after Johannes Vermeer, following his arrest in 1945

to say – the masterpiece of Johannes Vermeer of Delft.'[5] Van Meegeren would have to prove himself as a forger by explaining every step in his process before the judge.

Unlike many forgers, for whom being caught allows them to reveal their genius to the wider public, Van Meegeren seems to have wished to remain anonymous, for his revenge to have remained a private one. Even after his arrest, he languished for a month in prison before revealing his forgeries only when he realized that his life depended on it. 'Fools', he is said to have finally shouted, 'you think I sold a priceless Vermeer to Göring? There was no Vermeer. I painted it myself!'[6]

In court, Van Meegeren explained that he painted with the same natural pigments as those used by Vermeer, including ultramarine, which was difficult and expensive to acquire. Once he finished painting, he had to 'age' the canvases artificially, both reproducing craquelure and drying the oil paints, a process that normally takes years. He knew that a simple test could be performed to determine the age of an oil painting: dripping pure alcohol onto the oils will result in the dissolution of any layers of oil paint that are not thoroughly dry. To achieve this rapid-drying effect, Van Meegeren concocted a recipe for oil paints

Han van Meegeren during his sentencing on trial in 1947

that included the synthetic resin Bakelite and oil of lilacs to speed up the aging and drying process. He baked dozens of quickly painted canvases in the oven in order to determine the precise temperature and time that would dry and then crack the paint to the required amount.

Despite having given a plausible step-by-step recipe for his ingenious forgeries, Van Meegeren was still not believed. Bredius refused to consider that he had been mistaken, remaining entangled in the wisteria of his own determination to be right. The trial turned truly cinematic when one of the presiding officers suggested that, if Van Meegeren had painted the Göring Vermeer, he should be able to paint a copy from memory while in custody. The haughty Van Meegeren responded: 'To paint a copy is no proof of artistic talent. In all my career I have never painted a copy! But I shall paint you a new Vermeer. I shall paint you a masterpiece!'[7]

And so he did, cheating the death penalty by proving that he was indeed a forger. In the process the pro-Fascist Van Meegeren went from Nazi collaborator to folk hero, labelled 'the man who swindled Göring'. Adding to Van Meegeren's new status, Göring was told while awaiting execution that the Vermeer he had so treasured was a forgery.[8] It was a small stroke of revenge against Göring, the fruit of Van Meegeren's vengeance against the art world.

THE MOST SKILFUL FORGER OF THEM ALL: ERIC HEBBORN

Eric Hebborn (1934–1996) was a London painter who struggled to find a market for his original works.[9] He turned to forgery to take revenge on a specific and storied London gallery, Colnaghi, which Hebborn believed had intentionally cheated him. Hebborn had purchased some drawings at a flea market that he had valued by Colnaghi, whose experts judged the drawings reasonable and agreed to take off his hands. Hebborn was pleased, having more than doubled his investment, but shortly afterward returned to Colnaghi and found the same drawings on sale for thousands of pounds, far more than he had been paid for them.

Hebborn was furious, and determined to exact revenge on the scheming 'experts'. While Colnaghi was his first target, he quickly expanded his field, attempting to show up the whole art world, which he felt was elitist and snobbish, and determined to take advantage of those outside its exclusive confines. By passing off his own works as those of

Old Masters, he simultaneously exposed the art trade's lack of expertise, at least to himself, and also won silent praise for his own artistic skill, making his work indistinguishable from an original by a great master. Financial gain was a secondary motivation – and certainly a bonus.

From the late 1950s to his death in 1996, Hebborn made more than 1,000 pictures in a huge range of styles and periods, though his specialization was Old Master drawings. Like all great forgers, Hebborn did not simply replicate known works. (What most people think of when they think of art forgery – copying the *Mona Lisa*, say, and then swapping the copy for the stolen original – rarely, if ever, occurs.) The best forgers use versions of the provenance trap to back up their work.

Hebborn created artwork that embodied provenance for known, extant paintings. He would study the work of major artists, visiting the British Museum in London and the Uffizi in Florence regularly, and then create what he would pass off as preparatory drawings for these renowned paintings. Because few Old Masters kept their drawings, which they considered not worthy of saving, let alone displaying, drawings are relatively rare, so there is little in terms of specific expectation of what preparatory works by any given artist should look like. When Hebborn created a drawing in the style of Anthony van Dyck, meant to ape a preparatory study for Van Dyck's *Crowning with Thorns*, he was able to loosely sketch sections of the finished painting in a convincing medley that passed muster as a plausible preparatory study. This was his trick in preparing the drawings that Nicholas Turner suspected were his handiwork at the Getty (see p. 83), and it was a formula that brought him hundreds of successes.

Modifying an existing motif was smarter and easier than concocting a new 'Van Dyck'. It used existing works as a form of the provenance trap, with experts themselves drawing the connection between the finished painting and the 'newly-discovered' drawing. The British Museum acquired Hebborn's sketch, satisfied that it was a Van Dyck original.

The larger problem with this is that Hebborn's forgery then entered the canon, so scholars would study it along with original Van Dyck drawings. Undetected forgeries, in this way, alter the historical record, strewing archives with lies. When a forgery is identified, every study that referenced that forgery must be reconsidered. Furthermore, it prompts scholars and the public alike to question legitimate works from the same collection by removing their confidence in the ability of an institution to detect a fake.

Hebborn was a charismatic, entertaining and brilliant man, and it is easy to forget that he was also a criminal. However, he met a gruesome end; he was murdered in Rome in 1996. The murder was never solved, but is a reminder that he was also an unsavoury character who was involved in the dark side of the art world, and with the shadow-lurkers who brought him to an untimely end.

The study of forgery owes a certain debt to Hebborn. He authored several books about his career that are both entertaining and informative, including *The Art Forger's Handbook*, which details his methods, and which has been found in the workshops of many a subsequent art forger.[10] Between Hebborn and Han van Meegeren, both of whom penned step-by-step 'recipes' for their work, one is left with a good sense of how forgers work, and therefore what to look for in order to avoid falling into the traps they lay.

Anthony van Dyck, *Crowning with Thorns,* 1618–1620, oil on canvas, 225 cm × 197 cm (88 ½ × 77 ½ in), Museo del Prado, Madrid

Aware of the forensic tests available to root out forgeries, Hebborn combined genuine artistic skill with forethought and presence of mind to create works that, even if they were scientifically examined, could defeat most of the testing mechanisms. Hebborn outlined the recommended 'ingredients' in a forger's 'kitchen', or studio as: water; eggs, used to make tempera paint; milk, a fixative for pencil, chalk and pastel drawings; breadcrumbs, traditionally used as an eraser and also used over chalk to simulate artists' use of their fingers to smudge shadows; potato, which when sliced can be rubbed over paper covered in varnish, wax, oil or grease to allow one to use ink on that area; coffee and tea, used to tint paper to give it the illusion of age; olive oil, to produce stains that look as though they might have come authentically with age; gelatin and flour to make pastes and glues; ice trays, used instead of a palette to compartmentalize shades of ink; and a stove for heating materials and supports to combine ingredients and to harden pigments and induce cracquelure.

Eric Hebborn, after Van Dyck, a forged preparatory drawing for Van Dyck's *Crowning with Thorns*, c. 1950–1970, ink on paper, 26 × 28.5 cm (10 ¼ × 11 ¼ in), British Museum, London

Hebborn insisted on remaining faithful to the original materials and processes of the artists he sought to emulate. For an ink drawing such as his *Crowning with Thorns*, Hebborn made ink from original ingredients because modern inks contain varnish to make them glisten. Carbon-black ink can be made simply with charcoal soot and a binder such as oil, glue or gum. Other inks include iron-gall ink, the most common in Renaissance drawings of the sort in which Hebborn specialized; bistre, a lustrous dark-brown colour, is made with burnt wood and used by artists like Rembrandt in the seventeenth and eighteenth centuries; and sepia, made from cuttlefish ink, which was used largely from the eighteenth century onwards.

In order to produce a fluid, unstudied line, Hebborn recommended using quill or reed pen – he cut his quills from the pinion feathers of birds (he drily instructed 'first, find an amenable bird'). He also suggested drinking alcohol during forgery sessions in order to be relaxed and encourage a fluidity of line. Slow, overly-meticulous lines inevitably look forced, and the quantity and location of ink within a line can provide clues to experts that the work was copied. Hebborn practiced constantly in order to perfect an artist's lines before drawing a picture quickly – while slightly drunk – in order to reproduce the natural fluidity of an original.

Hebborn was a careful chemist and understood that some inks, like oak gall, might eat through their paper support, and that astute experts might look for deeper grooves in drawings where oak gall ink was used. He suggested choosing the sections of drawing that have the heaviest amount of ink and tracing those sections with a quill or reed pen dipped in sulphuric acid to mimic paper eaten away after centuries of contact with oak gall.

Hebborn bought Early Modern books in order to cut out blank pages and use them as supports for his drawings. He chose artists to forge based on what ingredients were available, matching an artist to the available paper. Hebborn was so confident with a wide array of styles that he could afford to allow the forensics to guide him. If he had access to a few blank pages from a seventeenth-century Dutch book, he would choose a seventeenth-century Dutch artist to replicate, ensuring that the material would match the intended period. All paper was handmade until 1798, when Louis-Nicholas Robert invented a paper-making machine in France. From that point on, paper was increasingly made of wood pulp rather than rag. It is important, therefore, for a forger to match the support to the period in question.

Hebborn also provided detailed and specific instructions on how to forge watermarks in paper of the desired age, specially prepare paper to receive ink or watercolour, repair or create wormholes, remove grease spots, clean paper, change the size of a sheet of paper, or 'age' new paper.

Although Hebborn's speciality was drawings, he also produced paintings and his handbook included instructions on how to prepare them. Hebborn's attention to detail is remarkable, and includes lists he drew up of the palettes of famous artists. Take, for example, Titian's most common palette, as analysed by Hebborn: flake white, genuine ultramarine, madder lake, burnt sienna, malachite, yellow ochre, red ochre, orpiment, ivory black. That makes for nine ingredients for every one of Titian's paintings. According to Hebborn, Frans Hals largely used only four pigments: flake white, yellow ochre, red ochre and charcoal black. Rubens employed fourteen. Hebborn revelled in levels of detail normally reserved for enthusiastic art history professors.

Based on his historical palette analyses, Hebborn recommended the following twelve pigments as the ideal 'forger's palette' for producing Old Masters: lead (flake) white, yellow ochre, chrome yellow, raw sienna, red ochre, burnt sienna, vermillion, raw umber, burnt umber, terre verde, genuine ultramarine and ivory black. He further included recommended ratios of pigment to oil to produce oil paints, such as a 50 percent flake-white to oil ratio for white.

One reason the majority of art forgeries take the form of twentieth-century works is that the materials are simply easier to come by and do not need to be dramatically 'aged'. Centuries-old paintings are particularly tricky to make anew, for time does two things to paintings: the colour tone becomes muted and craquelure develops. In order to replicate the process, Hebborn recommended darkening oil paints. He cited a letter Rubens wrote to a friend in 1629, in which he described using the same technique for effect, rather than forgery: darker oil can be made by boiling linseed or nut oil with litharge (lead monoxide) or flake white. This requires a double-boiler and is a highly volatile process, so it is not to be undertaken lightly. Hebborn also suggested using richer, lower tones to mimic the muted qualities of an old painting.

The reproduction of craquelure is key to a painting looking a century or more old. The natural webbing of cracks appears in the surface of paintings over time due to changes in humidity that often make paintings shrink and the paint become brittle. Cracks might

also appear for other reasons such as the application of new coats of paint before the coat beneath has fully dried, an over-absorbent ground layer or varnishes mixed unevenly with colours, which results in various rates of drying. This micro-network of cracks traps dust and dirt and become visible to the naked eye as subtle dark lines.

There are a number of ways to produce premature craquelure. One is to simply roll a painting around a stick, paint inward. This will produce cracks parallel to the stick, so the process can be repeated at various angles in order to produce a web-like network of cracks. The method used by Han van Meegeren for his 'Vermeers', meanwhile, involved baking finished paintings. Rapid changes in temperature produce cracks, but baking at a low temperature also forces paints to dry faster – otherwise it can take months or even years to complete an oil painting, as it did for Old Masters. Few forgers are that patient.

Eric Hebborn photographed in 1994

Van Meegeren baked at a single steady heat, 100–105°Celsius for two to three hours. But this requires a degree of patience – at least a year must pass between finishing the painting and baking it, because if the paint is not completely dry it risks boiling, and therefore bubbling, in the heat rather than cracking. Canvases were taken off their stretcher and placed in the center of the oven, so the maximum amount of hot air circulated evenly around them.

Cracks may also be painted on, a painstaking process. Hebborn preferred a varnish produced by a French firm, Lefranc et Bourgeois, specifically to reproduce craquelure. *Vernis craqueleur* artificially induced cracks in the paint beneath it after about twenty minutes. Adding some dirt to the dried varnish then filled the cracks in a relatively convincing way.

The masterful work produced through these methods succeeded in fooling world-renowned experts. Many of Hebborn's forgeries were authenticated by Sir Anthony Blunt, the director of the Courtauld Institute and surveyor of the royal family's art collection. Blunt was a universally-praised authority on Italian art in particular, though he has since become better known as a member of the infamous Cambridge spy ring. It was never clear whether Blunt collaborated knowingly with Hebborn, as Hebborn liked to imply, or whether Blunt was genuinely fooled. But Blunt's seal of approval for a number of forged drawings was a ticket for Hebborn to sell his new Old Masters.

Hebborn combined an understanding of the investigative techniques of connoisseurs with knowledge of scientific and provenance-related inquiries in order to pass off his forgeries as works by famous artists. No documented forger was as careful, as passionate about the research and details, nor as artistically skilful. He was perhaps the most influential of all modern forgers, because his detailed accounts of his methods became standard reading for forgers who hoped to follow in his footsteps.

Skilful though he was, could Hebborn be considered a great artist? Aristotle praised Homer for 'the art of telling lies skilfully'.[11] He could have been speaking about art forgers. There is a tendency in the media to praise forgers,[12] and many demonstrated praiseworthy skill, though put to disreputable use. But most were not great artists in the traditional sense, with the confidence trick 'selling' works that, in a vacuum, would fool no one. While Eric Hebborn could stand strong among the Renaissance greats he forged, most forgers are not of his calibre.

We should also remember that, no matter how convincing the forgery, a forger's work is inherently derivative. Renaissance artists looked to Aristotle for a definition of what makes a work of art great. Aristotle suggests suggests three criteria. A work of art must be 'good', as in exhibiting skill and successfully accomplishing what the artist set out to do; it must be 'beautiful', meaning aesthetically pleasing or morally elevating; and it must be 'interesting', which concerns the idea behind the work's content and what thoughts and emotions it provokes.

There is, without doubt, an art to forgery, just as there is an art of a different sort to the confidence tricks and deceptions that pass off art as greater than it actually is. But forgers are largely failed artists who are missing one component of greatness.

IN THE SHED OUT BACK: THE GREENHALGH FAMILY FORGERS

On 16 November 2007, the failed contemporary artist Shaun Greenhalgh (born 1961) was convicted for a forgery scheme of unprecedented diversity in the history of art crime. His octogenarian parents, Olive and George, were likewise sentenced for their roles as frontmen in an elaborate con to sell Shaun's forged creations. The family produced more than 120 fake artworks over seventeen years, earning at least £825,000 and fooling experts at such institutions as Christie's, Sotheby's and the British Museum. Scotland Yard fears that more than 100 of their forgeries are still out there, mislabelled as originals.[13]

Most forgers specialize in creating works in the style of a single artist or period. Greenhalgh produced everything from 'ancient' Egyptian sculpture, an eighteenth-century telescope and nineteenth-century watercolours to a mid-twentieth century Barbara Hepworth duck statue. The Greenhalghs were finally caught for a simple oversight: in attempting to forge an ancient Assyrian relief sculpture, they misspelled several words in cuneiform.

Shaun Greenhalgh was raised in an impoverished council estate in Bolton, UK. Though he had no formal artistic training, his father George, a technical drawing instructor, encouraged him in his desire to paint professionally. After galleries repeatedly rejected Shaun's paintings, he developed a grudge against the art world for failing to recognize his artistic talents.

In order to allow Shaun to avenge himself against the art community – and to supplement their meagre income – the Greenhalghs

concocted a plan. They sold forgeries made by Shaun by way of a provenance trap. The family would locate a slightly obscure catalogue from an old auction, and select a lot that was described in vague terms, such as 'antique vase, possibly Roman'. Shaun would create a new artwork, artificially aged, to match the existing provenance of the auction catalogue. Experts would then be lured into 'discovering' the old provenance for the new object before them. The presence of the authentic provenance, and the enthusiasm of having discovered the link, proved enough to convince experts of the authenticity of Shaun's fakes. It was the con that made the crime successful, not Shaun's artistic abilities. In Shaun's own words, his creations were simply 'knocked up in the garden shed out back'.[14]

The genius of the con lay in the performance of Shaun's wheelchair-bound father, George. In his guise as a loveable and charming invalid, George would present the forged artwork to experts, claiming that it had been in his family for generations. George would never suggest what the object was, but he would leave a hint as to where it came from – a clue that would lead the experts, hot on the scent of a major discovery, to the real provenance. The experts would be given space to reach their own conclusion: that the object before them was the object referred to in the provenance, which had until now been lost.

Shaun Greenhalgh, *Risley Park Lanx*, date unknown, silver, 38 × 51 cm (15 × 20 in)

The details of one of Shaun's forgeries serve as example of the family's methods. A silver lanx, or decorative platter, dating back to the ancient Roman occupation of Britain was found at Risley Park, Derbyshire, in 1736. The ploughman who found the lanx had broken it up and distributed the pieces as souvenirs among his fellow workers. There has been no record of the Risley Park lanx since. In 1991 the Greenhalghs offered a Roman silver lanx to the British Museum. They had bought relatively inexpensive original Roman silver coins and smelted them using a miniature furnace stored above their refrigerator. They fused the lanx together, the solder lines visible, making it look as though it was the complete reconstructed Risley Park lanx of William Stuckeley's description. The British Museum purchased it.

Other Greenhalgh forgeries included sculptures 'by' Constantin Brancusi, Gauguin and Man Ray, busts of John Adams and Thomas Jefferson, and paintings by Otto Dix, L.S. Lowry and Thomas Moran, whose work Shaun boasted that he could 'fire off in 30 minutes'. His two most profitable creations were the *Amarna Princess*, a 20-inch tall Egyptian calcite sculpture purported to be from 1350–1334 BC,

Shaun Greenhalgh,
Amarna Princess,
dated c. 1350 BC,
alabaster,
51 cm (20 in) high,
Bolton Museum

and Assyrian stone relief tablets (c. 700 BC). The Assyrian reliefs, supposedly from Sennacherib's palace in Mesopotamia, raised the first suspicions about the family, leading to their eventual arrest. The misspelled words in cuneiform were noted by experts at the British Museum, from whom the Greenhalghs had sought authentication.

The story of Shaun Greenhalgh and his family exemplifies the subject of this chapter: Forgers seek to fool the art community as revenge for its having dismissed their own original creations. As Detective Constable Ian Lawson of Scotland Yard said, '[Shaun] thought he was having it over a lot of people that should have known better. It is more of a resentment of the art world, to prove that they could do it.'[15] Unlike so many forgers who seemed to enjoy their post-incarceration celebrity, however, Shaun Greenhalgh refused to give any interviews and avoided the spotlight after his release from prison in 2011.

For those who feel alienated from the art world, Shaun is something of a folk hero, showing up a community that many consider elitist and undeserving of sympathy. Profit was not the primary

Shaun Greenhalgh, after L.S. Lowry, *The Meeting House*, date unknown, pastel on paper. The Greenhalgh family claimed the work was given to Shaun's mother, Olive, as a 21st birthday present from her father who owned a gallery

Shaun Greenhalgh pushes his 84-year-old father, George, from a court
hearing in Greater Manchester, 2007

motivation for the family. Despite their income, the Greenhalghs
continued to live in relative poverty, rarely spending any of their
illicit earnings. When asked by Vernon Rapley, the then-head of
the Arts and Antiques Unit, why they chose to live so modestly with
so much money in the bank, Shaun replied with candor, 'I have five
brand new pairs of socks in my dresser. What more could I want?'[16]
Shaun succeeded in showing the art world that his skill, with the help
of a provenance-trap con, surpassed their connoisseurship.

Shaun Greenhalgh's garden shed workshop, recreated by the Metropolitan Police's Art and Antiques Unit for an exhibition of fakes and forgeries held at the Victoria and Albert Museum, London, in 2010

The man who caught the Greenhalghs is one of the few specialist investigators who deal with art forgeries, and his work is exemplary of how future investigators might approach cases. Vernon Rapley, the former head of Scotland Yard's Arts and Antiques Unit, is perhaps the most successful hunter of art forgers, leading what is statistically the most effective art squad in the world.[17] During Rapley's eight-year tenure, art theft in London dropped by 80 percent, and his team recovered a staggering 60 percent of artworks reported stolen.[18] That makes Rapley and his team the most successful art detectives in history. By the end of his time with the Arts Unit, art theft in London had all but ceased and Rapley concentrated almost exclusively on forgers, arresting a number of the famous forgers in this book. After his career with Scotland Yard, he worked as head of security at the Victoria and Albert Museum – an apt venue, considering its rich collection of fakes and forgeries, including many by Dossena and Vasters. He even curated a sold-out exhibition at the museum called 'Fakes and Forgeries' that featured works from the museum's collection and objects seized by Scotland Yard during investigations, including the typewriter on which John Drewe forged provenance and the garden shed in which Shaun Greenhalgh worked.

One of the difficulties of investigating forgeries is that identifying them usually requires a degree of specialization possessed in many cases

by only a few scholars in the world. Police cannot be expected to have such knowledge, nor can even a generalist art historian. So the police must call in outside experts to assist as needed on a case-by-case basis. 'What became very obvious to me at an early stage on the A&A Unit was that we needed expert help and this expertise in many cases didn't exist in the police service,' Rapley said. 'So there were two solutions. Firstly, to train police officers and staff, or secondly to devise a way of trusting outside experts. The first option wasn't really practical. At the time, it took twenty weeks to train a police officer, but a lifetime to train an art expert. So I went about recruiting art experts as police officers.' This was great fun for experts who had the opportunity to step out of their archives, libraries and museums and join the police forces as volunteers. Within a few years, Rapley had assembled a team of ten to fifteen Special Constables, all of whom were art and antiquities experts but who did not work in the trade. They were vetted, their backgrounds checked, and they were sworn to the Official Secrets Act, so Rapley felt that he 'could trust them as our own'. The team was called 'ArtBeat'.[19] The innovative idea not only helped within the police force, but also attracted media attention despite its small size, giving 'the real impression that the police were interested and doing something about Heritage and Cultural Property Crime'.

Rapley's highest-profile arrest was that of the Greenhalgh family. The family had been found in possession of fakes and forgeries years earlier, but it always seemed that they had been the victims and had bought the forgeries unknowingly. It was only when their 'dishonest intent' became apparent that they were seen as suspects. The misspelled cuneiform on the supposed seventh-century BC Assyrian relief tablets led the British Museum to call Rapley, and the investigation proper began. (Rapley makes the important point that the police do not investigate fakes and forgeries, but the fraudsters who use fakes and forgeries to break the law.)

Rapley gathered sufficient evidence to get a warrant to visit the Greenhalgh home:

'None of us expected to find what we did ... There was evidence everywhere in just about every room of the house. It was in the attic, the shed and in the garden ... There had been no attempt to conceal the forgeries or the making of them. On one bed we found a silver plate, next to it a sharp blade and scrapings of silver. On the pillow was an old document with an image of an ancient plate. It was the art forgery equivalent to a smoking gun!'

TIME BOMBS & BOOBY TRAPS:
TOM KEATING AND POST-EXPOSURE CAREER MOVES

The loveable British painter, Tom Keating (1917–1984), saw a remarkable rise in his career from art restorer to art forger to television celebrity. Raised in a poor neighbourhood of London, Keating restored paintings after World War II, also painting houses to make ends meet. His dream was to become a recognized artist in his own right but, while he exhibited his paintings on several occasions, he could not make a living selling them. He felt that the gallery system was an exclusive club driven by the need for avant-garde work at the expense of quality, with gallerists and critics taking advantage of artists and collectors. It was his anger at the art community's perceived treatment of struggling artists – including himself – that led him to turn to forgery in a direct attempt to subvert the community that would not grant him entry.[20]

To this end, Keating not only created forgeries, but also hid within them what he called 'time bombs' – subtle clues that would prove a painting's inauthenticity but which he was certain would

Tom Keating, in the style of Vincent van Gogh, *Van Gogh Smoking a Pipe (in the manner of Van Gogh)*, date unknown, pastel on paper. One of the many artworks that Tom Keating later sold under his own name, in the manner of another artist

Rembrandt, *Self Portrait at the Age of 63*, 1669, oil on canvas, 86 × 70.5 cm (33 ¾ × 27 ¾ in), National Gallery, London

Tom Keating, in the style of Rembrandt, *The Artist as Rembrandt with Titus (in the manner of Rembrandt)*, date unknown, oil on canvas. One of the many artworks that Keating later sold under his own name, in the manner of another artist

John Constable, *The Hay Wain*, 1821, 1.3 × 1.85 m (4 ft 3 ¼ × 6 ft ¾ in), oil on canvas, National Gallery, London

be overlooked by so-called experts. This was not a subconscious desire to be caught so much as a conscious desire to catch out the experts: Keating's frauds were meant to be discovered. He knowingly integrated anachronisms into his works, either technically – such as writing text in lead white beneath a painting so that it would show up in an x-ray – or visually, inserting a twentieth-century object into a seventeenth-century painting, for example. This trick has been used as a defence against accusations of fraud by forgers who claim that their work should fool no one because of its 'obvious' anachronisms. In Keating's case it was a deliberate trick to prove the experts wrong.

Keating believed that his works should express true artistry, and he employed traditional techniques, including oil painting based on the methods of Titian and Rembrandt. Staying true to an artist's methods was both a means of creating a better forgery and also a tribute to the artist. Keating did not like to cut corners. He would reproduce Rembrandt's methods of mixing paints in order to better forge a Rembrandt. Once, he boiled nuts for over ten hours and filtered the resulting oil through silk to acquire a binder for his oil paintings.

Keating also often employed a provenance trap. A favourite method was to search flea markets for old frames that still bore auction house lot numbers on the back. He would buy the frame, look up the

Tom Keating photographed in 1983, standing in front of his most famous work, *The Hay Wain in Reverse*, painted as if from the opposite perspective to Constable's original

painting that it once housed and reproduce it for the frame. He was as successful as a forger in watercolours as he was in oils, which is rare. Most forgers specialize in one period, style or medium, but Keating is known to have forged artists from Modigliani to Gainsborough, Titian to Rembrandt, Fragonard to Renoir.

Despite this meticulous effort, Keating occasionally set booby traps in his 'time bombs' that would destroy the painting in the process of revealing it as a fake. He sometimes added a layer of glycerin beneath the paint so that, if his forgery was ever cleaned, the glycerin would react and dissolve the paint above it, leaving the work destroyed – but also revealing it as an obvious forgery. This suggests that the painting process was as much a pleasure as the end result for Keating, something that may be said for few forgers.

With all of his 'time bombs' set and ticking, it was only a question of when Keating's forgeries would be revealed. An article in *The Times of London* in 1970 reported the concerns of an auctioneer who came across thirteen watercolours attributed to the British artist Samuel Palmer, all of which were for sale at the same time and all of which depicted the town of Shoreham. Such a coincidence was a statistical improbability, and the rather public concerns aired in the article gave Keating the stage that he had sought. He confessed to having created

all thirteen 'Palmers', and went on to claim to have forged at least 100 artists, with more than 2,000 forgeries in circulation. Keating declared that he forged as a protest against the art trade, which grew rich at the expense of the artists themselves. He refused to inventory his forgeries: that was for the art world to investigate and discover. No one had yet bought the Palmers, so no one was out of pocket – and therefore no charges were brought against him at the time, because nothing but the thirteen 'Palmers' could be linked to him.

Tom Keating in his studio, c. early 1980s

It took another seven years for Keating to be arrested on a charge of conspiracy to defraud. The charges were dropped due to his failing health – the results of a lifetime of smoking compounded by years of exposure to chemical inhalants used in restoration. That same year, 1977, saw the publication of Keating's autobiography.

By 1982 he had recovered enough to present a radical new television program, shown on Channel 4 in the UK, in which he essentially taught viewers how to forge the works of various famous painters, with each episode covering the techniques of a renowned artist and how to reproduce them. By then, numerous collectors deliberately sought out Keating's forgeries. The year he died, 1984, Christie's auctioned of 204 of his forgeries, labelled as such. In just a few years, Keating had gone from struggling artist to unpunished art forger to television celebrity to artist whose works sold in the world's most prestigious auction houses.

FAME

Art forgery appears to be an unthreatening and victimless crime (or rather, one that only affects the very rich, with the media and forgers alike implying that these elitist victims deserve to have the wool pulled over their eyes), so its criminals tend to be seen as skilful rapscallions, part-illusionists, part-practical jokers, the ones who point out that the emperor (in this case, the art world) wears no clothes. The prison sentences for forgers tend to be so slight, and the popular interest in them so great, that it may seem worth a year or two in a minimum-security prison to emerge as a sort of folk hero with a lucrative career. So many forgers go on to wealth and fame after they are caught and punished that there is little disincentive for trying one's hand at forgery.

This chapter examines forgers who have chased – and embraced – fame after their forgery career was exposed. They may not have turned to forgery with the idea of growing famous, but when the opportunity arose they seized it. For these forgers, fame, acclaim and recognition were key to their decision to 'out' themselves.

—

THE MAN WHO SUED HIMSELF: LOTHAR MALSKAT

Some of history's most prominent forgers rode the thin line between crime and practical joke. One of the greatest practical jokers who also happened to be a great forger was the German painter, Lothar Malskat (1913–1988). If Malskat's own admissions are to be believed, he created around 2,000 forgeries in the style of at least seventy-one different artists from ancients to Chagall, though the accuracy of his claims is a matter of debate.

Malskat fits many of the criminal profiles of art forgers. He subconsciously wished to be caught in order to reveal his prowess. When his exposure was not forthcoming, he announced his forgeries to the world – yet no one believed him. Eventually he essentially turned himself in in order to 'cash in' on the practical joke that embarrassed an entire nation. The recklessness with which he worked can only be interpreted as a desire to be found out. When he was exposed, he used the notoriety to develop his own myth, claiming, for example, that it took him only one day to make a complete new painting that would fool experts. This might

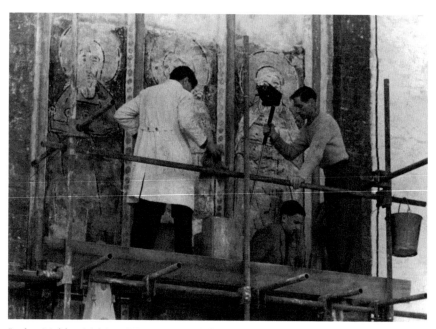

Lothar Malskat (right) and Dieter Fey (middle) with the Lübeck Marienkirche frescoes while the newly 'discovered' works were being appraised, 1952

be possible with a watercolour, but tempera and oil paints need to dry and be artificially aged, so the claim sounds dubious, as does the total of 2,000 forgeries. But Malskat was certainly skilful enough to fool his nation's leading medievalists.[1]

The forgery that made Malskat a household name took place in 1948, when he and a colleague, Dieter Fey, were commissioned to restore damaged frescoes in the Marienkirche in Lübeck, Germany. Fey had been the first restorer charged with bringing the frescoes back to life after they were severely damaged by an Allied incendiary bomb in 1942. Fey hired local artist Malskat to work with him.

The problem they faced was that there was no photographic documentation of what the frescoes had once looked like. Fey and Malskat restored what they could of the surviving frescoes, but they had to re-imagine the extent of the fresco scheme in the clerestory and other sections, such as the north wall of the nave, that were irrevocably damaged. While painting the re-imagined frescoes, which only occupied a small portion of the church's interior, Malskat took the opportunity to insert supplementary images that essentially amounted to inside-jokes (what Tom Keating would have called 'time bombs').

The anachronisms, or 'time bombs', in Lothar Malskat's work included painting turkeys into the fresoes, such as these in Schleswig Cathedral

In order to explain the new frescoes that they had painted, the artists hatched a plan to claim that they had discovered lost frescoes that had been whitewashed over and which remained undamaged. Such a claim was not preposterous. Churches would sometimes plaster over existing frescoes, like the tiny fortified medieval church of Hrastovlje in Slovenia, where a redecoration at the time of the Counter-Reformation covered – and therefore protected – what is now one of the most complete 'Dance of Death' fresco cycles, revealed only in the twentieth century.

A commemorative postage stamp for Deutsche Post celebrating the 700th anniversary of the founding of the Marienkirche, showing the Malskat forgeries, 1954

When the restoration of the Marienkirche was finished on 2 September, 1951, scholars were shocked to learn that, in addition to the restorations, the restorers had uncovered previously unknown medieval frescoes. These new discoveries had, of course, been painted by Malskat, with Fey as a knowing accomplice.

It seems that Malskat was waiting for his forgeries to be found out, but no one suspected a thing. His situation captures the tension inherent in so many art forgers: they enjoy their passive–aggressive success for a time, knowing they have fooled the experts, but at a certain point knowing a secret is no fun unless you can share it. Malskat's greatness as an artist, albeit a forger, would go unacknowledged unless he showed that he had painted the newly-discovered frescoes, which were revealed to the world in a large-scale press event timed to coincide with the 700th anniversary of the founding of the church – an anniversary the West German government marked by printing four million postage stamps depicting a detail of the newly discovered frescoes.

In 1952, the dissatisfied Malskat announced to the media that he had painted the frescoes himself – and was not believed. Fey

denied the claim was true, and he had been Malskat's colleague in the enterprise. The government had endorsed the frescoes with their stamp issue. Malskat was therefore ignored. Incensed, he instructed his lawyer to sue both Fey *and himself* for fraud.

Fey and Malskat were brought to trial in 1954, with Malskat as both a defendant and a witness for the prosecution, but still he was not believed. Malskat had prepared for such a reaction. He demonstrated that the church had been practically without original frescoes when the restoration began by showing a short film of the unpainted walls. He claimed that so little was salvageable that he had just whitewashed over the originals. He also pointed out that he knowingly inserted certain anachronisms that should have proven to even nonexperts that the frescoes were inauthentic. In one, he painted a turkey into the frescoes, a species that did not exist in Europe until after the settlement of North America, centuries after these supposedly medieval frescoes would have been painted. He also included portraits of post-medieval historical figures, including sister Freyda, the 'mad monk' Rasputin and the actress Marlene Dietrich. Despite all this evidence, no one believed that these frescoes were anything other than a major art historical discovery.

Part of this mass-confusion may come down to the timing. So soon after World War II, in a country fraught with self-loathing and guilt, and crippled by a shattered economy, the discovery of a new work of medieval German art was a small positive that would have gone a long way. That it proved to be a fraud only served to lower German morale further. The forged frescoes feature in the 1986 Günther Grass novel, *The Rat*, as a symbol of the corruption of post-war Germany.

The trial also exposed an earlier forgery scheme. As a young artist Malskat had apprenticed himself to Dietrich Fey's father, the restorer Professor Ernst Fey. In 1937 Professor Fey, his son and Malskat were asked to restore the frescoes in Schleswig Cathedral, which had been repainted in 1888 and which the community wished to restore to their former medieval grandeur. The first step in the process was to remove the top layer of nineteenth-century paint to reveal what remained beneath to restore. But when the three men peeled away the top layer, they found that almost nothing of the original frescoes remained.

The restorers were worried that they might be accused of having damaged the original frescoes themselves in the process of stripping the nineteenth-century paint. But Malskat had a plan. He would

insert his own 'Gothic' frescoes where now none stood. According to Malskat, the Feys agreed – and when he had finished, several months later, it was Ernst Fey who was showered with credit for having so beautifully restored these 'original' frescoes. Renowned art historian Albert Strange wrote that 'the author of these paintings is one of the greats in the realm of art... He worked in Schleswig circa 1280, and hailed from the time of the Hohenstaufen emperors. We do not know his name.' His name was Lothar Malskat.

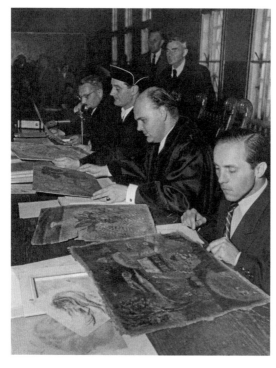

The court panel considers forged paintings during the trial of Lothar Malskat in Lübeck, May 1954

During the trial, Malskat went on to detail how he had returned from fighting in the war and found Dietrich Fey in Hamburg. They set up a forgery studio, in which Fey took care of the business and sales and Malskat produced all manner of works to pass off as paintings and drawings by the likes of Chagall, Munch, Toulouse-Lautrec, the German Expressionists and others. Fey would sell these works to art dealers, who would sell them on – it was never clear if these secondary dealers knew that they were handling forgeries or whether they would have cared had they known. Immediately after the war, all the dealers wanted to know was that the art was not looted, a serious concern after the enormous redistribution of Europe's artworks and

the disappearance of tens of thousands of works during the Nazi era. Malskat provided a written guarantee that none of the works had been stolen and, indeed, none had been.

Malskat had spent his career working in the shadow of the Fey family: first the father, who had taken credit for the Schleswig frescoes, and then the son, who was given credit for the Marienkirche frescoes. The desire to receive proper recognition seems to have been Malskat's prime motivation in suing his partner and himself.

Malskat used the platform of his trial to tout his other forgeries, including works passed off as being by nineteenth-century artists like Toulouse-Lautrec. He presented evidence for these forgeries, but was unable to substantiate his claim to have created more than 2,000 works. Malskat was found guilty and sentenced to eighteen months in prison. Fey, who was found complicit but who never confessed to his crime, was sentenced to twenty months.

The relatively short prison sentence was worthwhile for Malskat for the artistic renown it brought him. He went on to a reasonably successful career painting antique-style works to which he signed his own, now famous, name. He made a specialization of painting Renaissance-style frescoes on the exteriors of country inns, some of which may still be seen today, such as at the Tre Kronor Inn in Stockholm. He held exhibitions of his original works in Germany, and a small market developed around collectors interested in owning an original Malskat forgery. Perhaps sadly, Malskat's additions to the Marienkirche frescoes were washed off the walls of the church.

THE PERFECT COUPLE: ELMYR DE HORY AND CLIFFORD IRVING, ARTISTIC AND LITERARY FORGERS

A textbook example of the remarkably consistent psychological profile of the majority of forgers comes in the form of Elmyr de Hory (1905–1976), who was so fascinated with his own fame and artistic legacy that he eagerly accepted the publicity of two mass-media projects about his work: a bestselling book entitled *Fake!* by Clifford Irving (1969) and a faux-documentary adapted from the book by Orson Welles, *F for Fake* (1973). But his story is also integrally linked to the story of another forger, one of literature.

Elmyr de Hory was born Elemer Albert Hoffmann, and claimed to have been the child of an aristocratic family. As most of his story

comes from his accounts alone, it is difficult to verify.[2] After his parents divorced, Elmyr (as he was most often referred to, by his first name only) moved to Budapest and then Munich, where he studied art under the abstract painter Fernand Léger. Returning to Hungary, he formed a friendship – possibly of a romantic nature – with a British journalist and suspected spy, which Elmyr claimed led to his imprisonment in Transylvania for suspected collaboration. He was released during World War II under unknown circumstances, but was quickly imprisoned again, this time in a concentration camp. Elmyr claimed that he was sent to the concentration camp because he was Jewish and homosexual. After barely surviving a beating, he was allegedly hospitalized in a Berlin prison hospital, from which he escaped to France, where he tried to make his way as an artist in post-war Paris. The story sounds questionable – few inmates were removed from concentration camps and cared for in hospital – and it has never been verified.

While Elmyr's original works were critically lauded, he could never find a market for them. He found a more lucrative sideline in copying the work of other artists, particularly Impressionists and Post-Impressionists. In 1946 a friend mistook his copy of a Picasso for an original, giving Elmyr the idea of producing forgeries to sell as originals to various Paris galleries. At first the rewards were small, as he received the equivalent of $100 to $400 per painting, but his career blossomed when he began to work with Jacques Chamberlain, who acted as his personal art dealer. Elmyr made such good money producing drawings and paintings after artists like Picasso, Modigliani and – his speciality – Matisse that it became his full-time occupation. Galleries initially tended to accept his forgeries as originals; when he returned offering more works, however, they grew suspicious.

Elmyr's collaboration with Chamberlain led to greater success, including sales tours of Europe and South America, but he soon learned that he was receiving only a fraction of what he was due. Elmyr separated from Chamberlain and moved to the United States in 1947. He began to sell pseudonymously by mail order, eventually moving to Miami.

Elmyr did not need to employ any elaborate schemes to pass off his forgeries. Because he created works purportedly made within the last fifty years or so, finding authentic materials did not pose a problem. In addition, World War II had so shaken up the art world that it was not overly suspicious for unprovenanced works to appear on the market.

But in 1955 the Fogg Art Museum at Harvard purchased a 'Matisse' by Elmyr that experts deemed a forgery. The same year, art dealer Joseph W. Faulkner acquired a painting and several drawings that he later learned were Elmyr forgeries. Faulkner brought a federal lawsuit against Elmyr not for forgery – itself not against the law – but for mail and telephone fraud, defined as 'intentional deception made for personal gain or to damage another individual'.[3] In order to avoid trial, Elmyr fled to Mexico City, where he became caught up in a police investigation that led to him being extorted by both the police and the lawyer he hired to protect him from the police. Elmyr returned to the United States, but now he had been exposed, he could only make money on a smaller scale, selling forged lithographs door-to-door. Depressed, he attempted suicide. While rehabilitating in a New York hospital, he met his next dealer, Fernand Legros.

Elmyr de Hory, in the style of Henri Matisse, *Odalisque*, 1974, oil on canvas. Elmyr was one of many forgers who later signed his works in the style of other artists under his own name

Elmyr made a deal for Legros to sell his forgeries – taking on the risk – in exchange for 40 percent of the profits. Elmyr also became romantically involved with another dealer, a Canadian named Real Lessard, who also sold his forgeries. Legros, like Chamberlain before him, began to keep more of the profits than was agreed, so when he followed Elmyr's next move – to Paris – their association continued for a straight fee of $400 a month (around $3,000 per month today), paid to Elmyr by Legros and Lessard.

Elmyr spent most of his life from 1962 living in a luxurious villa on Ibiza. He hosted lavish parties and seemed to tire of his life as an artist. Consequently, his work became less and less convincing.

Amedeo Modigliani, *Blue Eyes (Mrs. Hebuterne)*, 1917, oil on canvas, 54.6 × 42.9 cm
(21 ½ × 16 ⅞ in), Philadelphia Museum of Art

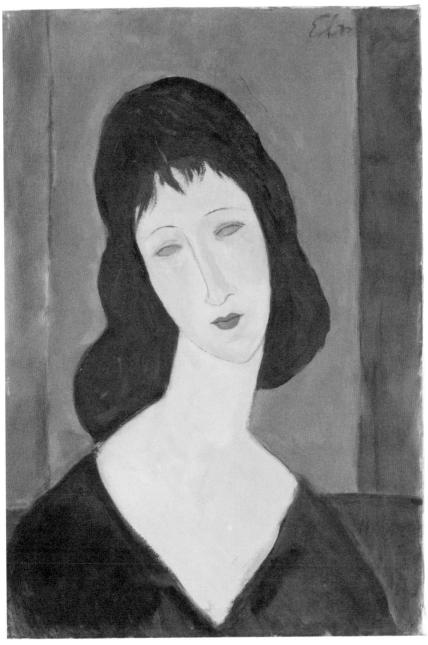

Elmyr de Hory, in the style of Modigliani, *Portrait of a Woman*, c. 1975, oil on canvas.
Another of the artist's later works, signed under his own name

Meanwhile, the police and Interpol were contacted by some of the galleries that had acquired his forgeries, and his dealers were also being pursued. Wealthy collector Algur H. Meadows had purchased fifty-six Elmyr forgeries, and was so enraged that he fought to prosecute Legros, from whom he had acquired them. Legros fled to Elmyr's villa on Ibiza, but when their relationship turned violent, Elmyr fled the island.

A 'Modigliani' drawing by Elmyr de Hory, signed under his own name

Elmyr was on the run, but he was also tired and depressed. In August 1968, he returned to Spain to turn himself in. He was convicted of the crimes of homosexuality and consorting with criminals, served two months in prison and was banished from mainland Spain. Elmyr returned to Ibiza, where he began to spend time with Clifford Irving, who eventually published the biography, *Fake! The Story of Elmyr de Hory, the Greatest Art Forger of Our Time*. The book became an instant bestseller and Elmyr went from being an exposed, exhausted forger and convict to a re-invigorated celebrity. Orson Welles optioned the film rights to Irving's book and in 1973 released *F for Fake*, a pseudo-documentary about falsehood that featured many scenes of Elmyr's lavish lifestyle on Ibiza. Elmyr took advantage of this new renown finally to exhibit his original paintings, but he also learned that French authorities were attempting to extradite him to face trial

on fraud charges in France. In 1976, after long negotiations, Spain accepted the French extradition request. Panicked, Elmyr overdosed on sleeping pills and died.

Elmyr denied having ever signed another artist's name on his forgeries – he claimed that they had all been copies in the style of other artists which he had made and which others, without his prompting, had 'authenticated' as the work of known masters. He, like many forgers, claimed to be able to churn out a Matisse drawing – his favourite artist and the one whose style came easiest to him – in a matter of minutes, and a painting in a matter of hours. His skill is undeniable, but choosing to forge early twentieth-century works made his forgeries easy to create from a technical and material perspective, and he did not rely on elaborate confidence tricks to convince his victims of the authenticity of the works. He seems to have been more interested in making a living, at least at first, but the fact that he accepted the notoriety that came with the Clifford Irving book and the Orson Welles film is evidence enough of his desire for fame and recognition as an artist.

The story of Elmyr is inextricably interwoven with a literary forgery perpetrated by the very man whose book launched the forger to international fame. Clifford Irving (born 1930), author of *Fake!*, was later found to be a literary forger himself. His highly anticipated next book, a ghost-written autobiography of Howard Hughes, turned out to be a fraud, written without Hughes' involvement. Irving counted on the famously reclusive Hughes choosing not to expose himself by denouncing the autobiography – compiled from various unauthorized biographies – but Hughes did indeed sue the publisher McGraw-Hill, resulting in a major scandal and Irving's imprisonment for seventeen months.

Irving had tricked McGraw-Hill into believing that he would write the 'autobiography' with Hughes' blessing and collaboration by forging letters in Hughes' handwriting, imitating real letters that he had seen published in *Newsweek*. Irving produced three forged letters in order to assure the publisher of his bona fides and to secure a huge advance, of which $100,000 would go to Irving and $665,000 to Hughes. Irving signed the contract himself and forged Hughes' signature. He deposited the cheque for Hughes' advance, made out to H. R. Hughes, in a Swiss bank account that his wife had opened under the false name Helga R. Hughes.

Irving's collaborator on the fraud was an old friend named Richard Suskind, with whom he produced a manuscript. Irving forged notes on the text, in Hughes' hand, that a handwriting expert declared genuine. The book was published in March 1972 to much acclaim.

Irving was a skilled confidence man. He convinced experts, publishers, magazine executives and journalists that he was working with Hughes. *Life* magazine published excerpts of the book. The last journalist known to have interviewed Hughes, Frank McCulloch, read the autobiography and believed it to be accurate. Irving even passed a lie-detector test about his authorship of the autobiography.

Then, on 7 January 1972, Hughes reached out. He gave an interview by telephone to seven journalists, whose end of the conversation was televised. Hughes stated that he had never met Irving and that the whole book was a fraud. Irving countered that the phone call had been faked – who could know for sure that it was really Hughes on the other line?

Elmyr de Hory in his studio with a 'Matisse' drawing, 1969

Hughes' lawyer finally sued Irving's publisher McGraw-Hill, *Life* magazine and Irving himself. Irving retreated to his own villa on Ibiza. The end came when the Swiss bank identified Irving's wife, Edith, as the woman who had deposited Hughes' royalty cheque. Irving finally confessed on 28 January 1972. He spent seventeen months of a two-year sentence in prison and returned a total of $765,000 to the publisher. His colleague, Richard Suskind, served five months and Edith Irving was also briefly imprisoned.

The scandal did not hurt Irving's book sales nor his career as a writer. In 1981 Irving published *The Hoax*, a book about his Hughes forgery that sold very well and was made into a film released in 2007 to favourable reviews. The irony would not end there, as Irving eventually denounced the movie as 'a hoax about a hoax', claiming that the portrayals of himself, his wife and Suskind were 'absurd and even more than inaccurate'.[4] And yet Clifford Irving is credited as the writer of the film.

From Elmyr de Hory to Clifford Irving to Orson Welles to Howard Hughes and back to Clifford Irving, Hollywood could not invent a stranger tale of multiple-forgery and fame.

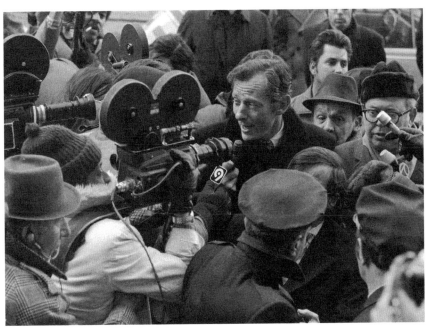

Clifford Irving outside the US Attorney's office having been called in for questioning by a federal grand jury, as well as a New York County grand jury, over Howard Hughes' purported 'autobiography', 1972

FORGING ONE'S FAME: KEN PERENYI

A surprising number of forgers have written memoirs, and these books make for interesting reading. All share certain characteristics, from Icilio Joni to Wolfgang Beltracchi, from Tom Keating to Eric Hebborn (who wrote two editions of his memoir, plus a handbook for other forgers). Forgers, understandably, paint themselves in the most positive light that they can. They tend to describe unruly – if not delinquent – childhoods, the early discovery of a talent and love for art. Each features a moment of dismay when the art world fails to accept the budding artist, and the artist's decision to turn to forgery for revenge and sometimes also for profit. Forgers often claim to have been led astray by someone who either lured them to use their talents for criminal gain or who planted the seed in their otherwise innocent minds. Most say that they find forgery very easy, are able to put together a convincing work quickly, can forge many styles and artists and have made around a thousand forgeries. And there is a great deal of self-admiration and patting oneself on the back at having fooled so many for so long and exhibited such skill. These characteristics will already be familiar from the case studies in this book, and are remarkably consistent across the pantheon of major forgers from memoirs, interviews, documentaries and even court testimonies.

A case in point is Ken Perenyi, whose 2012 memoir, *Caveat Emptor*, 'outed' him as the self-proclaimed most successful American forger. Very few people had heard of him prior to the publication of the book, allowing him to tell his own story almost entirely before anyone else had the chance to do so.[5]

Perenyi is a rare American art forger – most known forgers are European – who made good money forging eighteenth- and nineteenth-century paintings but chose a strategic career shift when he learned that the FBI was onto him. Before he could be caught, he stopped forging and began to create very beautiful, high-end copies for sale to interior decorators. His memoir announced his career as a forger voluntarily, with the added benefit not just of a potential income via book sales but also of a greater interest in his own 'genuine fakes', to borrow the term coined by John Myatt. Furthermore, his life story has been optioned by the film director Ron Howard.[6]

Perenyi did not forge the style of particularly famous artists, which was clever in itself as it helps avoid scrutiny. Forging Vermeers is asking for trouble, but a James E. Buttersworth, John F. Herring, Gilbert Stuart,

Charles Bird King or Martin Johnson Heade is far more likely to slip beneath the radar. In fact, one could be forgiven for having never heard of any artist Perenyi forged. The most Perenyi made from a single forgery was a Martin Johnson Heade painting of two hummingbirds, sold at Sotheby's in 1993 for $650,000. The work is included in Heade's catalogue raisonné, the author of which – Theodore E.Stebbins Jr – is not entirely sure that it is by Perenyi at all.[7]

Martin Johnson Heade, *Two Humming Birds: 'Copper-tailed Amazili'*, 1865–1875, oil on canvas, 29.3 × 215 cm (11½ × 8½ in), Brooklyn Museum, New York

Ken Perenyi, *Pair of Hummingbirds after M.J. Heade*, date unknown, oil on canvas

Perenyi began painting in 1967, and took it as a compliment when friends regularly commented that his work reminded them of Old Masters rather than the Abstract Expressionist work then popular in New York. When he found himself in financial straits, an artist friend joked that he should try to forge a painting and gave him a book about Han van Meegeren. Perenyi relates, 'I was impressed and in the brashness of youth, I figured, maybe I can do this?'[8] On his next trip to a museum, he wandered through a gallery of Dutch portraits thinking, 'They've got to be simple … why don't I try something like this'. He found a piece of seventeenth-century furniture in bad repair and scavenged a wooden panel from it, on which he painted a small portrait. 'I was able to sell it to a gallery on 57th Street [in New York].

I got $800 for it – that was my first fake. From that point on, it wasn't a matter of if I would paint another one, but when.'

Perenyi claimed that his paintings were sufficiently good that he did not think about provenance. His 'story' was that he had inherited some art from a deceased uncle. 'I think the dealer looked me over and thought that this guy's not sophisticated enough to even know what provenance is, so I'll accept the story.'

Ken Perenyi surrounded by his works in the manner of J. E. Buttersworth and others

Perenyi's work did look convincing. He is proud of a technique he developed for engraving craquelure: 'I can engrave a line as fine as a human hair, control it in any pattern that I want. It's a very convincing technique, although I don't engrave cracks anymore – I've since developed more sophisticated ways of persuading cracks to appear on paintings.' There is a clear element of pride in Perenyi's work, fueled by his decades of success and genuine artistic talent. He can finish a small, Dutch-style portrait in 'a few days, a week at most'. Drying oil paint takes longer, but he chose styles wherein the paint was thin. He admits that a chemical test, like the application of a solvent such as acetone, will reveal that it was newly-painted. He keeps a photo archive of all his work, which contains 'at least a thousand paintings'. These are divided into paintings that he passed off as originals, and those he sold to 'so-called dealers of dubious repute. Folks who have bought them knowing they were fakes, but who probably sold them as originals.'

Perenyi's biography is typical of that of art forgers. The son of a factory worker, he was entirely self-taught, painting as a teenager to pass the time. He tried to become a legitimate artist but could not get a break, so he forged to earn cash for supplies and food, because forgeries were his only pictures that sold.[9] He was broke and homeless

in 1960s New York, unable to make a career out of his own work.[10] He was careful to avoid the style of famous artists, whose works would be better-scrutinized. He told the *Guardian* 'I wouldn't want to fake a George Stubbs, as paintings like that are usually accounted for. However, you take an artist like John F. Herring or Thomas Buttersworth and there could always be another one in somebody's attic.' He likewise made many paintings that were not linked to a specific artist at all, generic nineteenth-century-style works that have a decent value but that are unlikely to excite anyone and can be kept 'under the radar', as he puts it.[11]

Like so many successful forgers, Perenyi developed a professional pride that could read as ego, and took great pleasure in his skill. When it was suggested in a CBS News interview that he was gloating about his successes, he replied: 'I wouldn't characterize it as gloating. I would say I'm just being honest. To this day, I am still thrilled with the pictures I could paint … It was me against the experts – can I outsmart them again?'[12]

In the end, Perenyi turned forgery into fame. He was never caught, and no one would have known about his career had he not published his own memoir. While forgers like John Myatt and Tom Keating launched lucrative careers after they had been exposed and punished, Perenyi never was. Instead, he chose to tell his own story – skipping any trial or punishment and moving directly to the post-exposure renown. Whether or not he is, as he suggests, 'America's #1 art forger',[13] he is certainly the cleverest from a PR standpoint.

NOT IN IT FOR THE MONEY: MARK LANDIS, THE GIFT FORGER

Although money is often a secondary motivation for forgers, it played no part in the scheme of Mark Landis, aka Steven Gardiner, Father Arthur Scott and Father James Brantley. Landis' scheme rested on the fact that museums rely on gifts to fill their walls, and his prize was fame and recognition. He craved the personal satisfaction from being catered to by the art world while knowing that he had fooled them.[14]

Landis is a painter and former gallery owner. In September 2010 he arrived at the Hilliard University Art Museum in Louisiana driving a large red Cadillac that belonged to his mother, Jonita Joyce Brantley. He was dressed in the black uniform of a Jesuit priest, with a Jesuit pin on his lapel, and said that his name was Father Arthur

Scott.[15] He had with him a painting that he claimed to have in mind as a gift for the museum, in memory of his mother, Helen Mitchell Scott, who he said was a Louisiana native. The painting was supposedly by the American Impressionist Charles Courtney Curran.

The painting looked good at first glance; even the back of it contained a yellowed label from a long-closed art gallery in New York. (Versos of paintings contain a wealth of information related to provenance, including markings, labels, stickers and other remnants of past sales and owners.) Since it was unframed, Father Scott offered to pay for a frame, and also suggested that he might consider donating more paintings from his family's collection. The only flicker of suspicion came when a museum employee began to chat with Father Scott about possible mutual acquaintances in the nearby Catholic community, at which point Scott seemed to grow nervous and claimed 'I travel a lot' to cover for his inability to recognize local names.

In the guise of Father Scott and others, Landis has spent decades creating fake artworks and gifting them to museums. He crafted meticulous back-stories for his own alter egos and the works that supposedly came from his collection. He never accepted any money for his paintings, even turning down the chance to swap the donated paintings for tax write-offs, and so for some time it was unclear as to whether Landis was actually breaking the law. In 2007 Landis came to the attention of Matthew Leininger, formerly of the Cincinnati Art

Mark Landis, after Charles Courtney Curran, *Women Seated on Lawn*, c. 2000, oil on pressed board, Paul and Lulu Hilliard University Art Museum

Museum, when Landis (using his own name) offered to donate several artworks to the Oklahoma City Museum of Art, where Leininger then worked. Leininger began to collect a dossier of Landis' contacts, sightings and forged works. The earliest donation of a fake by Landis in Leininger's dossier is from 1987, when one of his works was given to the New Orleans Museum of Art, and he has tracked Landis' travels through four states and contacts with close to fifty museums, including major museums like the Art Institute of Chicago.

Landis was never caught, since he gave only fake addresses and names. The last appearance of Father Scott came in November 2010, when Landis tried to donate a drawing to the Ackland Art Museum in North Carolina. That same month the *Art Newspaper* broke a story about Landis and his scheme, running a photograph of him.[16]

Landis went quiet until 25 July 2011, when Leininger received an email from the principal of Cabrini High School in New Orleans. It seemed that a Father James Brantley, who looked remarkably like Landis, had donated an oil-on-copper painting to the school, *Holy Family with Saint Anne*, ostensibly by sixteenth-century painter Hans van Aachen. The principal became suspicious and contacted Leininger.

Leininger quickly discovered that James Brantley was the name of Mark Landis' step-father. Landis was clearly operating under a new pseudonym, and Leininger soon received a second call, this time from Brenau University in Georgia. A Father James Brantley had donated

Landis' *Women Seated on Lawn,* under black light, shows no underdrawings, indicating it was most likely copied from a finished painting rather than developed organically on the board

several pictures to the university, including a drawing attributed to Edith Head, and promised a $100,000 donation. Leininger looked up Landis' email and wrote to him anonymously, saying briefly that he was aware of Landis' continued activities and his new name. Landis did not respond, but the Father James Brantley sightings abruptly ceased.

The works Landis created were good enough stylistically to fool a first glance, and had some details, like the worn label on the back of the fake Curran, to pass initial examination – but not close scrutiny. The Hilliard discovered that they had been given a fake within hours – as soon as the painting was examined under a microscope and ultraviolet light – but long after Landis had gone.

Landis did not set out to fool scientific investigation. According to John Gapper, who investigated Landis for a *Financial Times* article, Landis' preferred method was to go to Home Depot (an American hardware store chain), spend about $6 on supplies, buy three boards cut to a desired size and paste digital reproductions of the works he planned to copy onto the boards. He would then paint directly onto the digital reproductions. The most he would do to give the works the appearance of age would be to scuff the surfaces slightly.

Mark Landis, after Paul Signac, *Untitled*, date unknown, watercolour on paper, Oklahoma City Museum of Art

Landis' goal was only to trick museums into accepting the work into their collections, usually as a gift in honour of a deceased member of his family. Once the work was part of the collection and Landis had left the scene, he did not seem to mind if the work was exposed as a fake. His lack of concern with details, creating fakes that even a nonexpert could tell were not right, shows his disinterest in the lasting effect of his fraud.

A forgery that exhibits such artistic skill that it is mistaken for the work of an acknowledged master both demonstrates the forger's skill and makes fools of the so-called 'experts' who dismissed the

forger's original work in the first place. With Landis, however, we still do not know the origin or motivations of his unusual habit of donating fairly obvious forgeries. He was a diffident, artistic child who was diagnosed with schizophrenia at age seventeen and institutionalized for eighteen months.[17] He studied photography in Chicago then became an art dealer in San Francisco, where he resided at sixteen different addresses between 1985 and 2000.

John Gapper located Landis shortly after *The New York Times* reported that Landis 'seems to have disappeared altogether'. Gapper simply drove to the gated community where Landis' mother lived, where the estate manager told him that Landis was in his old apartment where he lived with his mother. The red Cadillac was parked outside and Gapper heard music coming from inside, but Landis did not answer. A week later, Landis phoned Gapper and invited him to visit. Gapper returned to Louisiana and spent a day with Landis, who gave him a painting he had done of Joan of Arc, signed with his own name. He ended the meeting with a request: 'See if you can smooth things over for me. Tell them I'm not a bad guy. I'm awful sorry if I caused them any trouble.'[19]

Mark Landis, after Honoré Daumier, *Untitled*, date unknown, mixed media, Oklahoma City Museum of Art

Landis' fakes would likely fail to stand up to scrutiny on the open art market. What makes them successful is his trick of playing on the reliance of museums on donations. Because he does not gain financially, it is still not clear if Landis has broken any law. Leininger thinks that he might be found guilty of money fraud. In 2002 a pastel drawing attributed to Everett Shinn was given by Landis, under his own name, to the Lauren Rogers Museum of Art. An identical

Mark Landis at home, 2010

copy of the pastel was sold at the Charlton Hall Auction House in South Carolina in March 2008, consigned by a private collector who claimed to be from Mississippi. It was sold for around $2,000. The auction house would not release the identity of the consignor, but if it can be proven that it was Landis, he might be charged with fraud. One of the two, if not both, is surely a copy, and if he profited to the tune of $2,000 then he will have finally committed a crime. The situation is, as yet, unresolved.[20]

With the possible exception of the 2008 pastel, however, no loss is known to have been suffered. So Mark Landis is still out there, having officially harmed no one but having successfully perpetrated a very bizarre forgery scheme for many years.

CRIME

In general, forgery is seen as being different from other types of art crime: theft, looting of antiquities, looting in war, and iconoclasm and vandalism. These other crimes tend to be linked, and often fall under the auspices of organized crime. Forgery – which is almost always perpetrated by one or two people – does not qualify as organized crime, and its profits do not fuel other types of crime in which criminal groups might be involved, such as the drugs or arms trades. Forgery is thus seen as being a less objectionable crime, because it affects only the direct victims and perhaps the reputations of those fooled: buying a forgery is not putting cash in the hands of terrorists, which might be the case for buying a looted antiquity. But rules are made to be broken, and this chapter examines several cases where organized criminal groups were behind long-term forgery schemes. They do not fit a precise definition of organized crime, because they involved only forgery rather than a variety of criminal enterprises, but in all other ways they fit the bill. This chapter also examines several cases in which a forgery was used as a means to an end to commit a different crime – art theft.

—

FORGING TO STEAL, STEALING TO FORGE: THE V-GANG, MONET AND MATISSE

In the 2013 movie *The Art of the Steal*, Kurt Russell and Matt Dillon play half-brothers who regularly steal art. But they do not bother to breach museums themselves. Instead, their modus operandi is to steal from thieves who have just burgled a museum, by swapping in a forgery for the stolen original. In reality, there are precious few instances in which forgeries are employed to steal art – but there are enough to warrant a new category of forgery motivation: forging in order to commit a separate, different crime.

The popularization of the idea that art theft and forgery go hand-in-hand dates back to a 1932 article in the *Saturday Evening Post* by Karl Decker called 'Why and How the *Mona Lisa* was Stolen'.[1] Decker, called 'an inventive reporter for the Hearst newspapers',[2] has been accused of having fabricated a number of his 'scoops', most famously the tale of the theft of the *Mona Lisa*.[3] According to Decker's account, in 1914 he met a man in Morocco who claimed to be an Argentine marquess named Eduardo de Valfierno. Valfierno told Decker that it was he who had designed the famous 1911 theft of Leonardo's *Mona Lisa* from the Louvre by an Italian amateur painter and handyman, Vincenzo Peruggia, who held onto it for two years before smuggling it to Florence and attempting to give it to the Uffizi. Peruggia claimed that his intention was to repatriate a painting he believed had been stolen from Italy by Napoleon. This was a decent guess, as Napoleon did order the removal of thousands of works from Italy during his military campaign there (1792–1802), but the *Mona Lisa* had been legally purchased by the French king, Francis I, when Leonardo died, and so was the honest possession of the French nation. But having missed this history lesson, Peruggia stole the painting anyway. Peruggia's story was a known fact, but before his arrest in Florence in 1913 creative newspapers around the world tried to guess who was behind the theft. In 1932, Decker supplied a more melodramatic, and perhaps more romantically satisfying, character behind the most famous theft in history.[4]

In the *Saturday Evening Post*, Decker claimed to recount Valfierno's story of having hired Peruggia to steal the painting. Valfierno never intended to sell *Mona Lisa*; his plan all along had been to have the *Mona Lisa* copied six times by a forger named Chaudron, and to sell each of the forgeries to six different, unwitting American millionaires.

Each victim would have read of the *Mona Lisa* theft and would think that they were buying the original. None could advertise their ownership of the stolen painting, so each had to keep their purchase secret – so none would realize that they had bought a forgery.

Not a word of this story was true. No scholars have been able to verify any of it, and it also makes no sense, even from the perspective of Decker supposedly waiting eighteen years from the time he was told this marvellous story to publishing it. But many believed the story, and many continue to do so.

Tilman Riemenschneider, *Madonna of the Rosary*, 1521–1524, limewood, Pilgrim's church of Weinbergen, near Volkach, Germany

While organized crime does not tend to be involved in art forgery, there are exceptions. The so-called V Gang – named after their leader, Alfred Vogler – regularly stole statuary from churches in Bavaria in the 1960s, slicing off limbs and heads and swapping them with other stolen statues in order to sell these Frankenstein's monsters that no longer matched the description of what had been stolen. Members of the gang included cabinetmakers and sculptors, with enough basic knowledge of woodwork to dismember and decapitate wooden statues and exchange their limbs, hagiographic icons and heads, or to alter their size so they could not be traced from stolen art

databases. The V Gang's most famous theft was of the *Madonna of the Rosary* by Tilman Riemenschneider (circa 1500), stolen in 1962 from the church of S. Maria im Weingarten in Volkach, Germany. One of Vogler's team, a sculptor named Franz Xavier Bauer, suggested that he could fashion a cloak out of wood to drape around the Madonna after the theft so that it would not match the description of the stolen statue. Eight men and one woman – apparently not including Vogler – were eventually arrested for a series of such schemes, but the *Madonna of the Rosary* was the one that made headlines. One of the gang, Hermann Sterr, managed to break out of a Bamberg prison just before the March 1968 trial and escape abroad. He was only caught in 1970 when he was stopped by police in Turkey and the officers recognized his face from an Interpol notice: it turned out that Sterr and Vogler were one and the same. [5]

There are also several examples of faking in order to steal. A Lucas Cranach oil on panel was stolen from Sternberk Palace in Prague in 1990: the thieves swapped a poster of the painting for the

Claude Monet, *Plage de Pourville*, 1882, oil on canvas, 60 × 73 cm (23 ⅝ × 28 ¾ in), Poznan National Museum

painting itself, which delayed awareness of the theft. The painting was recovered in 1996 in Wurzburg by the German federal police, the BKA.[6] On 19 September 2000, at the National Museum in Poznan, Poland, Monet's *Plage de Pourville,* worth approximately 740,000 Euros, was cut out of its frame and stolen. The thief replaced the canvas with a painted copy of the Monet he had made on cardboard by painting over a poster purchased from the museum gift shop. The thief, known publically only as Robert Z, was a forty-one-year-old construction worker who kept the painting in a cupboard at his parents' home in Olkusz. He would take it out to look at on occasion, as he later admitted to the police. He had been seen admiring the painting in the museum in the days leading up to the theft, and he was arrested on 12 January 2010.[7] It had taken the museum several days to notice that their Monet had been 'replaced by a badly painted copy on cardboard', as a spokesman was quoted as saying.[8]

Another similar case may be examined in more detail. In 2014, Matisse's *Odalisque in Red Trousers* was eventually recovered after an FBI sting operation and returned to the Caracas Museum of Contemporary Art in Venezuela, from which it had been stolen. Yet it took two years for anyone to notice that the painting had been

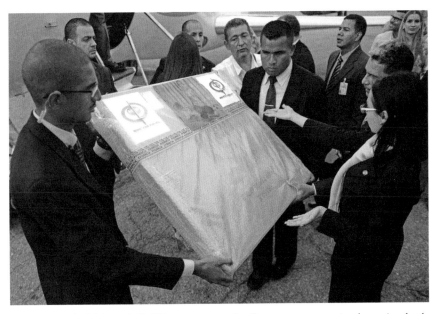

Henri Matisse's *Odalisque in Red Trousers*, 1925, stolen fourteen years previously, arrives back in Venezuela and is greeted by local authorities in 2014 prior to its return to the Caracas Museum of Contemporary Art

stolen. The real Matisse had been taken back in 2000, but no one – no curator, no guard, no visitor, no staff member – was aware of the theft, because the thieves had replaced it with a very good forgery. It was only in 2002 that museum staff noticed the swap. Looking back over photographs, curators noted that the forgery was already in place in a September 2000 photograph of President Hugo Chavez standing proudly in front of the museum's prized possession.[9] An emergency inventory was undertaken in 2002, and a total of fourteen works listed in the museum's collection were found to have gone missing.[10]

In the case of the Polish Monet swap and the Czech poster insertion, the goal of the thieves was only to buy themselves enough time to make their escape. The brazen Caracas thieves, however, had produced a forgery so convincing that it took years for anyone to notice. That is particularly striking and unusual, and begs the question of who the forger might be, for the union of art theft and forgery is a rare occurrence indeed.

In an article on the affair of the Matisse *Odalisque*, art critic Jonathan Jones recalls the famous 1936 essay by theoretician Walter Benjamin, 'The Work of Art in the Age of Mechanical Reproduction'.[11] Benjamin described a quasi-mystical 'aura' that surrounds great, authentic works of art that evades description. This 'vibe' of authenticity is what Bernard Berenson tried to articulate during the Hahn trial over the 'American Leonardo' (see p. 66–67), and detecting that aura is the supposed skill of connoisseurs. Yet an entire museum's worth of staff and curators, not to mention thousands of visitors to the Caracas museum, failed to note that the masterpiece on the wall was not a Matisse.

A mechanical reproduction, such as a photocopy, has no 'aura' because there is no passionate human creator behind it. But a great forgery is a handmade copy, and clearly can contain the passion and skill of the human hand.

THE WOLF IN THE GANG: THE BELTRACCHI AFFAIR

Gangs of forgers are rare, but there are cases in which more than one or two skilled forgers work alongside one another, as happened with Icilio Joni and his 'school of forgers' in Siena. Other cases, such as that of Wolfgang Beltracchi, feature a single forger but a whole gang of confidence tricksters who help pass off the forgeries in the art market.

Beltracchi and his associates – his wife Helene, his sister-in-law Jeanette Spurzem and a colleague, Otto Schulte-Kellinghaus – made headlines for fooling a large number of high-profile victims, including actor Steve Martin who bought a 'Campendonk' for 700,000 Euros in July 2004. Beltracchi has shown himself to be particularly unrepentant, enjoying (as many forgers seem to) the celebrity status that followed his exposure. German magazine *Der Spiegel* published an article with a title that says it all: 'Art Forger All Smiles After Guilty Plea Seals the Deal'.[12]

Wolfgang Beltracchi, born in 1951 as Wolfgang Fischer, spent his criminal career producing forgeries of works by twentieth-century masters including Heinrich Campendonk, Max Ernst and Fernand Léger. He took on the surname of his wife, Helene Beltracchi, when they married in 1993.[13] He informally claims to have made 'hundreds' of forgeries in the style of more than fifty artists, though in court he officially accepted responsibility for just fourteen paintings. Police have to date identified fifty-eight paintings they believe Beltracchi made and tried to pass off as the work of twenty-four different painters.[14] The forgeries are of a very high quality, and were accompanied by plausible, invented provenance.

The gang had one primary provenance story that worked over many years: they had inherited the paintings from their art-collector grandparents, who built their collection in the 1920s. This dating was key, as buyers would be wary of even authentic German collections assembled during the Nazi era. The names of the grandparents were genuine, but neither set of grandparents were actually art collectors. The gang claimed that both did business with the renowned – and real – collector, Alfred Flechtheim.[15]

Among Beltracchi's most successful forgeries is a painting called *La Forêt*, purportedly by Max Ernst, painted in 1927. It was appraised and authenticated by Werner Spies, a renowned art historian whose word about the work of Ernst was definitive, as curator of the first ever Ernst retrospective exhibition (at Paris' Grand Palais in 1975) and a friend of Max Ernst himself.[16] The painting was subsequently sold for 1.8 million Euros in 2004 to the Galerie Cazeau-Béraudière. The work was convincing enough that it was loaned to and exhibited at the Max Ernst Museum in Germany in 2006. With such remarkable provenance – surely only an authentic Ernst would be featured in the Ernst Museum – it later sold to a collector named Daniel Filipacchi for $7 million.

Spies' reputation was badly damaged when it was discovered that *La Forêt* was a forgery. In May 2013, he was convicted at high court

Heinrich Campendonk, *Tiere*, 1917, oil on canvas, 60 × 76.5 cm (23 ⅝ × 30 ⅛ in)

in Nanterre, France, for having incorrectly authenticated another Beltracchi forgery after Max Ernst, *Tremblement de Terre*, in 2004. Spies and the dealer who bought the work, Jacques de la Béraudière, were together fined 652,883 Euros in damages to be paid to the collector Louis Reijtenbagh, who bought it from de la Béraudière's gallery.[17] Reijtenbagh had put the painting up for sale at Sotheby's in New York in 2009, where it was bought for $1.1 million. But the Sotheby's buyer, whose name has not been made public, grew suspicious and the work was tested and found to be a forgery. The work was returned and Reijtenbagh was obliged to reimburse the buyer, the sum of which he was seeking to recover from Spies and de la Béraudière via a civil action.

Spies turned out to have authenticated seven paintings by Beltracchi as works of Max Ernst.[18] It is highly unusual for a connoisseur to be fined for having mis-authenticated a work, and it sets an interesting and surprising precedent that an expert should be personally fiscally liable for any work he or she authenticates. Connoisseurs, as we have seen, are always able to say that they were fooled – and in most cases they were – but a court conviction seems to imply that Spies *knowingly* misattributed the work. For his part, Spies claimed to the French media not to be

Wolfgang Beltracchi, after Campendonk, *Red Picture with Horses,* dated 1914, actual date unknown. This painting was exposed as a forgery after it underwent scientific analysis when it came up for sale at Christie's, and was discovered to contain titanium white paint, which would not have been available to Campendonk in 1914

an expert 'in the legal French sense of the term', and also claimed never to have given a certificate of authenticity.[19] Most of the art world feels that Spies was genuinely fooled, and that his prominent career should not be defined by having been tricked by a skilful con man. In a very public show of exoneration, Spies was invited to curate a major retrospective on Ernst, hosted by the Albertina in Vienna, marking Spies' seventy-fifth birthday and featuring 180 works by Ernst.[20]

As with most forgers, fifteen years of success for the Beltracchi ring ended after hubris led to a slip-up or two that tipped off experts. Experts spotted what seemed to be a fake sticker on the back of a painting that indicated it was from the 'Collection Flechtheim'. Flechtheim was indeed a renowned pre-war German art collector, but it was known that he never placed stickers on his paintings. After the sticker raised suspicions, the painting in question was chemically tested and found to contain titanium white, a paint that had not been developed when the painting was meant to have been made. This was an accidental inclusion of what Tom Keating would have called a 'time bomb' – indeed, Keating intentionally used titanium white. Beltracchi likely included it in the belief that the work would never be tested.

It was a somewhat lazy shortcut that led to his undoing.[21] Once one work linked to the Flechtheim Collection was brought into question, other inquiries followed and Beltracchi's scheme began to unravel. Works linked to Flechtheim through the 'Jagers Collection', several of which were initially bought by the Galerie Cazeau-Béraudière, were uncovered, and the Beltracchis were arrested on 27 August 2010.

Wolfgang Beltracchi awaiting his sentence on trial in 2011

In court, Beltracchi cut a striking figure with his long hair and beard, which more than one member of the art world noted as being one-part Christ, one part Albrecht Dürer.[22] Julia Mischalska, in the *Art Newspaper*, noted that the German media seemed hugely sympathetic to Beltracchi. She notes that an op-ed in *Die Zeit* 'calls for an exhibition of the fakes', while *Frankfurter Allgemeine* wrote that Beltracchi 'painted the best Campendonk that ever was'. More disturbingly, Mischalska noted, *Frankfurter Allgemeine* claimed, 'Art forgery is the most moral way to embezzle 16 million Euros' (in fact, the Cologne public prosecutor's office rated the value of the scam at 34.1 million Euros for just fourteen of the Beltracchis sold).[23] *Der Spiegel* observed, 'Compared with crooked bankers, Beltracchi and his co-conspirators haven't swindled the common people out of their savings, but rather people who may have wanted to be deceived.'[24] This attitude, expressed by three of the leading newspapers in Germany, is dismaying but is also in keeping with the history of public and media attitudes towards art forgers.[25]

In the end, despite substantial prison sentences, Beltracchi is having the last laugh. He smiled in court as he achieved self-actualization and celebrity, praised by the world as a great artist who despite swindling millions from collectors, did not really hurt anyone who could not afford – or even deserved – to be a victim.

Through the history of art forgery there is a distinctive lack of remorse on the part of convicted forgers. Germany's liberal penal system meant that Wolfgang Beltracchi and his wife were permitted to serve their sentence in an open prison, spending nights and weekends in prison but commuting each day to work in a friend's photography studio. There is no indication that Beltracchi wished to be caught – but neither did he seem in the least bothered when he was exposed. Given the positive publicity, why should he?

Beltracchi showed no sign of remorse for his crimes, and nor do the majority of art forgers. Sentences tend to be short, say two to four years in prison (or six years in an open prison for Beltracchi), so dread of punishment is not a strong deterrent. In addition, being caught is not such a disaster for a forger as for other criminals: often there is actually a bonus in finally being able to take credit for one's victory over the art community. Beltracchi serves as a case in point about how the usual disincentives to crime do not apply to art forgery – indeed, one might ask whether there are sufficient reasons *not* to try one's hand at the crime. In the field of art forgery, the benefits outweigh the risks, and by a mile.

THE FALL OF THE KNOEDLER GALLERY

In autumn 2011, a venerable New York art gallery closed its doors. The Knoedler Gallery had been open since before the Civil War, and was one of the mainstays of Manhattan's art scene before it was brought down by allegations of having knowingly dealt in art forgeries. Five civil charges were brought by the Manhattan US Attorney's office against the gallery, its former director Ann Freedman, an art dealer named Glafira Rosales and others. But a year into the civil proceedings, in September 2013, the Attorney's office requested a halt in light of further criminal charges that might also be brought and further arrests that might be made.[26]

The Knoedler affair caused a huge scandal. Founded in 1857, it was the gallery of choice for the wealthiest of the robber-baron era, who bought up the trappings of aristocracy from European nobles who could

no longer afford it. From the Morgans to the Rockefellers, the Mellons to the Astors, the Fords to the Fricks, they all patronized the Knoedler Gallery. So important was the gallery to the history of American collecting that the Getty Archive purchased Knoedler's entire archives (from 1850–1971) in 2012 to preserve it for research purposes.[27] How did this once-mighty New York art institution so suddenly crumble?

The issue began when Rosales brought in a number of works to sell via the gallery. She called the seller 'Mr X. Jr', and revealed only that his parents were based in the Philippines. Codes of privacy and anonymity have been common in the art trade since the eighteenth century, so an anonymous seller did not raise suspicions. The works had ostensibly been part of the collection of David Herbert. Herbert's collection was said to include de Koonings, Rothkos, Klines, Pollocks – all the big guns of twentieth century Abstract Expressionism. Rosales, who was not known to Freedman or the New York art scene, explained that the parents of Mr X. Jr had been friends with Abstract Expressionist painter Alfonso Ossorio and had bought the works in the collection with Ossorio's introduction, often directly from the artists themselves. The man after whom the collection was named, David Herbert, was a gallerist and member of the art-world community in 1950s' Long Island who, the story went, became

The entrance to the once-powerful Knoedler Gallery, New York

romantically involved with Mr X. Sr, a fact that the latter had to keep secret, since he had a wife and children. David Herbert died in 1995.

The first piece that Rosales brought in, a Rothko work on paper, appeared to be authentic, and Freedman claims to have consulted external Rothko experts who confirmed its authenticity. Rosales brought other paintings in one at a time, and agreed a set price that she would receive on behalf of Mr X. Jr for each work sold. Knoedler could keep the difference between that price and whatever they sold for. The first big sale came when Goldman Sachs chairman Jack Levy bought a Jackson Pollock – one of four Rosales would consign – for $2 million in 2001. Freedman told Levy that the provenance of *Untitled 1949* 'was yet to be fully sourced... the owner's identity unknown'.[28] Levy asked for the work be checked over by the International Foundation for Art Research (IFAR). IFAR could not be certain that the work was by Pollock; nor could it verify a story about Ossorio having introduced Mr X. Jr's parents to Pollock. Ossorio was no longer alive, but his life partner, Ted Dragon, claimed that Ossorio never mentioned Mr X., and would not have kept something like that from him. In addition, IFAR researchers could not find any evidence that *Untitled 1949* had ever existed. Levy returned the painting in 2003 and was refunded. Both he and the gallery preferred not to go public with what had happened.

The back of a disputed 'Robert Motherwell' painting, *Elegy*, showing the Dedalus Foundation's forgery stamp

Glafira Rosales (centre) leaving court with her lawyers after pleading guilty to selling over sixty works of forged art, 2013

The first chimes of panic sounded on 29 November 2011. The millionaire hedge-funder Pierre Lagrange planned to sell *Untitled 1950*, a Jackson Pollock he had purchased from Knoedler – consigned by Rosales on behalf of Mr X. Jr – for $17 million in 2007. He sent the painting for forensic testing that revealed the presence of a yellow paint that was not available until the 1970s, whereas the painting was allegedly completed in 1950 and Pollock died in 1956.

Lagrange gave the Knoedler Gallery an ultimatum: reimburse him within two days or be sued. Rather than fight, to the astonishment of the art world the Knoedler Gallery closed down. They did not have enough money left to reimburse any more claimants, nor the resources to pay for a lengthy legal fight.[29]

The subsequent trial brought to light some twenty paintings from the so-called David Herbert collection, consigned by Rosales and handled by Freedman, that had all sold for eight-figure sums. Freedman continued to claim they were all authentic – 'The works are of a five-star quality. Maybe a few are four-star, but mostly five-star, which is why they've stirred such attention' – while the results of forensic testing were awaited. Freedman's own role remained unclear. Did the former Knoedler director know the paintings were fakes, or was she simply fooled? Either way, her reputation was in tatters.

Former Knoedler Gallery director, Ann Freedman, in 2012

Rosales pleaded not guilty to charges of money laundering and tax evasion, for which she faced a debt of up to $81 million in restitution and up to ninety-nine years in prison.[30] In court, she confessed that works that she had promoted as by Robert Motherwell, Jackson Pollock, Mark Rothko and others 'were, in fact, fakes created by an individual in Queens'. The individual is thought to be Pei-Shen Qian, a septuagenarian Chinese immigrant who moved to the United States in 1981 to study art. He was 'discovered' by Rosales and her then-lover and subsequent husband, Jose Carlos Bergantinos, who recruited Qian to paint forgeries that they would sell on as originals. At least forty forgeries were sold by Rosales through the Knoedler Gallery, while at least twenty-three others were sold through another Manhattan dealer, Julian Weissman, whose involvement received less attention than the storied Knoedler & Company. Rosales earned $33.2 million, while the galleries pulled in over $47 million. Mr Qian made only a few thousand dollars for each painting he made.

Even as the trial continued, the US Attorney's office prepared new charges based on new complaints. One was lodged by another victim, John Howard, a businessman who bought a forged Willem de Kooning painting for $4 million.[31] Another was a civil suit against Knoedler brought by the Dedalus Foundation, established

by the painter Robert Motherwell, which accused Freedman of selling Motherwell forgeries. During the trial it was revealed that Rosales lived with Bergantinos, a convicted art fraudster, a fact that Freedman claims not to have known – although it was available information via an Internet search. In total, the 'Herbert collection' sales amounted to some $80 million. Whatever the outcome of the trials, Knoedler & Company, a once-mighty Upper East Side Manhattan institution, nearly two-centuries old, has been knocked down to size and has since closed. It remained to be seen how many other reputations would crumble along with it.

OPPORTUNISM

Many forgers have turned their talents to criminal enterprise thanks to the encouragement of others. Some even appear relative innocents who were corrupted by opportunistic con men who were the ones actually committing fraud, while the forgers were simply producing objects in the style of others. It is most often the confidence trick that passes off the forgery, for few forgeries viewed in a vacuum without a compelling story behind them would fool any sober expert. Forgers themselves are rarely the front men. The person who offers the forgeries for authentication and sale requires a different skill set: good acting abilities, a cool temperament and perhaps even a mild sociopathy to remain so brazen in the face of supposed experts. This chapter looks at forgers who engaged in long-term careers thanks to wily opportunists, who often wound up taking advantage of the forger in the end.

—

ALCEO DOSSENA: MEDIEVALIST SCULPTOR

More than any other events, wars prompt the movement of art. Art is either looted or is sold by fleeing refugees or others to raise cash. Jewish families were obliged to sell art to escape the Nazis during World War II or sometimes to abandon entire collections as they fled central Europe. The Nazis also confiscated thousands of artworks owned by 'Aryan' German citizens – these were never compensated and were sold to fund the war effort. Napoleonic art looting represented the first major, organized military looting of art, and resulted in private as well as institutional looting on an unprecedented scale. A single officer in Napoleon's art theft unit, Citizen Wicar, stole so many prints and drawings for himself that he sold most of them during his lifetime, but still had enough left to leave 11,000 stolen works to his native city of Lille.[1]

One tidal wave of art movement came during and after World War I, and Italian master forger Alceo Dossena (1878–1937) was there to take full advantage of the situation – although the situation, in the end, took advantage of him.

The first major works of apparently medieval and Renaissance sculpture that would prove to be by Dossena came on the market in Paris in 1918. They were of such high quality that the art community concluded that they must have come from an extensive private collection, reasonably assuming that a once-wealthy aristocrat had fallen on hard times and was now obliged to sell off his family's trove. Since the works had been shipped from Rome, some even wondered whether the Vatican was perhaps trying to raise money by de-accessioning parts of its vast collections.[2]

Ownership and origins in the art trade have been a guarded secret since Sotheby's and Christie's were first founded (in 1744 and 1766, respectively), at a time when aristocratic families forced to sell the trappings of their nobility did not want the general public to know of their straitened circumstances. The rise of art auction houses paralleled the first art forgery cases. In 1797, a British art dealer named Jendwine sued another dealer, Slade, in order 'to obtain compensation for losses sustained through the purchase of forged pictures by Claude Lorraine and Teniers'.[3] This is cited as the first case involving art forgery to come before an English court, just one generation after the foundation of Sotheby's and Christie's had

Alceo Dossena, formerly attributed to Mino da Fiesole (Italian, 1429-1484), *Tomb of the Savelli*, c. 1920s, marble, 180 cm (70⅞ in) high, Museum of Fine Arts, Boston

effectively launched the international resale trade in fine art.[4] To this day, there are many legal hoops to jump through in order to force auctioneers and gallerists to disclose who is selling or purchasing art if those involved wish to remain anonymous. This gentlemen's silence is an ideal environment for criminal advantage, as Dossena knew well.

Dossena produced dozens of fake sculptures from a small studio by the Tiber River in Rome, a stone's throw from Castel Sant'Angelo. Dossena arrived in Rome as a soldier on leave on Christmas Eve 1916. He had barely enough money to feed his family, but he did have remarkable skill as a sculptor and a cunning plan. He had with him, wrapped in newspaper and concealed under his greatcoat, a Madonna he had carved in relief on wood. Tired, Dossena stopped at the renowned Frascati wine shop on Via Mario de Fiori and drank a bottle of Chianti. The shop owner asked what was wrapped in newspaper, and Dossena showed him. Curious, but not in the market

Alceo Dossena, *Head of the Virgin*, c. 1920s,
marble, 35.6 × 24.4 cm (14 × 9 ⅝ in),
Metropolitan Museum of Art, New York

for religious objects, the shop owner summoned a friend, goldsmith
Alfredo Fasoli, whose studio was across the street. Fasoli knew good
art when he saw it, and he asked Dossena where it had come from.
Dossena said that he was selling it for a friend. Fasoli assumed that
Dossena had lifted the sculpture from a small church, or some similar
story of quick fingers in times of hardship and conflict. The middle of
a world war was no time for moralizing. Fasoli bought the sculpture
for 100 lire, a huge amount to the impoverished Dossena. Suddenly
flush, Dossena slipped away into the snowy Christmas night.

Fasoli, thinking he had a bargain on his hands, took the sculpture
back to his studio. Studying it, he realized that it was a magnificent
piece of craftsmanship, but that it was not old. It had been made to
look old, but it had been made recently. Rather than becoming angry,
Fasoli saw an opportunity. He tracked down Dossena and suggested
that they should go into business together. Dossena would produce
'antique' sculptures and Fasoli would help to 'age' and sell them.

After the war, Dossena settled in Rome to work with Fasoli.
His studio was by no means secret – even today in Rome one may
see craftsmen working in small workshops, restoring antiques, and
Dossena's workshop would have looked no different. The first work

he produced after the war, a medieval-style statue, was sold by Fasoli for 3,000 lire, 2,000 of which was paid in gold to combat the rapid inflation in Italy. Fasoli paid Dossena a fee of 200 lire, not telling him the selling price. For Dossena, 200 lire was a small fortune.

The best-selling work of Dossena's career was called *Tomb of the Savelli*. It was a High Gothic sculpture apparently found at the tomb of an aristocratic family in a rundown church. A scholar discovered a receipt signed by the purported artist, Mino da Fiesole, which noted the payment by the Savelli family for his work on their family tomb. If there was any doubt about the authenticity of *Tomb of the Savelli*, it was dispelled by the discovery of this piece of provenance, confirming the existence of a previously unknown work of art. At the time, no one thought to wonder if this document was also a forgery. *Tomb of the Savelli* eventually sold for 6 million lire, and was later acquired by the Museum of Fine Arts of Boston for $100,000. Dossena, a man who thought 200 lire was a fortune, must have thought that the heavens poured forth manna when he received 25,000 lire in payment.

Among the works by Dossena that entered the market after 1918, and which sold for high sums, the most remarkable include: a sculpture thought to be by Simone Martini, a painter by whom no sculptures were known; *Greek Goddess,* purchased by the Metropolitan Museum of Art in New York; *Madonna and Child* thought to be by the Pisano family, acquired by the Cleveland Museum of Fine Arts; reliefs of *The Virgin with Saint Anthony* and *Madonna and Child*; archaic Greek sculptures of *Athena* (life-size at 5 feet, six inches tall) and an *Attic Warrior*; as well as Gothic carvings and Renaissance terracottas. Dossena developed a paste that resulted in a hard, slightly discoloured patina that made his sculptures look far older than they were. He never revealed the recipe for his paste. All that is known is that Dossena dipped his 'archaic' sculptures in this concoction multiple times, using a winch to lower them into a cement-lined pit in the floor of his Rome workshop.

Dossena's wife died in 1928, just as he was learning, to his dismay, that his forgeries had been sold for enormous sums of which he had seen only a tiny portion. He had worked with other dealers in addition to Fasoli, and he now approached a Roman dealer who had sold his *Madonna and Child* relief sculpture for 3 million lire, of which Dossena had received 50,000 lire. Dossena asked for money to pay for his wife's funeral and was told that he could get an advance – but only when he showed the dealer his next object for sale. Dossena was upset and felt

taken advantage of. Instead of producing a new work, he made the surprising decision to consult a lawyer. The lawyer knew how to present the case: Dossena had never sold a sculpture under false pretences; he had simply made antique-style sculptures that had been purchased by unscrupulous dealers who had sold them on as originals. Dossena confessed to his forgeries – which is why more is known about him and his life than of other art forgers – and brought an action for fraud against his two main dealers, Alfredo Fasoli and Romano Palazzi.

Art experts at first refused to believe that Dossena's works were not the authentic works they were purported to be. Jakob Hirsch, a Parisian dealer who had authenticated the *Athena*, travelled to Rome to confront Dossena, whom he believed was lying. In order to prove that he had created the *Athena*, Dossena produced a stone finger he had broken off the statue's hand to make it look more authentic. The finger matched perfectly the empty spot on the statue.

Hirsch understood that the reputations of numerous prominent experts, himself included, were on the line. He organized a network of acclaimed experts who had authenticated works now claimed by this unknown forger to try to outmuscle and out-shout the artist by insisting that all of the works were, in fact, originals. The experts could not accept that any forger could be so successful in a wide variety of sculptural styles and periods. But while these experts drew up their battle line, others pointed to what they now saw as obvious indications that the works were indeed forgeries. Experts turned on one another, each trying to shatter the reputation of their rivals.

Some experts tried to rationalize Dossena's abilities by calling him a 'copyist', but none could ever find a work that he had copied. He had created wholesale forgeries at a time when neither provenance nor scientific tests were absolutely necessary in order to pass off a fake as an original. What was required was enough skill to fool experts who based their decisions on personal opinion alone, on connoisseurship.

A Berlin sculptor travelled to Dossena's studio, after having been fooled by Dossena's *Goddess Enthroned*, an 'archaic Greek' sculpture in the Berlin Museum of Antiquities. Dossena welcomed him and showed him leftover works in his studio, varying in style from Gothic to Early Renaissance to High Renaissance to ancient archaic. The sculptor concluded that Dossena must be the head of a forgery school, and that various students specialized in art of different periods, all under Dossena's supervision.[5] He could not imagine that one man might be so diversely prolific.

It had long been thought that there existed 'forgery schools' in Italy, and in fact there had. Icilio Federico Joni was part of one in Siena (see p. 44), but the phenomenon of Italian 'forgery schools' was not as widespread as was thought, and it does not appear that Dossena was involved in one. He was simply a talented artist who happened to make forgeries instead of his own originals.

To counter Dossena's suit, Fasoli accused Dossena of being an enemy of Mussolini's Fascist regime – entirely untrue but one of the few things that Fascoli could do to undermine Dossena's true accusations against him. The charges against Dossena were dropped, but Dossena never received the financial compensation he sought.[6]

After his lawsuit against his dealers, Dossena had no source of income. The Italian government auctioned off the thirty-nine works remaining in his studio in 1933. He died a pauper in 1937. Dossena said of himself 'I was born in our time, but with the soul, taste, and perception of other ages'.[7] Perhaps that explains the tremendous skill of a forger who was as much taken advantage of as taking advantage, and who ultimately led an unhappy life.

Alceo Dossena, *Madonna and Child*, c.1929, terracotta, 158 × 33 cm (62 ¼ × 13 in), Victoria and Albert Museum, London

Dossena's story is similar to that of the origins of many forgers, which begin with almost inadvertently passing off a work as a valuable original.[8] Realizing that the art trade is a fortress easily breached, these artists felt emboldened to try more elaborate schemes, which turned them into full-blown career fraudsters. This progress is reminiscent of the 'Broken Windows' theory of criminology, first proposed in 1982 by James Q. Wilson and George Kelling.[9] It states that a society, or subset of a society, that appears lawless will, in fact, become lawless. The basic symbol used to express the theory is a building in a rough neighbourhood with its windows broken. The outer appearance of disorder promotes the idea that this area is one in which disorder is the norm and will go unchecked; the neighbourhood therefore becomes a bubbling cauldron that encourages more serious civil and criminal disorder. This theory has also been applied to the escalating criminal activities of individuals, from graffiti and minor vandalism to more serious crimes.

Both the personal and territorial aspects of the 'Broken Windows' theory apply to forgery. Forgers recognize that the art community is one in which minor crimes and illicit behaviours (money laundering through cash payments, intentional misattribution for profit, purchase of illicitly-excavated or exported antiquities) are relatively commonplace and often go unpunished. It is therefore a welcoming environment for criminal activity. Forgers such as Alceo Dossena and John Myatt (whom we meet next) often begin with an initial, small-scale success, which encourages them to escalate their criminal activities.

THE MOST DESTRUCTIVE PROVENANCE TRAP: JOHN MYATT AND JOHN DREWE

The scheme developed by John Drewe, who recruited the struggling artist John Myatt as his forger, used a version of the provenance trap, but one which was, sadly, far more destructive than other incarnations of it.[10]

John Myatt (born 1945) was a farmer's son who studied art and developed a talent for imitating the style of renowned artists, largely of the early twentieth century, but his painting career never took off and he became a teacher. When he separated from his wife in 1985, he stopped teaching in order to spend time with his young children and wondered if he might be able to earn money from his talent for

copying the style of famous artists. He began to advertise in *Private Eye* magazine: 'Genuine fakes. Nineteenth and twentieth-century painting from £150'. Myatt would paint a copy of any work ordered, signing his own name to it. There was nothing criminal about this, and he sold a handful of works, including several to a man called John Drewe. But Myatt was still not making ends meet.

Ben Nicholson, *1955 (still life–red oxide)*, 1955, oil and pencil on canvas, 57.1 × 45.4 cm (22 ½ × 17 ⅞ in)

John Myatt, after Nicholson, *Cockrel*, details unknown

One day Drewe contacted Myatt and told him that Christie's had accepted one of Myatt's 'genuine fakes' for consignment, believing it to be by French Cubist painter Albert Gleizes. The work sold as authentic and netted £25,000 (Drewe had paid £150 for it). Drewe suggested that they work together and Myatt, who had never before considered criminality, succumbed to temptation.

Myatt began to paint forgeries on a regular schedule, delivering them to Drewe in London. He mimicked the style of an impressive array of early twentieth-century artists, including Chagall, Le Corbusier, Giacometti, Matisse, Ben Nicholson, Jean Dubuffet and many more. In total, police estimated that Myatt produced around two hundred forgeries over many years. This may sound low compared to the huge numbers claimed by some other forgers, but it comes from the police rather than from the mouth of an

apprehended forger eager to play up his output. Police believe Myatt earned about £275,000 as his cut from Drewe over the course of the forgery scheme.

For his part, Drewe recognized that a stylistic semblance alone would not convince the contemporary art world that a newly-discovered work was by a great master. He understood that provenance is the key to a successful forgery. Myatt claims to have painted his forgeries using emulsion paint and K-Y jelly, when the originals would have been made in oils. Any expert should have been able to tell the difference between emulsion paint and oils, and Myatt did not go to any great lengths to defeat scientific analyses of his forgeries. The provenance provided by Drewe was convincing enough that the forgeries would not be submitted to close scrutiny.

John Drewe sitting at his desk at home, 2000

Drewe was smart enough to realize that intelligent forgers do not copy existing works, but rather create new works in a convincing style and, most importantly, with a convincing story that will pass them off as lost originals. Drewe began to forge provenance: historical, archival documents that would provide a plausible paper trail to support the fraudulent artwork. He forged letters, receipts and inventory notices that purported to be from galleries, museums or individuals no longer in existence or alive, and therefore impossible to verify. He then inserted this false provenance into real archives.

When an auction house is offered a work for consignment, they check the historical records to see if the work has appeared in the catalogue raisonné of the artist it seems to be by. Experts check books and historical archives for provenance, even when a work is accompanied by little or no provenance of its own. The more background they can build up around a work of art, the higher price it will bring.

There are two reasons why art with more provenance sells better at auction. First, provenance assures potential buyers of the legitimacy of the object, both its authenticity and the assurance that it is not stolen. Second, the story behind art objects is part of their appeal. Tracing the history of ownership as far back as possible gives a work a historical and cultural significance beyond its aesthetic appeal. And so galleries and auction houses seek out as many clues to the provenance as possible. Convincing provenance is, therefore, the real key to a successful forgery.

For Myatt's works, researchers would be confounded at first. They had what looked like an authentic Chagall or Giacometti, and yet the catalogues raisonnés did not refer to the work in question. The next step was to go to the archives to see if they could find something a past researcher had missed. In fact, what they found would have been surreptitiously inserted by John Drewe, posing as a researcher at the same archive in order to insert his forged provenance.

For the researcher, the discovery of new provenance is a two-fold success. Not only is new provenance found in a historical archive that 'proves' the authenticity of the work, but a previously overlooked archival document is discovered that might be useful for future research. Such discoveries can make careers. The Myatt forgery would thus be authenticated and sold, thanks to Drewe's version of the 'provenance trap'.

Drewe breached a number of archives, including the Victoria and Albert Museum, the Tate Gallery and the Institute of Contemporary Arts in London – there were surely more of which we are unaware. The Victoria and Albert launched an exhaustive examination of all of the archives Drewe might have tampered with, in an effort to expunge false material so that future scholars will not question the real documentation.[11] The problem is, of course, that once real archives have been impregnated with fake historical evidence they are poisoned. Every piece of documentation in the archive must be called into question as to whether it, too, might be fake. This method of the provenance trap is severely destructive because it makes us question the reliability of the very grounds from which scholarship begins.

Alberto Giacometti, *Head of a Man (Diego)*, 1951, oil on canvas, 73.3 × 60.3 cm (28 ⅞ × 23 ¾ in)

John Myatt, in the style of Giacometti, *Portrait of Samuel Beckett, 1961*, dated 1961, oil on canvas. One of Myatt's 'genuine fakes' sold under his own name, in the style of another artist

Drewe coldly tricked friends and colleagues into pretending to be owners of Myatt's paintings. He corresponded with family members of deceased artists, tricking them into authenticating works that their relations had never made. He lured a casual acquaintance, Clive Bellman, into helping to sell a number of forged paintings by telling him that they were real works, the sale of which would help acquire important archival documents related to the Holocaust. He pressured an old friend, Daniel Stokes, into claiming ownership of a forged Ben Nicholson painting, saying that selling it would help a family in need. He verged on sociopathic, and was ruthlessly clever.

In September 1995 Scotland Yard arrested Myatt. They had been tracking him for some time, and also knew that Drewe was the mastermind behind the scheme, since Drewe's scorned ex-girlfriend, Bat-Sheva Goudsmid, had informed the police and the Tate Gallery about his actions. Myatt confessed immediately and agreed to help the detectives catch Drewe, whom Myatt had grown to dislike for personal reasons – Drewe seemed not only untrustworthy but dangerous. Myatt detailed his forgery methods, pointing out that he did not even use the same media as the artists he copied and that experts should surely have been able to tell the difference. He also volunteered to help Scotland Yard in their investigations of other art forgers, a role he has continued to this day.

John Myatt at work in his studio, 2011

On 16 April 1996, police arrested John Drewe at his home in Reigate, outside London. They found the tools he used to create false provenance, including certificates of authenticity and the fake historical documents that were inserted into archives. At trial, Myatt was sentenced to one year in prison for conspiracy to defraud. He was released for good behaviour after four months. Drewe was sentenced to six years in prison and served two.

While Drewe has slipped out of the public eye, John Myatt's career has just begun. Like so many art forgers who have been caught, Myatt found fame and fortune after his arrest. His original works sell for five-to-six figures, as do his high-profile 'genuine fakes', signed with his own celebrity name. In 2007 his life story was optioned to be made into a film and, like Tom Keating before him, he is now the star of his own television series for Sky Arts: 'Fame in the Frame', in which he paints portraits of celebrities in the style of famous artists, and 'Virgin Virtuosos', in which he re-creates famous paintings on camera.

ELY SAKHAI AND THE COPYING SCHEME

When most people think about forgery, they think about the copying of existing artworks. As we have seen, it is wiser for a criminal to produce a 'lost' artwork or a work in the style of a known artist that might be mistaken for an original. The problem with copying an original is that, if the original is still extant, it is easy to prove that the copy is a copy. But that has not stopped people from trying. Recall the myth around the theft of Leonardo's *Mona Lisa* from the Louvre in 1911. Eduardo de Valfierno, an Argentine criminal, was alleged to have commissioned the theft in order to sell six forgeries of it to unsuspecting collectors (see p.150), each of whom would believe that they had the stolen original and none of whom would be able to advertise their acquisition of a stolen masterpiece, so none would be the wiser.[12]

Aside from the fact that the *Mona Lisa* was indeed stolen – by Vincenzo Peruggia – the rest of the story was completely fabricated. And yet the myth continues, because it fulfils some of the resonant stereotypes of art crime: aristocratic swashbuckling Robin Hoods cutting the elite down to size. But despite the proliferation of the Valfierno myth, forgery is rarely linked with villains copying famous paintings. At least one criminal, however, did take a leaf out of Valfierno's book and succeeded for a long time in creating copies of known works to sell.

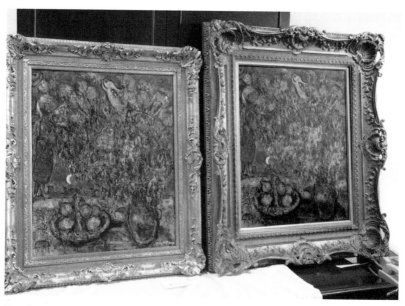

Two forgeries of Marc Chagall's *La Nappe Mauve*, confiscated by the FBI, suspected to be from Ely Sakhai's forgery scheme

Ely Sakhai (born 1952) was a respected New York art dealer with a luxurious gallery in Manhattan.[13] An émigré from Iran, he established The Art Collection Inc. and Exclusive Art, a pair of galleries that did a good business. He was a philanthropist, having sponsored the Ely Sakhai Torah Center, and was well-known among New York art dealers. He had a significant collection of his own and also to sell through his galleries, preferring Impressionist and Post-Impressionist paintings. His collection included Monet's *Le Mont Kolsas*, Renoir's *Jeune Femme S'Essuyant* and several lovely Chagalls. While these were known, authenticated works by renowned artists, they were not renowned works, and they were purchased for prices considered on the low end for fine art. While blockbuster works, generally defined as those worth over $1 million, raise a lot of eyebrows and interest, most works are in the five-to-six figure range. These tend to be examined with less care than the more valuable pieces, and can more easily slip beneath the radar. This worked to Sakhai's advantage.

Sakhai hatched a plan that would allow him to keep the originals he purchased, while still selling works on for a profit. He employed a small workshop of Chinese immigrant artists to copy the works he bought. They painted identical copies from the originals in an upstairs room of Sakhai's gallery. When he was satisfied with

The back of the two forgeries of Chagall's *La Nappe Mauve* confiscated by the FBI

the likeness, Sakhai framed the new copies in the original frames. He also attached to the copies the legitimate provenance, letters and certificate of authenticity, which had entered his gallery after he purchased the works legitimately. The originals remained on his wall, but after time had passed Sakhai could submit them for expert analysis to receive a new certificate of authenticity, which they would receive as they were, indeed, originals. In theory, he could then sell the originals, thereby profiting twice by selling two versions of each real painting he purchased.

Sakhai recognized that it was inevitable that at some point collectors would note that two versions of each work he sold entered the market, but a combination of greed and hubris impelled him to proceed nevertheless. Sakhai sold the copies in Asia and the originals in New York or London to stave off the problem, believing that Asian collectors had faith in the certificates of authenticity. In fact, it was various European galleries that grew suspicious when certain works they wished to put up for auction appeared to be *already* owned by Asian collectors, primarily in Japan. It is always possible that an artist produced more than one version of a work, but there should be a historical record of the existence of multiple copies. The FBI became involved, and Sakhai was made aware that he was under investigation.

Paul Gauguin, *Lilacs*, 1885, oil on canvas, 34.9 × 27 cm (13 ¾ × 10 ⅝ in),
Thyssen-Bornemisza Museum, Madrid

Anonymous, after Gauguin, *Lilacs,* dated 1885

Sotheby's and Christie's had realized that they were both consigned the same painting by Gauguin, *Vase de Fleurs*, in May 2000. Each believed that they had been consigned the original. They brought the two paintings to a Gauguin scholar, Sylvie Crussard, who determined that the painting consigned to Christie's was a forgery. Christie's withdrew the painting, recalled their catalogue and informed the embarrassed consignors, the Gallery Muse in Tokyo. Sotheby's sold the original, consigned by Sakhai, earning him $310,000.

But by now the FBI had traced the forgeries back to Sakhai himself. He was arrested and charged with eight counts of mail and wire fraud. His estimated criminal profits were $3.5 million. Sakhai was released on bail. On 4 March 2004, he was again charged, this time on eight counts of fraud. He was again released on bail. It was only in July 2005 that he was finally sentenced. He served forty-one months in prison, was fined $12.5 million, and had eleven artworks confiscated.[14]

MONEY

Most people assume that money is the driving motivation for forgery. In fact, it is rarely the forger's initial aim, although it often becomes the main rationale for a forger to continue forging after the initial flush of success. Testing and demonstrating one's genius and ability, revenge against the art establishment that has slighted you and achieving personal fame and acclaim are more common reasons forgers initially try their hand. But there are others who are more mercenary, for whom money is not a nice bonus, but the whole point. They are not out to prove a point, but to make a profit.

—

THE APPEL FALLS FAR FROM THE TREE: GEERT JAN JANSEN

Few art forgers adhere to the stereotypes associated with art criminals: refined gentlemen of aristocratic bearing with collections of legitimate art hanging on tapestry-draped walls. This is a picture developed largely from fiction, particularly the fin-de-siècle Raffles and Arsène Lupin novels. But several forgers do fit the bill, one of whom is the remarkably prolific and skilled Dutch forger, Geert Jan Jansen.[1]

Jansen (born 1943) worked as a forger for decades, ultimately residing in a spectacular white-walled castle in the Dutch countryside decorated with scores of authentic masterpieces, living the lifestyle of an aristocrat, though without the blue blood. When he was finally arrested in 1994, the scale of his industry shocked the police.

Jansen, like many forgers, began his career intent on making a living through his original works, only copying the works of his famous counterparts to improve his own technique. He opened a gallery to show his paintings, but he could not make inroads into the art market. His first forgeries were on a small scale. He purchased mass-produced lithographic posters by the Dutch artist Karel Appel (1921–2006), a founder of the Dutch Experimental Group in Amsterdam and an artist in the Cobra group. Jansen signed Appel's name on the posters and sold them at a mark-up, apparently autographed by the artist of the original. Many forgers began this way, either inadvertently finding that someone mistook their copy for an original or probing the waters with a small-scale fraud.

After his success with the Appel posters, Jansen thought he would attempt a more advanced form of forgery. He made a complete, new 'Appel' artwork and sold it for 2,600 guilders (around $1,500). These initial criminal victories encouraged him to be bolder, and he sent another 'Appel' forgery to an auction house in London. By this point Jansen was not working cautiously. Whether through blissful ignorance or hubris, he was choosing to forge the works of a living artist who could be consulted as to the authenticity of his works as they went on the market.

Jansen was both skilful and lucky. The auction house sent a photograph of Jansen's 'Appel' to Karel Appel, asking if it was indeed an original work. Appel said that it was. The work, a gouache painting, broke the sales record for a work by Appel.

Although word got out that Jansen was making forgeries, the Dutch police had no direct evidence against him. In 1981 they received a tip-off that a painting by twentieth-century De Stijl artist Bart van der Leck was in fact Jansen's handiwork. The police searched Jansen's home, but found nothing to link him to the Van der Leck. Later they searched a local warehouse and found seventy-six forged Appel lithographs hidden in the ceiling – but these could not be definitively linked to Jansen, and no charges were brought. Jansen was not charged, but it was clear the authorities knew about his criminal activity. The attorney general issued a strong warning: Jansen must not make artworks in the style of other artists, much less try to pass them off as originals, for three years.

Jansen's next encounter with the law came in 1988, when he sought to sell another flurry of Appel paintings through various galleries. The scale was huge: in June 1988, Dutch police confiscated hundreds of Appel forgeries from one gallery alone, MAT in Amsterdam. The MAT Gallery owner claimed to have acquired a hundred works that turned out to be forgeries from the Tripple Tree Gallery. The Tripple Tree Gallery owner claimed in turn to have bought the 'Appels' from a Paris-based Dutch dealer, Henk Ernste.

Geert Jan Jansen surrounded by his own works in the style of Karel Appel

Karel Appel, *Child with Birds*, 1950, oil on canvas, 100.4 × 101 cm (39 ½ × 39 ¾ in), Museum of Modern Art, New York

Anonymous, after Appel, details unknown. The work was photographed in the studio of Geert Jan Jansen in 2008 but Jansen's studio has not confirmed authorship

Ernste was arrested but never sentenced – the case was settled out of court when Ernste paid a 5.5 million guilder fine (about $3 million). It was assumed that Ernste got the 'Appels' directly from Jansen, but this was never proved. Jansen, however, quickly moved to France.

Nothing was heard from Jansen until March 1994. That year, a man calling himself Jan van den Bergen visited the Karl & Faber auction house in Munich. He presented himself as an art dealer from Orléans who wished to sell three small works: a gouache by Asger Jorn, a drawing by Chagall and a painting by Karel Appel. The Jorn and Chagall had certificates of authenticity, but the Appel did not. The visitor immediately struck the auction house as suspicious, because he said that he wanted the works auctioned quickly and left promptly after filling out the requisite paperwork and handing over the objects.

One of the auction house staff, Sue Cubitt, examined the works. She found a typo in the certificate of authenticity that accompanied the Chagall, which raised alarm bells. After contacting the foundation that authenticates Chagall works, she confirmed that the certificate itself was a forgery, suggesting strongly that the drawing was a forgery, too. A quick check with Jorn experts led to the same conclusions. The auction house withdrew all three works from the sale, and informed an art forgery specialist, Ernst Schöller of the Stuttgart Fine Art and Antiquities Police Unit.

Cubitt, Schöller and his team began checking auction catalogues for suspicious works that might have been consigned by the same 'Jan van den Bergen'. It seemed that the same works, including but not limited to the three pictures offered in Munich, had been put up for sale in other auction houses in a variety of European countries. In collaboration with French police, Schöller investigated the address in Orléans on Van den Bergen's business card, and found it was only a factory making wine bottles. Schöller and his colleagues eventually tracked down and arrested Geert Jan Jansen, aka Jan van den Bergen, on a farm in La Chaux, outside Poitiers, on 6 May 1994.

The scale of Jansen's operation staggered the police. Approximately 1,600 forged artworks were found in storage at the farm, including works after Picasso, Dufy, Matisse, Miró, Cocteau and the Dutch artists Bart van der Leck and Charles Eyck.

Even after the arrest, French police had trouble coaxing more Jansen forgeries out of the woodwork. Appeals in the media for collectors to come forward with suspected forgeries produced no results. It seemed that the Drouot Gallery in Paris was Jansen's main sales point, and a number

of suspicious works were confiscated there, having been consigned under false names. But they could not be definitively linked to Jansen.

Jansen's trial began in September 2000 in Orléans. The police had accumulated over 2,000 forgeries attributed to him, but could not persuade victims to testify. Those duped into buying Jansen forgeries preferred not to come forward. Instead, Jansen was charged with fraud related to false passports. Jansen was eventually sentenced to six months in prison, with five years of suspended sentence. He was exiled from France for three years. The seized works were marked for destruction, but Jansen's lawyer pleaded successfully that they should not be destroyed because they included some authentic works.

Released from prison, Jansen remains an unrepentant and proud artist. Two hundred of his forgeries are on display at the Castle Beverweerd in the Netherlands, where he has lived and painted since 2006. He discussed his career on a popular Dutch radio program, 'The State We're In', which aired on 11 November 2011. In it he discusses his trial, his career (claiming that he produced around forty forgeries per year, although the 1,600 works found at his farmhouse suggest that he was about four times as prolific as he claimed) and how he would be proud if someone ever tried to forge his own original works.

WILLIAM SYKES AND JAN VAN EYCK: THREE WAYS TO TURN AN ORIGINAL INTO A HIGH-PRICED FAKE

Altering an authentic object in order to increase its value is far easier than creating a wholesale work in imitation of a great masterpiece, for not all fraudsters are fine artists of the rank of Giordano or Michelangelo.

Horace Walpole, the eighteenth-century English art historian, called the con man William Sykes a 'noted trickster' – and his assessment could have been an understatement. We do not know the true extent of Sykes' criminal activities beyond his reputation – such is the case all too often with successful criminals – but one major fake scheme relying on the fraudulent alteration of an authentic work established Sykes's disreputable reputation.

In 1722 Sykes legally purchased an authentic fifteenth-century Flemish oil painting on an oak panel depicting a medieval saint in ecclesiastical garments seated on a throne in a Gothic church, surrounded by other clerics who lower a bishop's mitre onto his head, as he whirls his hand in benediction. The artist was unknown, as was its subject.

Anonymous (previously attributed to Jan van Eyck), *The Enthronement of Saint Romold as Bishop of Dublin*, dated 1490, oil on oak, 114.5 × 71.3 cm (45 × 28 in), National Gallery of Ireland, Dublin

Sykes added three things to the painting in order to increase its value, carefully maximizing its interest to collectors in eighteenth-century England. Sykes first attributed the painting to Jan van Eyck, the most famous and highest-selling artist in the late eighteenth and throughout the nineteenth centuries in England.[2] The picture would surely fetch more money if the subject could be determined, so Sykes suggested that it depicted the most famous British saint, Thomas Becket, the twelfth-century Archbishop of Canterbury, being ordained in Canterbury Cathedral. The final addition had to do with ownership history. For a painting that was going to be passed off as having been made in 1421, the most resonant owner, for British collectors, was King Henry V, of Agincourt fame, who died in 1422.

Sykes put the three fraudulent additions together to forge an inscription on the back of the painting that stated that the work had

Hans Memling (originally attributed to Jan van Eyck), *Donne Triptych*, c. 1475, oil on oak, overall 70.5 × 131.5 cm (27¾ × 51¾ in), National Gallery, London

been commissioned by King Henry V, was by Jan van Eyck and showed the ordination of Saint Thomas Becket in Canterbury Cathedral.

Sykes' additions were enough to convince the Duke of Devonshire to buy the picture for a huge sum in 1722. It was given pride of place at Devonshire House in Piccadilly until the story behind it was brought into question by Horace Walpole, forty years later. The painting now hangs in the National Gallery of Ireland in Dublin, acquired in 1958. It is dated to 1490 and is entitled *The Enthronement of Saint Romold as Bishop of Dublin*. The artist is unknown. As a result of its re-attribution, the picture is now perhaps less exciting but has a better story behind it. The story of an artwork, as much as its history and content, increases interest in it and thus its value. There are those who eagerly seek out forgeries for that very reason. London's Victoria and Albert Museum long had a gallery of fakes and forgeries, celebrating the works of artists who aped others, and who, in doing so, sometimes became more famous than the artists they copied.

The eighteenth-century was an era of Van Eyck forgeries. Walpole also pointed out an authentic Hans Memling, the *Donne Triptych*, which hung at Chiswick House as part of the collection of the Earl of Burlington. The painting was authenticated as a Memling by art historian Gustav Waagen in 1835, but it had been purchased by Burlington as a Van Eyck, for it bore a forged Van Eyck signature on the back. Whether or not this was the handiwork of William Sykes remains a matter of speculation.

LIQUID ART FORGERY: THE WORLD OF WINE FRAUD

Fine wines do not necessarily come to mind when one thinks of forgery. However, wine fraud is a relatively widespread phenomenon. It can take three forms: there can be fraudulent contents inside the bottle, so that the wine does not match its label; the bottle can be altered to suggest that the wine inside is of greater value than it actually is; or both the bottle and its contents may be fraudulent. There has been a long tradition of fraud in the fine wine business, and one particular case involving supposed bottles of Château Lafite Bordeaux, once owned by Thomas Jefferson, made international headlines, and spawned a best-selling book and two films. It remains unsolved.[3]

On 5 December 1985, Christie's in London sold a bottle of wine with the following hand-etched into the hand-blown glass: '1787, Lafitte, Th.J. [sic.]'. The provenance of the bottle, purportedly one of a large collection of Château Lafite wines purchased by Thomas Jefferson (Th.J.) when he was in Paris, sounded like the outcome of a miraculous treasure hunt. Jefferson was a wine collector of almost obsessive proportions, who during his first term as president of the United States alone spent $7,500 on wine (about $120,000 today). Now a bricked-over wall in an old Parisian cellar had been dismantled to reveal cases of wine, including bottles from the most famous of the old vineyards: Mouton, D'Yquem, Margaux and Lafite.

The find caused a stir, despite the problem that eighteenth-century bottles of wine are collector's items that may or may not be drinkable, and to drink the wine would greatly lower the value of the bottle. The first 'Jefferson Lafite', as it became known, sold for a world record price to Malcolm Forbes: £105,000 (around $170,000). Other bottles from the same stash were sold later, one to the publisher of *Wine Spectator* magazine, another to a Middle Eastern businessman and four to American millionaire Bill Koch, who amassed an extensive collection of eighteenth-century wines. When Boston's Museum of Fine Arts wanted to exhibit Koch's collection, Koch began to look for provenance on the four Jefferson Lafite bottles he had purchased. He could find nothing and, to make matters worse, when he contacted the Thomas Jefferson Foundation, responsible for keeping track of Jeffersonian material, they told him that they did not believe the Jefferson Lafites had ever belonged to Thomas Jefferson.

Allegedly a bottle of 1787
Château Lafite Bordeaux
once owned by Thomas
Jefferson, sold through
Christie's London in 1985

The origin of the Jefferson bottles was the private collection of an oenophile and former pop band manager named Hardy Rodenstock. Rodenstock enjoyed hosting invitation-only tastings of famous vintages – a chance to show off his knowledge, wealth and collection with fellow enthusiasts, while drinking wines valued for their collectability. The rarity of the wines, and the even rarer chances to actually drink them, meant that almost no one in the world knew what eighteenth-century wines were supposed to taste like – this would prove key to passing off newer wine as an eighteenth-century product. Rodenstock was a friend and colleague of Christie's wine expert Michael Broadbent, who was the only person to authenticate the Jefferson Lafite Malcolm Forbes had bought at Christie's back in 1985.

Koch began investigating the Jefferson Lafites and Hardy Rodenstock, a story told in *The Billionaire's Vinegar* by Benjamin Wallace. A bottle was tested in 1991 using carbon-dating, and the wine inside was found to have much higher levels of carbon-14 and tritium than an eighteenth-century bottle should have, suggesting

that it was either much younger than 250 years old or had at least been 'topped up' with younger wine so the bottle would appear fuller. Scientists determined that the wine inside came from a variety of sources, and at least half of it dated from after 1962. But another Jefferson Lafite bottle was tested using a different method, looking for traces of cesium 137, an isotope formed only as the result of nuclear testing in the atmosphere. This bottle's wine contained no cesium 137, proving that the contents were not produced in the atomic age (post-1943).

It seemed that the contents of the Jefferson Lafite bottle were not what they claimed to be, but what of the bottle itself, with its famous inscription? Jim Elroy, an FBI expert in identifying the tools by which markings were made, examined Koch's Jefferson Lafite bottles. In the eighteenth century, inscriptions would have been carved into a wine bottle using a copper wheel, which produced an irregular cut. The tool expert was suspicious that the inscriptions on the bottles were regular, and slanted in a way that a copper wheel could not produce. His best guess was that they had been made by an electric dentist's drill.

This story is far from clear. While *The Billionaire's Vinegar* implied that Hardy Rodenstock had actively forged rare wines, creating fake bottles and injecting them with fake wine, this has not been proven. Michael Broadbent, the Christie's wine expert who was accused in the book of improper behaviour with regard to his declarations of authenticity, won an official apology from the book's publisher, Random House, in 2009. Rodenstock maintains his innocence and has cautiously avoided any statements or situations in which he could be implicated or brought to trial.

Experts say that the problem of fake wine is almost exclusively within the narrow realm of rare wines. But incorrectly-labelled bottles of wine earn criminal income through quantity rather than quality. The head of Sotheby's wine department joked that more 1945 Mouton was drunk in 1995, the fiftieth anniversary of the vintage, than was ever produced in the first place, while Sotheby's wine expert Serena Sutcliffe told the *New Yorker* that most wealthy collectors would rather not know about the fakes. This is a phenomenon that one finds throughout the art world. As long as something is not shown to be a fake, it is authentic. If it turns out to be fake, someone has been duped, losing money and losing face. There is, therefore, an at least subconscious desire on the part of the art world to *will* questionable objects to be authentic.

FORGERY IN CHINA: JINGDEZHEN AND THE FALSE ARMY

An army of thousands of life-size clay statues of soldiers lay sleeping where they were buried, in the tomb of the first Emperor of China, until they were accidentally discovered by a farmer digging a well in 1974. Since their discovery, the Terracotta Warriors have become China's iconic artwork, drawing millions of tourists. For the first time, the Chinese government permitted some of the original Terracotta Warriors to travel for exhibition in the West in 2007. Several prominent exhibitions were held, most notably in the British Museum in London. But with the fanfare came scandals. The security at the British Museum exhibition was so poor that a political activist was able to place surgical masks over several of the warriors on display. Not only did no alarms go off, but museum-goers had to search for a guard to inform them of the prank. While the mask incident was relatively innocuous, other scandals surrounding the Terracotta Warriors have shaken the art world.[4]

On 25 November 2007, the Museum of Ethnology in Hamburg, Germany, launched a high-profile exhibition entitled 'Power in Death', featuring ten original Warriors, alongside nearly one-hundred modern copies. But on 19 December 2007, it was suddenly announced

Terracotta Warriors on display in Hamburg's 'Power in Death' exhibition in 2007

that the exhibition would close. The museum had been accused of exhibiting fake Terracotta Warriors, while claiming that they were 2,200 year-old originals.[5] The accusations also implicated other German museums that had mounted exhibitions in Leipzig, Stuttgart, Erfurt and Nuremberg.

The Hamburg museum posted warnings that the objects may not be authentic, but on further investigation all of the warriors were found to be contemporary copies. With the public outraged, the media leapt on the case. Was this a conspiracy on the part of major national museums to trick the museum-goers into buying tickets to an exhibition of frauds? Or was China somehow to blame, having intentionally sent fake statues that managed to fool top museum experts?

The man who alerted the police to the Hamburg forgeries was German art dealer Roland Freyer, a founding member of the Leipzig-based Centre of Chinese Arts and Culture (CCAC), which organizes international exhibitions of Terracotta Warriors, including the Hamburg show. Freyer had fallen out with the CCAC, claiming that he personally had an exclusive contract to organize Terracotta Warrior exhibitions until 2012. Freyer claimed that the Shaanxi Provincial Bureau of Cultural Heritage, responsible for loaning Terracotta Warriors for foreign exhibition, knew nothing of the Hamburg exhibition and had sent no original statues to Germany. A representative of the Shaanxi Provincial Bureau of Cultural Heritage claimed to have only heard about the Hamburg exhibition from the television news.[6]

It remains uncertain as to whether Chinese authorities had knowingly sent copies, if the CCAC or the Shaanxi Provincial Bureau of Cultural Heritage was guilty of something sinister or if the whole thing was the result of a high-profile misunderstanding. But the probable source of most of the Terracotta Warrior copies is no mystery. It is the world's leading producer of both antique and modern copy ceramics: the Chinese city of Jingdezhen.

In the twelfth century, the Song dynasty settled their imperial potters in Jingdezhen, a location with access to abundant natural clay. The city in China's Jiangxi province turned the craft of porcelain into a world-renowned art form. At its peak in popularity, during the Ming (1368–1644) and Qing (1644–1911) dynasties, Jingdezhen porcelain was prized throughout the world. All of the Imperial Ware, made for the emperor's court and therefore most valuable to collectors, was made in the factories of Jingdezhen. Some

Ceramics on sale in Jingdezhen, China, also known as the 'Porcelain Capital'

60 percent of the city's 1.4 million residents are employed in the ceramics industry. The city is home to 150 ceramics factories and 100 kilns, producing 10,000 pieces of ceramic per day, resulting in $100 million in annual legal sales. This is where Ai Weiwei's 100 million ceramic sunflower seeds, which were scattered on the floor of the Turbine Hall in the Tate Modern in a 2010–2011 exhibition, were made. Since the Ming dynasty, Jingdezhen has been the leading producer of porcelain in the world.[7]

But it is also a city dedicated to creating reproductions that look old. The concept of 'fake' is a Western import. In China, older art has always been considered more desirable, so great Chinese artists have always copied the work of their predecessors, trying to create works that would be perceived as older than they were. What was antique was of greatest value, so the legitimate art trade in China involved copying ancient works.[8]

As you walk along the city streets in Jingdezhen, past alleyways lined with wooden buildings and factories spiked with chimneys erupting coal smoke, some 80 percent of all the goods that you see for sale are fake. That estimate comes from a consensus among gallery owners, dealers, locals and police – but some observers believe that up to 95 percent of goods are actually modern copies, manufactured locally using ancient methods.

Attributed to Dong Yuan, *Riverbank*, 907-960, hanging scroll; ink and colour on silk, 220.3 × 109.2 cm (86 ¾ × 43 in), Metropolitan Museum of Art, New York

The Ming and Qing craftsmen specialized in contemporary imitations of famous ware made for the imperial court. There was no stigma attached to a copy, and no requirement that an artwork be unique in order to be collectible, as has long been the case in Europe. But contemporary Chinese collectors, as well as the hordes of Western buyers who crave Jingdezhen ceramics, have inherited the expectations of European collectors. They demand rarity and authenticity, and will not settle for copies, no matter the quality or artistic tradition from which they emerge. The first Chinese law against counterfeiting and piracy came only in 2004 – mainly to satisfy Westerners – but it has been infrequently enforced. China tends to feel that copyright policing is less important than keeping people employed and products affordable, so a blind eye is often turned to questionable activities.

Expertise in Chinese ceramics is no guarantee against being tricked by a fake. Pieces end up in major world museums and private collections thanks to honest recommendations from experts. In 1997,

the Metropolitan Museum of Art in New York purchased a group of Chinese paintings, including one entitled *Riverbank*, which the museum claims is an extremely fine and rare millennium-old painted silk scroll. Many scholars believe not only that the Met has been fooled, but also that they know the forger – a colourful character named Zhang Daqian (1899–1983). A prolific artist of both original and fake works, Zhang Daqian was said to have authored 30,000 paintings.

Because Chinese art experts are frequently unable to tell masterful fakes from original antiques, criminals can hide behind the excuse of having been fooled themselves. Chinese art is particularly vulnerable to fraud, because it rarely comes with a provenance.

In China, only licensed dealers are officially permitted to sell antiquities, which is not the case in most Western countries. Works of Chinese art are normally authenticated by examining the 'chop', a detailed Chinese character used to sign ancient pieces. But chops can be forged using computer technology and digital imaging. Modern ceramics can be convincingly 'aged' through low-tech methods such as intentional breakages and repairs, burial and excavation (Michelangelo's preferred technique) and baking ceramics to induce craquelure.

Thermo luminescence (TL) is the best available method for authenticating ceramics. The process involves heating a sample of powder scraped off a ceramic object. The powder releases a thermo-luminescent signal that determines how long it is since the ceramic object was fired in a kiln. But even this high-tech procedure is no longer foolproof, as forgers have been known to inject radioactive material into ceramics to throw off the TL sensors.[9] Experts must therefore fall back on connoisseurship – but we have seen how relying on fallible opinion can be dangerous. In the case of the Hamburg exhibition, all of the museum's experts were fooled.

It remains unclear who was responsible for the Terracotta Warriors exhibition fraud. There may have been a simple linguistic confusion in the semantic distinction made by Chinese art dealers between 'authentic' and 'antique'. 'Authentic' means that the objects are made using traditional methods in a style that should make them difficult to distinguish from original antiques: only the patina of age separates an authentic piece, which might have been made last week, and a 500-year-old 'antique'. When the Chinese authorities agreed to ship 'authentic' Terracotta Warriors, perhaps Hamburg thought this meant they were original while the Chinese thought they were modern copies made in the authentic manner?[10]

Artist studios in Dafen, China, are filled with copyists producing works ranging from Old Masters to contemporary artists

The fact remains that, in terms of intellectual property law, which deals with matters like art fraud and artistic trademark, China is the Wild East, with little to no restrictions and an entirely different attitude to the antique and the authentic than that of the West. The potters of Jingdezhen have their equivalents in the painters of Dafen, a city of approximately 1 million whose population churns out copies of paintings in every style imaginable, and varying in quality from excellent to tacky.

POWER

Most of the forgeries that have been covered thus far have affected the art world. This chapter goes beyond fine art to examine forgeries that were implemented by those in search of power – and that often changed history. There are mundane examples of false archival material being planted in real archives, as in the case of the Priory of Sion, but some of these cases cannot be dismissed as pranks. The pamphlet entitled *Protocol of the Elders of Zion* was woven together by racists from works of fiction, but convinced enough people of its falsehoods that murders have taken place because of it. The cases in this chapter show how, even though the objects involved in frauds have been exposed as forgeries, they have a continuing power. Most enjoyed a period – sometimes years, sometimes centuries – when their authenticity was completely believed and they became entrenched in the popular consciousness. Regardless of scientific proof that they are fakes, many people refuse to believe that they are not authentic and of huge importance. This demonstrates that even forgeries that are found out have the ongoing power to change history – just as the forgers had hoped.

—

WHEN FAKES CHANGE HISTORY:
THE DONATION OF CONSTANTINE, THE PROTOCOL
OF THE ELDERS OF ZION AND THE PRIORY OF SION

The Donation of Constantine is a Latin manuscript supposedly written in the fourth century AD. It suggests that Emperor Constantine 'donated' all of the Western Roman Empire to the Roman Catholic Church, in thanks for having been cured of leprosy by Pope Sylvester I, an account wonderfully illustrated in the fresco cycle at the Church of the Santissimi Quattro Coronati in Rome.

Detail of a fresco of Constantine with marks on his face appealing the Saint Sylvester, Church of Santi Quattro Coronati, Rome

The manuscript was forged to appear to precede the eighth century Donation of Pepin, in which the Carolingian emperor, Pepin the Short, bequeathed to the Lombards the territory north of Rome (roughly what is now called Lombardy). The Donation of Constantine was an attempt to contradict the Carolingian claim to lands throughout Europe. It gave the Church and the Pope all of the land in Italy and elsewhere in Western Europe, helping make the Church now the wealthiest private institution in the world. If the Donation is a fake, then that land was never meant to be owned by the Church.

One of the Vatican Library's own experts, a Latin scholar named Lorenzo Valla (1407–1457), wrote *De falso credita et ementita Constantini Donatione declamatio*. Valla showed that the Donation of Constantine could not possibly be authentic, based on his analysis of the Latin grammar employed by its author, which was clearly of the eighth century rather than the fourth.[1]

Although Valla was employed by the Vatican, he went public with his discovery because his primary patron, Alfonso of Aragon, was involved in a territorial dispute with Pope Eugene IV. That the Donation was almost certainly a fraud, created specifically to contradict the authentic Donation of Pepin, was a lever which Valla's employer could wield against the Pope. Valla's book was a popular read among Protestants, as it demonstrated the illegitimacy of Papal holdings: Thomas Cromwell even had an English translation made and published in 1534.

When the English edition came out, the Vatican placed Valla's text on its Index of Forbidden Books. This guaranteed, inadvertently, that it would increase in popularity. But the idea that the Church would scramble to cover up the discovery by one of its own staff of a forgery in its library shows just how important the document was. However, no-one was in a position to push the Papacy out of the territory it had occupied for centuries, so whether or not the Donation was real, false or an eighth-century adaptation of a lost fourth-century original, the Vatican territories remained.

The pamphlet known as the *Protocol of the Elders of Zion* is a short text written around 1903. It purports to describe a combined Jewish/Masonic plot to take over the world, through the control of finance and the media. It is considered the first modern piece of conspiracy theory literature, but it also represents a most dangerous hoax. It stirred a genuine belief in its invented conspiracy, a belief that fueled anti-Semitism, racism, violence and even murder.[2]

The authors of the Protocol remain a mystery. Most of the passages in the text were copied almost word for word from earlier published works of non-racist political satire. The most commonly quoted had nothing to do with racism at all: an 1864 humorous pamphlet, published in France by Maurice Joly, called *Dialogue in Hell Between Machiavelli and Montesquieu*, using humour to attack Napoleon III. The rest of the text was taken from Hermann Goedsche's 1868 novel *Biarritz*, which did have an anti-Semitic theme.

The Protocol was officially disproven in a 1921 investigation. Since then, only those looking for fuel to sustain their hatred of other races have chosen to believe that it contains any truth. But from the Nazis to the Ku Klux Klan to a raging, drunken Mel Gibson, who shouted anti-Semitic quotes from the text when he was arrested in 2006, the document has remained a weapon for the racist and the ignorant. Racists and racist institutions through the mid-twentieth century cited the Protocol as a historical document that 'proves' the global Jewish conspiracy.

The front cover of the Czech edition of the *Protocol of the Elders of Zion*, 1900

What John Drewe did to art archives, the authors of the remarkable and bizarre Priory of Sion forgery did to the renowned Bibliothèque Nationale in Paris, infecting an important historical library with fraudulent material that had a purpose worthy of Dan Brown's novel *The Da Vinci Code* that made the Priory famous: the fraudulent secret society was created by a man who wanted to become king of France.

Trailing prior convictions for confidence tricks, Pierre Plantard hatched a plan during the 1950s to re-instate the French monarchy, and to plant information that would suggest that he was the heir to the throne. The Priory of Sion was first mentioned on 20 July 1956, when Plantard officially registered the organization in France to lobby for the reinstatement of the monarchy.[3]

Between 1961 and 1984 Plantard invented and planted clues regarding a mythical pedigree for the Priory. Plantard and fellow members of his new organization began forging historical documents and hiding them in France's national library, laying a trap for future scholars. The false documents suggested that the Priory of Sion was an ancient organization entrusted with a great secret linked to the Knights Templar. Even better for the popular imagination, the documents included a list of the supposed Grand Masters of the society, which featured the names of such celebrated figures as Sandro Botticelli, Leonardo da Vinci, Victor Hugo and Isaac Newton. Because the documents indicated that the heir to the French monarchy was none other than Pierre Plantard, he soon fell under suspicion for the forgery and was eventually brought to trial for fraud.

The trial took place in France in 1993, and Plantard admitted to the entire scheme. Letters from the 1960s produced at the trial explicitly detailed Plantard's ideas and his methods of faking pedigree and combatting skepticism. It was all a hoax.

Plantard succeeded in fooling a handful of over-enthusiasts, who took what he fed them and ran with it. Ironically, while not intended to be a hoax, the content of the best-selling novel *The Da Vinci Code*, which resuscitated the myth of the Priory of Sion, was taken by millions of readers as fact.

FORGING LANGUAGES FROM LEAD: PETRICEICU-HASDEU AND THE SINAIA DACIAN LEAD PLATES

The lessons drawn from art and cultural artefact forgery are largely the same, provided that the primary value of the objects in question is non-intrinsic. In the case of the Dacian lead plates, the authenticity of which is still debated by scholars, the objects themselves, leaden blocks, have little artistic value.[4] But they may represent something very significant indeed, in terms of nineteenth-century nationalism and the history of language.

Bogdan Petriceicu-Hasdeu (1836–1907), born Tadeu Hasdeu, was a scholar, philologist and noted linguist, conversant in an astonishing twenty-six languages. Born to a family of minor Moldovan nobility in what is now Ukraine, he moved to Romania in 1863 and began writing *Arhiva historica a Romaniei* (Archival History of Romania), which was distinguished as the first published history book to use sources in both

Slavonic and Romanian. He went on to publish a respected book on Trajan's Column in Rome and numerous other scholarly books, including histories of Romania and an encyclopedic dictionary of the Romanian language (though he only got through letter 'b').

Hasdeu became involved in a debate over whether or not Romanian was a Latinate language (as it is considered today). He concluded that Romanian was of Slavic origin, but that Slavic words were frequently displaced by Latin ones in what linguists call the 'theory of words' circulation'. In 1876 Hasdeu was appointed head of the State Archives in Bucharest and two years later professor of philology at the University of Bucharest.

At an unknown date after 1875, Hasdeu claimed to have discovered approximately two hundred lead plates in a warehouse of Romania's Museum of Antiquities in Bucharest. The plates contained writing in the Greek alphabet, but the language was not Greek, nor indeed a language ever seen before, although scholars could discern in the text the names of ancient Dacian kings as well as ancient place names in what is now Romania. Experts concluded that this was a lost language – the language of the Dacian tribe that settled in Romania before being colonized by the Romans under Trajan in 106 AD.

Much has been learned of the original Dacian language since the discovery of the lead plates.[5] It seems to have been in the Indo-European family of languages and it likely reached the region of the Carpathian Mountains in around 2500 BC. But while scholars have found writings *about* the Dacians, largely Roman and Greek histories, no lengthy texts have been discovered *in* Dacian – all that remains of the language are a handful of individual and place names and very short phrases copied down by Latin and Greek scholars. The language survived in spoken form until as late as 600 AD, but little more is known about it. It was only in 1977 that Romanian scholars used comparative linguistic methods to decipher some Dacian, based on the ancient names. Back in the nineteenth century, therefore, the Sinaia, or Dacian, lead plates, appeared to be a major anthropological discovery.

The lead plates were roughly rectangular, aside from one round plate, and of various sizes. They were written in *scriptio continua* Greek with several additional letters, including the Latin 'v' and a 'c' and 'g' resembling Cyrillic. They also contained numerous illustrations in a traditional antique style. One set of images showed an alliance made between Dacians and Scythians, while another showed a genealogy of the Dacian royal family.

One of the alleged Dacian lead plates

The images and text were largely convincing as ancient work – but the story behind them was not. Few observers believed they were authentic, even in the 1870s. They had no provenance, having conveniently been 'discovered' in the warehouse, and they looked new. A story developed that they had been made in 1875 as copies of gold originals that had gone missing. This explained their discovery and new appearance, but there was no sign of the originals, nor any historical reference to them.

It then came to light that the lead in the plates had been made from recycled nails at a factory in Sinaia, Romania. The nineteenth-century origin of the lead plates was confirmed by a recent study of the thirty-five surviving plates (the others have gone missing), which are made of printing lead used in the second half of the nineteenth century. The plates could still conceivably have been cast from ancient originals, but a single word in the text renders them suspect. It is the Greek name for a town in Dacia, Comidava, which was described by the ancient author Ptolemy. However, in 1942, it was discovered that Ptolemy had miswritten the name of the town, which was actually called Cumidava.

Hasdeu is said to have discovered the plates – and most skeptical scholars now believe that he also designed them. They were printed in the Sinaia nail factory, but would have required extraordinary knowledge and patience in order to prepare the remarkably consistent and detailed text, and the perhaps even more impressive images. Hasdeu was one of the few scholars in Romania with both the knowledge and interest to pull them off.

Some aspects of the text in the plates also seem to support Hasdeu's theories about language, and this might suggest a possible motive for the forgery, if indeed it is a forgery. For example, the language on the plates is not what modern linguists would expect Dacian to resemble. It contains many words that are similar to modern Romanian and many that are close to Slavic words, but very few from what contemporary scholars believe is the ancient Dacian substratum. These eccentricities support Hasdeu's theory that Romanian is not a Latinate language but one that evolved from ancient Dacian.

The plates also contain several anachronisms that might confirm them as forgeries. One shows a battle scene with a cannon, but cannons were developed in China in the twelfth century and first appeared in primitive form in Europe and the Islamic world in the thirteenth century, long after the Dacian tribe was no more. That would seem to be conclusive – but a few clues also argue for the plates' authenticity. On one, the city of Sarmizegetusa is shown with a degree of accuracy that was only confirmed by archaeological excavations long after 1875. How could Hasdeu have depicted it so accurately before the ruins of the buried city had been unearthed? Likewise, an authentic Dacian medallion was found in the tomb of the Dacian King Burebista (d. 44 BC), inscribed in a language very similar to that of the plates but excavated only *after* the Dacian plates were discovered. Similarly inscribed gold plates have since been discovered in Bulgaria. Unless these too are forgeries – and there is no suggestion of that to date – they contribute to the authenticity of the Sinaia plates. Finally, the fact that the plates were written in the Greek alphabet actually contradicts Hasdeu's belief that the ancient Dacian alphabet was similar to the Hungarian one. The plates suggest that the written language of the Dacians, at least for official material, used the Greek alphabet.

There was no clear beneficiary from the discovery of the plates. Hasdeu himself considered them to be modern copies of authentic originals. In 1901 he noted his theory that a branch of the Dacian language lived on and morphed into Albanian, and referenced the plates in doing

so. But the plates were never considered to be authentic by enough scholars to permit their entry into the proper study of Dacian. They were so quickly disregarded that the thirty-five that still existed as of 2003 were deteriorating and not considered worthy of conservation.

The one thing that all scholars agree on is that the lead plates, if they are indeed inauthentic, represent a truly brilliant forgery designed by a scholar of the highest order, with a vast knowledge of archaeology, linguistics, history and ancient art. Circa 1875, Hasdeu fits the profile.

LITERARY FORGERIES AND MANUSCRIPTS: THOMAS CHATTERTON, THE INVENTION OF OSSIAN, FAKING SHAKESPEARE, THE HITLER DIARIES AND THE VINLAND MAP

Literature has been a fount of frauds that resemble fine art forgery in their motivations. Literary forgeries are often perpetrated to gain notoriety by passing off one's own work as the work of someone far more famous, which is ultimately about power, feeling important and having one's own theories proven, even if the proof is based on falsehood.

Thomas Chatterton (1752–1770) is best known as a poet who showed great promise but died tragically before his time, killing himself at the age of eighteen. The Pre-Raphaelites saw him as a Romantic figure who was too beautiful for this world. He wrote several original poems, but he is best known today for his forgeries of medieval-style poetry.[6]

Chatterton was raised in Bristol, England, and took a great interest in medieval church architecture, literature and documents. His uncle was sexton at a local church, Saint Mary Redcliffe, where the young Chatterton played among the collection of antiques. He began writing from age eleven, and published some religious poems in a local magazine called *Bristol Journal*. He would spend his days in the attic of his family's home, surrounded by old books and documents, many of which had been taken from the church after a new and unpopular churchwarden took over.

By age twelve, Chatterton had produced his first forgery, a poem in a fifteenth-century style which he passed off as original, convincing the usher at his boarding school of its authenticity. At this stage, Chatterton could hardly be considered a 'forger' in any real sense – he was simply a precocious young man trying to get away with

something. But his work was convincing linguistically, likely because of his avid reading and his study of the *Dictionarium Anglo-Britannicum*, which gave him an appropriate lexicon.

By 1769, aged fifteen, Chatterton had adopted the pseudonym of Thomas Rowley, a fifteenth-century monk of his own invention. That year, he sent a copy of *Rowley's History of England* – his own work – to the famous antiquarian Horace Walpole, who for some years believed that he was in possession of a hitherto unknown Renaissance text. Chatterton continued to publish under the name of Rowley and other pseudonyms, writing both histories and political commentaries. He made some money from these texts, which were published in various journals, but he was likely a clinical depressive. He took his own life on 24 August 1770, after shredding all the documents that remained in his room, destroying his life's work. The only likely rationale for his forgeries was personal satisfaction and the empowerment of getting away with something, having older and theoretically wiser people admire something they would have been unlikely to consider it if they knew it had been produced by a teenage boy. It was about power and feeling important.

In 1777 a Chaucer scholar named Thomas Tyrwhitt published a book entitled *Poems Supposed to Have Been Written at Bristol by Thomas*

Henry Wallis, *Chatterton*, 1856, oil on canvas, 62.2 × 93.3 cm (24 ½ × 36 ¾ in) Tate, London

Rowley and Others in the Fifteenth Century, in which he discussed the works as authentic. Thomas Warton included the fictional Rowley in his 1778 *History of English Poetry*. Not everyone was fooled, however, and the debate as to the works' authenticity was published in Andrew Kippis' 1789 *Biographia Britannica*.

Young Chatterton had made a small stamp on English literary history by confusing a handful of scholars, but it was the bizarreness of his life and his early death that really captured the popular imagination. Percy Shelley referred to Chatterton in his poem 'Adonis', as did William Wordsworth in 'Resolution and Independence'. John Keats' poem 'Endymion' is dedicated to his memory, and Samuel Taylor Coleridge penned 'A Monody on the Death of Chatterton'. That death scene, a beautiful young man surrounded by shredded poems, was painted by Henry Wallis and made a lasting impression.

In the 1760s the Scottish poet James Macpherson published what he claimed was a group of ancient epic poems that he had gathered and translated from Scots Gaelic, passed on by oral tradition for centuries. The original poet was Oisin, anglicized to Ossian, the son of Fionn mac Cumhaill (anglicized to Finn McCool), a mythical–historical figure from Irish mythology. The idea that a Celtic equivalent to Homer might have once inhabited the British Isles greatly appealed to Romantic Britain.

The Ossian poems were published in Macpherson's *Fragments of Ancient Poetry, Collected in the Highlands of Scotland and Translated from the Gaelic or Erse Language*. The following year, 1761, Macpherson claimed to have found another poem by Ossian, published as *Fingal* in 1762. The process culminated in the 1765 publication of *The Works of Ossian*. But even when the poems were first published, it was generally assumed that they were the original work of Macpherson, and that his attempt to convince the public that he was merely the translator of an ancient epic was fraudulent.

The poems, whether by Macpherson or the mysterious Ossian, were a great success, counting Thomas Jefferson, Walter Scott, Goethe, Mendelssohn and Napoleon among their admirers. They were translated into many languages and inspired numerous paintings. Their content aside, the story behind them – the idea of a lost series of epic poems passed down, through word of mouth, for centuries in the dark Scottish forests – greatly appealed to Romantics and empowered Scottish nationalists.

Anne Louis Girodet-Trioson, *Ossian Receiving the Ghosts of Fallen French Heroes*, 1805, oil on canvas, 190 × 180 cm (74 ⅞ × 70 ⅞ in), Musée National du Château de Malmaison, Paris

A debate over authenticity began as soon as the poems were published, and went beyond literary concerns. Irish nationalists argued that Ossian was as much, if not more, Irish as he was Scottish, and that Macpherson was wrong to appropriate him for Scotland. Forgery claims flew as well. The great author Samuel Johnson stated that Macpherson was 'a mountebank, a liar, and a fraud, and that the poems were forgeries'.[7] When Johnson claimed that the poems themselves were poor, he was asked, 'Do you really believe that any man today could write such poetry?' He replied, 'Yes. Many men. Many women. And many children.' But Johnson met counter-arguments, most prominently in the form of Hugh Blair's *A Critical Dissertation on the Poems of Ossian* (1763), which supported the poems' authenticity. The following year an Irish scholar, Charles O'Conor, again questioned the authenticity of Ossian, in *Remarks on Mr. Mac Pherson's translation of Fingal and Temora*.

These debates continued for centuries. In 1952 the poet Derick Thomson argued that Macpherson likely did collect aspects of oral traditions, but that he had converted them into his own, largely original work, which he introduced as being by Ossian. Historian Hugh Trevor-Roper, in his 2008 *The Invention of Scotland*, largely agreed. In the end, it seems that the Ossian poems, and the mythical–historical figure of Ossian himself, were the inventions of James Macpherson, who made a fortune from them, empowered both himself and his nation and greatly influenced two centuries of scholarship on epic poetry.[8]

While Thomas Chatterton invented Rowley and James Macpherson seems to have invented Ossian, another Romantic-era Englishman re-invented himself as Shakespeare. William Henry Ireland (1775–1835) wrote poetry and Gothic novels, but he will forever be known as the Shakespeare forger for his short-lived attempts at penning a play that the world would think was by the Bard of Avon.

Shakespeare's plays were as acclaimed as ever in the late eighteenth century and performed regularly in London. Ireland's father, Samuel, was a publisher of travelogues and an avid collector of Shakespeariana – and thus faced the frustration that no document exists that can be definitively attributed to Shakespeare's hand. This lack of material evidence has given birth to many conspiracy theories, leading some commentators to conclude that such a great writer could not disappear from the earth traceless, and that therefore the author must, in fact, be someone else, writing pseudonymously. While there are contemporary records of a William Shakespeare of Stratford-upon-Avon, the lack of tangible 'relics' has lead to reams of scholarship, dozens of books – and a series of alternate-author theories ranging from the intriguing (Sir Francis Bacon) to the bizarre (the idea that Shakespeare was Christopher Marlowe's pen name, used after faking his own death, or that Shakespeare was actually Queen Elizabeth I in disguise).[9]

Ireland's father collected Shakespeare plays and other memorabilia but naturally could not find what he most wanted – a document in Shakespeare's hand. His son, meanwhile, was familiar with the stories of Thomas Chatterton and James Macpherson, and perhaps influenced by them began to toy with basic forgeries during his legal apprenticeship, for instance practicing signatures.

In December 1794, Ireland excitedly told his father that he had located a stash of documents belonging to an anonymous colleague. One was a deed that included the name of the Earl of Southampton, and that was signed with the name 'Shakespeare'. William asked his father to take a look. His father was naturally thrilled, and his enthusiasm meant that he did not look too hard at the document in question.

Ireland began to make more 'discoveries', coming up with several other documents ostensibly in Shakespeare's hand. These included a declaration of his adherence to the Protestant religion, which seemed to settle a long-standing debate among scholars who wondered whether Shakespeare had been a crypto-Catholic; a promissory note; a letter to Queen Elizabeth; and a letter to Anne Hathaway (Shakespeare's wife), which even included a lock of hair. Claiming

that all these treasures came from the same stash, Ireland also produced books that were meant to have marginal notes written by Shakespeare, plus the original manuscripts for *King Lear* and *Hamlet*.

Reeling with delight, Ireland's father prepared the documents for publication, along with his own scholarly commentary. The resulting book, entitled *Miscellaneous Papers and Legal Instruments under the Hand and Seal of William Shakespeare,* was published on 24 December 1795, and soon became the talk of London. The reception was split. Some, including Samuel Johnson's friend James Boswell, hailed it as the literary discovery of the century, but many others expressed their suspicions from the start. Shakespeare scholar Edmond Malone published a response to Samuel Ireland's book, *An Inquiry into the Authenticity of Certain Miscellaneous Papers and Legal Instruments*, refuting the claims of authenticity over four hundred pages.

Hubris led to Ireland's undoing. Flush with confidence, he determined to take the fraud one step further. He wrote an entire new play, entitled *Vortigern and Rowena*, meant to be a manuscript in Shakespeare's hand. A lost play by Shakespeare would have been the

Frontispiece from Edmond Malone's book, *An Inquiry into the Authenticity of Certain Miscellaneous Papers and Legal Instruments, Published Dec. 24, MDCCXCV and Attributed to Shakespeare*, published in 1796

greatest discovery of all, but it was also ludicrously difficult to pull off. The Irish playwright Richard Brinsley Sheridan bought the rights to produce the new Shakespeare play in London for £300, a large sum at the time, plus a guarantee that the Ireland family would receive half the profits. Sheridan, however, did note that the play was rather simple and inelegant compared to Shakespeare's other works, and the actor–manager of the Drury Lane Theatre, John Philip Kemble, also expressed doubts about the play's authenticity during rehearsals, suggesting that opening night be on April Fool's Day. Samuel Ireland did not take kindly to this idea, and the play opened on 2 April, three days after Malone's dismissive book was published.

On opening night, the audience listened attentively – if perhaps disappointedly – for the first three acts. It was said that Kemble intentionally repeated a line on stage to express his belief that the play was fraudulent: 'And when this solemn mockery is over'. The final two acts went downhill and the audience, stacked with pro-Malone disbelievers, shouted the actors off the stage. It was the one and only performance.

THE QUINTAIN SEAL.

Frontispiece from William Henry Ireland's book, *The Confessions of William Henry Ireland* published in 1805, showing an engraving of William Shakespeare's forged signature on the Quintain seal

Critics condemned Samuel Ireland as the forger of all of the Shakespeare material, but shortly thereafter William Henry Ireland published a complete confession, *An Authentic Account of the Shaksperian Manuscripts* [sic.], primarily to clear his father's name. Ironically, no one believed that a young man like Ireland could pull off such a daring scam. His reputation shattered, Samuel Ireland died in 1800.

Wishing to make posthumous amends, William Henry Ireland published *The Confessions of William Henry Ireland* in 1805, but still he was either disbelieved or disdained. He would lead an unhappy life, eventually publishing *Vortigern and Rowena* as his own play, but to no acclaim.[10] For a few years he had felt important and powerful, and had relished the attention and joy he brought to his father. Financial rewards followed, but his was a crime of power, though it ultimately led to ruin, 'a tale told by an idiot, full of sound and fury, signifying nothing'.[11]

In April 1983 the German magazine *Stern* published selections from what were said to be the newly discovered private diaries of Adolf Hitler. The magazine had paid the huge sum of 10 million deutschmarks for sixty slim volumes, plus an additional book specifically about Rudolf Hess' defection to England. The books were thought to represent the personal diary of Hitler from 1932 to 1945.

The desire to get inside the mind of Adolf Hitler was nothing new. Countless biographies and novels had tried to map his mania, but the diaries promised something altogether different: the thoughts of the man himself.

A journalist at *Stern*, Gerd Heidemann, claimed to have received the diaries from a Dr Fischer, who had smuggled them out of East Germany. They were said to have been part of a cache of documents recovered from an airplane crash near Dresden in April 1945. The division of Germany and Berlin at the time made it easier to believe and harder to check the story.

Even so, the company that owned *Stern*, Gruner and Jahr, carefully took its time, fearing the possibility of a scam from the start. They acquired the diaries in secret, over a period of a year and a half, and commissioned three different handwriting analyses from impartial sources in Europe and the United States. All three confirmed that the diaries were in Hitler's own hand.

The company was satisfied enough to purchase the diaries, and did no further forensic tests. The desire for secrecy, and fear of leaks,

meant that publications offered the chance to bid on translation rights, including *The Times of London* and *Newsweek,* were only shown small sections. The British historian Hugh Trevor-Roper was sent by *The Times* to Switzerland, to study the diaries and other Hitler material, ostensibly all salvaged from the same plane crash. He was convinced, and argued for the authenticity of the material in *The Times.* It would be an authentication that he would not live down.[12]

Concerns over the diaries' authenticity were voiced within days of their first publication. The press conference held by *Stern* to launch the publication was a hailstorm of questions and accusations. It took only two weeks for the German Federal Archives (Bundesarchiv) to announce that the so-called 'Hitler Diaries' were 'grotesquely superficial fakes'. They were found to have been made on modern paper and with modern ink – there had been no attempt to fool forensic examination, only to trick superficial assessors.

The diaries were also peppered with historical inaccuracies. Much of the content had been copied directly out of collections of Hitler's

Konrad Kujau holding volumes of the supposed 'Hitler Diaries' during his trial in 1984, after which he was sentenced to four and a half years in prison

published speeches. The majority of the archive that Trevor-Roper had been shown was likewise found to have been forged. Further examination by another handwriting analyst, Kenneth W. Rendell, confirmed that the diaries were 'bad forgeries, but a great hoax' and that 'with the exception of imitating Hitler's habit of slanting his writing diagonally as he wrote across the page, the forger failed to observe or to imitate the most fundamental characteristics of his handwriting'.[13]

The scandal was huge. Various editors who had been fooled resigned from their posts, and Trevor-Roper's career would be forever blemished. German investigators discovered that the team behind the forgery included Gerd Heidemann, who perpetrated the con and convinced his own magazine to buy the diaries, and Konrad Kujau of Stuttgart, who had been guilty of previous forgeries. The scam was about money, of course, but also about feeling empowered, throwing a false bone to a pack of media wolves so hungry and so thrilled that they seized the opportunity without examining it as closely as they should have. The two went on trial in 1984, and were sentenced to forty-two months in prison each. The money from the diary purchase was mostly lost: Heidemann seemed to have invested it in several homes, sports cars, jewellery and World War II memorabilia. Kujau, like many forgers before him, came out ahead in the end. After he served his sentence, he made a living selling 'original Kujau forgeries'.[14]

In 1965, Yale University announced that it had purchased a map purported to be the earliest of North America, made in around 1440, that depicted a Viking voyage to the continent in the year 1000. The map contains highly accurate coastlines of Greenland and Newfoundland – some would say too accurate for a document a thousand years old – and also features an inscription that tells the story of two Viking explorers, Leif and Bjarni Eriksson, who discovered what they called 'Vinland' (today a region on the coast of Canada): 'By God's will, after a long voyage from the island of Greenland … the companions Bjarni and Leif Eiriksson discovered a new land, extremely fertile and even having vines, the which island they named Vinland.'[15] If the map were real, then it documents the first European exploration of the New World, five centuries before Christopher Columbus and Amerigo Vespucci. The map itself would predate Columbus' first voyage by fifty-two years. If, that is, the map were authentic.

The map had been purchased on behalf of the university by

a wealthy donor in 1957 from a Swiss rare book seller, Laurence C. Witten, who claimed to have bought it from a friend, an Italian dealer in Spain, Enzo Ferrajoli. Witten believed Ferrajoli had acquired it from the respected dealer Don Luis Fortuny, although the provenance was unclear.[16] But Ferrajoli did not appear to be a man of good repute. He was eventually convicted for the theft of a large number of books and manuscripts from the library of the Cathedral of La Seo in Saragossa, Spain (Witten thought that he had been framed by the Franco government). Ferrajoli ultimately died of a heart attack while in prison, after hearing of his son's suicide. The true story of the map died with him.

The debate has raged since the 1960s, with scholars divided as to whether the map is authentic, a Renaissance forgery or a modern forgery. Complicating the plot, the Vinland Map was discovered together with a strange document called the 'Tartar Relation', a short text that tells of a European explorer's travels through Asia in a similar vein to the work of Marco Polo. Unlike the Vinland Map, this text is considered authentic to the fifteenth century.

The paper type and handwriting suggest that the Vinland Map and the Tartar Relation are leaves taken from the same manuscript. Since they were found together and sold together, this would make sense – except for the fact that the wormholes on the two manuscripts do not match.

Wormholes are holes in old books and manuscripts made by insects eating through the support. If the two manuscripts were both cut from the same book, the miniature burrows should line up. They do not. Some scholars believe that a forger mimicked the paper, handwriting, wormholes and style of the Tartar Relation and added the forged Vinland Map to it. But while the wormhole debate is a concern, the idea of forging such a map to place alongside an authentic fifteenth-century document sounds illogical.[17]

The story doesn't end there. Thomas Marston, a respected New Haven book dealer and friend of Witten, and also Assistant Keeper of Rare Books and Curator of Medieval Literature at Yale, gave a gift to Witten's wife, Cora, shortly after her husband acquired the map and the Tartar Relation. Marston's gift was a fifteenth-century manuscript of Vincent de Beauvais' *Speculum Historiale*. Marston explained that the pages were similar to the map and Relation, even down to the watermark, so he thought the Wittens might particularly like the book. As the Wittens were admiring their new gift, they noticed that the page size was *exactly* the same size as the map and Relation.

The Vinland Map is possibly the first map to show the New World,
dated c. 1434, but now mostly believed to be a modern fake,
27.8 × 41 cm (11 × 16 in), Yale University, New Haven

Thule ultima

Tatartati flauus

mentes inferioteu alrupti

Cenacio Rev

mare
Oceanum
Orientale

Insule
Sub aquilone

kitano

Gotyus

Imperiu Tartarorum

Margoq

Arzan

Tanaus

Mogali

Jmad

Mare
Tartarorum

magnus Rai

Zucani

Tartaria magalica

Postreme Infula

Samara

Terra
Indica

mare
Indicum

Blemundad

Jerusalem

Rev
Solhanus

Chara

mare
Judicum

Sineus
mons

Imperiu Baseg

Ethiopia

Gundar superior

Ethiopicus

Looking closer, they were shocked to find that if they placed the map at the front of the Beauvais book, and the Relation at the rear, then the wormholes matched perfectly. This seemed to be too much of a coincidence – but Marston's motivation for his gift was unclear.

Witten offered to sell the map and the Tartar Relation, which he had bought for $3,500, to Yale University for $300,000 (approximately $3 million today), and the university accepted. The deal was brokered by Marston, suggesting both a potential conflict of interests and that money have been a primary motivation for any hoax. But the scholars and collectors involved may likewise have simply been thrilled to have discovered what the world thought was the first map of North America.

The latest piece of evidence against the map came in 2001. A forensic analysis using Raman microprobe spectroscopy found that the ink of the Vinland map was a modern carbon-based pigment which had a modern titanium-based pigment added to it to simulate the appearance of old iron-gall ink. For most scholars, that proved conclusive: the Vinland map was a modern forgery, while the Tartar Relation was authentic and from the Beauvais book. But the official position of Yale University remains equivocal, and some scholars maintain that the map is the real deal.

FAKE RELICS: THE JAMES OSSUARY AND THE SHROUD OF TURIN

The Middle Ages saw a lively trade in fake religious relics. There are so many pieces of the so-called True Cross that one could build a small village from them, and there are enough leg-bones of any one saint that one might think they could perform in a circus. At the time, however, there was no way of knowing whether or not bone or cloth shards came from a particular saint. Coupled with a demand for religious relics among believers who felt empowered in their faith by seeing tangible proof – whether in the form of miracles or physical remnants of holy men and women – this was a ripe situation for confidence men to flourish.

The scale of the trade in relics – fake and ostensibly authentic – rose dramatically with the Crusades. The Fourth Crusade in 1204, in particular, saw the redistribution of religious relics from the sacked Orthodox Christian city of Constantinople, with major objects such as the Shroud of Turin and the Holy Lance looted by Christian

knights and brought home to Western Europe. It required no leap of the imagination for pious Europeans of all backgrounds, incomes and educational levels to believe that any knight or foot soldier might have acquired this or that relic while on Crusade.

In the pantheon of Catholic relics, there are few more renowned than the Shroud of Turin. A linen cloth thought to have been used to wrap the body of Christ as he was prepared for burial – and apparently bearing his image – the Shroud is still a major tourist attraction, both secular and religious.

And yet, as early as the fourteenth century, a bishop wrote to the pope demanding that the Vatican declare the Shroud a fake. In the twentieth century, the Shroud was subjected to scientific analysis, a hugely rare event for a religious relic, and the thirteenth-century bishop's suspicions were confirmed. It appeared to have been created – painted – in around 1300 in order to look like an ancient relic. But that has not stopped tourists, pilgrims and conspiracy theorists from stoking the intrigue surrounding one of the most famous objects in the world.

The cult of a miraculous cloth began around the same time as the bishop's suspicions were raised, the thirteenth century. The legend of the Veronica Veil, a *sudarium* (literally a 'cloth for sweat') that Veronica was said to have proffered to Christ on his way to his crucifixion, does not appear in the Bible. The story goes that Christ wiped his blood-stained brow and handed the cloth back to Veronica – and that the cloth, or veil, miraculously retained an image of Christ's face upon it. It became one of the most important relics held at the Vatican, where it is still venerated, although the public is not permitted to see it.

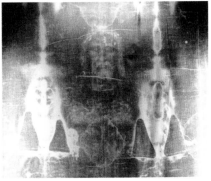

The Shroud of Turin under normal light (left) and under x-ray light (right), in which the outline of Jesus is clearly visible

The Veronica Veil story was largely disseminated by the hugely popular group biography of the saints called *The Golden Legend* (published in 1260) by the thirteenth-century Archbishop of Genoa, Jacobus da Voragine (1230–1298), which was the best-selling book in medieval Europe after the Bible itself. The Veronica Veil story, as related in *The Golden Legend*, became part of the apocrypha: stories that are not in the Bible, but that are associated so closely with the life of Christ that most people assume they are indeed from the Bible. Jacobus himself ends his relation of the Veronica Veil story with a caveat: 'And hitherto is this story called apocryphum read. They that have read this, let them say and believe as it shall please them.'

A sculpture from the studio of Bernini showing Veronica holding her 'veil' or mandylion, in Saint Peter's Basilica, Rome

The Shroud of Turin rises from the tradition, launched largely by the popularity of the Veronica Veil, of an *acheiropoieta*: a spontaneously-generated image not made by human hand. In particular, the Shroud is associated with a version of the Veronica Veil story in which a sick king was sent the veil, or *mandylion*, by Veronica and was miraculously cured.

The Shroud, a linen sheet of the sort that would wrap a body as it was prepared for burial, bears the imprint of a bearded man, arms folded across his groin. Most importantly, one can clearly see wounds in his wrists, as if he had been crucified. However, it is far easier to see the image in a photographic negative image – on the actual Shroud, the details are difficult to make out.

The first record of the Shroud came from Lirey in France during the 1350s, when the Lord of Savoy established a church dedicated to its veneration. It was said to have been brought to France from the Holy Land by a French knight, Geoffrey de Charny, who died at the Battle of Poitiers in 1356.

Pierre d'Arcis, Bishop of Troyes, wrote to Pope Urban VI in Avignon in 1389 requesting that the Shroud be declared a *false* relic. The bishop's rationale, art historian Martin Kemp writes in *Christ to Coke*, was that his predecessor as Bishop of Troyes, Henri de Poitiers, 'eventually, after diligent inquiry and examination' concluded that 'said cloth had been cunningly painted, the truth being attested by the artist who had painted it, to wit, that it was a work of human skill and not miraculously wrought or bestowed.'

The Bishop's word was insufficient to quell the enthusiasm of the worshipping masses to see relics, and nor did the active trade in fake relics. The Shroud remained part of the House of Savoy, and was a tourist attraction even in the sixteenth century, when it was moved to Turin so that pilgrims could see it more easily. There it has remained. In 1958, the Vatican officially approved of the Shroud as a legitimate means of Catholic devotion.

Martin Kemp, who authenticated Leonardo's *La Bella Principessa*, offers an art-historical analysis of the Shroud that does not support its authenticity. Kemp notes that the linen, had it been placed on a corpse, would have moulded itself around the body. When the linen was stretched flat afterwards, impressions of the flanks of the body, the top of the head and the soles of the feet would likely be seen, but on the Shroud only the front of the body is visible. Further, the limbs of the corpse are stick-like, and even the fingers look more like Gothic painted anatomy than any real body. Kemp suggests that, if asked to estimate the date of the Shroud as an *artwork*, he would suggest the late thirteenth or early fourteenth century.[18]

Kemp's analysis is borne out by scientific studies. In 1988 the authorities in Turin did something extraordinary: they permitted the Shroud to undergo scientific testing from three different international laboratories. Carbon-dating from scientific labs placed the Shroud circa 1300. The University of Oxford, University of Arizona and the Swiss Federal Institute of Technology all agreed that the Shroud dated from 1260–1390 AD, with a 5 percent margin of error. It appears that the Shroud was created around 1300 in order to look like an ancient relic. A separate study in 1979, by renowned forensic scientist Walter McCrone,

had suggested that the image of the body on the Shroud was made up of microscopic pigment particles, and therefore that the image had been painted with hematite, an iron oxide otherwise known as 'blood ore'.

The debate continues, as it will when objects of devotion clash with scientific studies, and when imagination and romanticism duel with empirical evidence. The forger surely succeeded beyond his wildest expectations, creating an object that has inspired devotion among millions over centuries. The bottom line is that belief in relics such as the Shroud is a choice that anyone is permitted to make, though so often we forget that the Church does not permit the worship of idols. Any image or relic is meant as a devotional aide through which one is brought closer to God – the object itself must not be worshipped.

The forgery of religious relics continues to this day. In 1976, the Israeli archaeologist Oded Golan claimed to have purchased a first-century-AD ossuary, a limestone box said to contain bones, from an antique shop in Jerusalem. In 2002 he applied for a permit to ship the ossuary abroad for exhibition in Toronto. He also showed it to André Lemaire, a scholar at the Sorbonne in Paris. Lemaire noted an Aramaic inscription on the outside of the box that Golan claimed not to have seen: *Ya'akov bar Yosef akhui di Yeshua* – 'James, the son of Joseph, brother of Jesus'. It suddenly occurred to both Lemaire and Golan that this might just be the ossuary containing the bones of James, believed to be the brother of Jesus Christ.

Lemaire published an article in *Biblical Archaeology Review* claiming that there was a very high probability that this was indeed an authentic inscription.[19] Golan, however, had not noted the inscription in his application for a permit to export the work – if it were indeed an important religious relic, then Israel would be less inclined to permit it to leave the country. The permit was granted, and the ossuary shipped to Toronto for exhibit.

Although Golan claims to have paid only $200 for the ossuary, he insured it for transport at $1 million. The Royal Ontario Museum to which it was shipped estimated its value at $2 million, because of its cultural significance. Suspecting that something was amiss, the Israeli Archaeological Association (IAA) began an investigation.

In March 2003, Israeli authorities arrested Golan on suspicion of forgery and dealing in fake antiquities. A board of IAA experts determined that, while the ossuary itself was an authentic artefact, the inscription was a modern addition. Thus it was a fake, not a forgery.

After the natural aging process that occurred to the limestone during centuries buried in a damp cave, the freshly-cut lettering of the second half of the inscription (which read 'brother of Jesus') on the back was covered with a homemade 'patina' based on a mixture of water and ground chalk. A five-man team of forgers, led by Golan, were suspected to have faked a number of biblical artefacts by adding inscriptions to authentic objects.[20] A search of a storage facility rented by Golan unearthed forged ancient seals and a series of inscriptions in various stages of production, as well as engraving tools and soil from excavation sites that would have been rubbed into the inscriptions to give the illusion of age and long burial.[21] But after a seven-year trial, Golan was acquitted, with insufficient proof of his proactive involvement in fraud – he was instead convicted of a number of lesser crimes, including 'possessing objects suspected of being stolen and selling antiquities without a license.'[22] The judge did not rule on whether or not the ossuary may be authentic. Whether or not Golan was proactively behind it, the various antiquities that had been tampered with to make them seem more historically significant than they were carries on a centuries-old tradition, and money may not have been the ultimate goal. Possessing what seemed to be a famous relic shot them into the headlines and brought them power, ephemeral though it proved to be.

The James Ossuary (stone burial box), which carries the inscription, 'James, son of Joseph, brother of Jesus'

SCIENTIFIC FORGERIES: THE PILTDOWN MAN AND THE ARCHAEORAPTOR FOSSIL

The same motivations that turn artists into forgers have also led scientists to 'discover' rather more than the natural evidence presents. The parallel motivations of fame and getting away with fooling a community of so-called experts also occur in the world of science.

One of the most famous cases began in 1912, when scientists learned of an unusual skull and jawbone said to have been excavated at a gravel pit in the town of Piltdown, in East Sussex, England. The bone fragments were purchased by collector Charles Dawson, and given the Latin binomial nomenclature *Eoanthropus dawsoni* in his honour. For several decades, it seemed that the fragments came from a previously unknown early homonid, a link between apes and *Homo erectus* that confirmed the theory of evolution. It was only in 1953 that 'Piltdown Man' was found to be a forgery: the lower jawbone of an orangutan had been coupled with a modern human skull.

Hybridizations of natural remains were nothing new in 1912. Collectors of natural curiosities during the Renaissance and Enlightenment gathered authentic wonders (Rudolf II of Prague kept

Charles Dawson (left) and Arthur Smith Woodward searching for fragments of the Piltdown Man at the gravel pit in Piltdown, Sussex, 1912

a giant octopus in a glass tank and had a gaggle of penguins running around his castle) alongside manufactured supernatural creatures. Narwhale tusks were sold as unicorn horns, and whale bones were thought to be from dragons.[23]

It is not always clear when an over-enthusiastic naturalist was guilty of nothing more than wishful thinking or when a crime was committed. Pre-modern scientists stumbling upon dinosaur bones might reasonably think that they had discovered the skeleton of a dragon – after all, what is a dinosaur, if not an embodiment of our concept of a dragon? Hanging behind the altar of the church of San Donato, on the Venetian island of Murano, are a pair of colossal bones that are called 'the Dragon Bones of San Donato', the saint who supposedly slayed a dragon by spitting on it. While the bones have not been scientifically tested, they almost certainly come from either a whale or a prehistoric skeleton. No one was wilfully practicing deceit when the bones were ceremonially arrayed in the church.

Some scientific forgeries run along similar lines, although in the case of the Piltdown Man the fraud was an active one. It was also one of the most enduring of scientific frauds, in that it succeeded for over forty years.

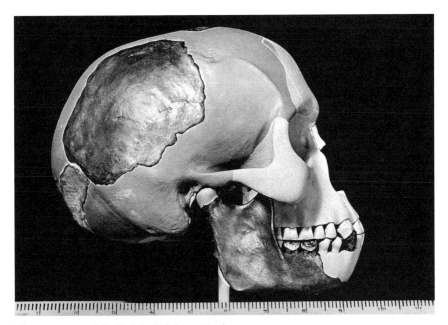

The reconstructed skull of the 'Piltdown Man'

The story began with Charles Dawson's announcement to the Geological Society of London on 18 December 1912, of his acquisition of the bone fragments. A workman at the site had found the skull, at first believing it to be a fossilized coconut. Dawson found further fragments at the site, and took them to the geology department of the British Museum. The curator there, Arthur Smith Woodward, studied the fragments for several months alongside Dawson. Their analyses were presented at the Geological Society meeting to great excitement.

Dawson claimed that the skull was remarkably similar to modern man's apart from the occiput (where the skull meets the spine) and the brain size, which was two-thirds that of a modern human. The teeth in the jawbone included two molars that looked indistinguishable from a chimpanzee's and ape-like canines. Dawson claimed that this new discovery seemed to provide an evolutionary missing link between apes and modern humans.

This assertion was contested from the start. While the British Museum and Dawson and Woodward had developed one reconstruction of the skull, the Royal College of Surgeons, led by Arthur Keith, produced a very different-looking one from copies of the same bone fragments in which the brain size was precisely that of modern man. This alternative reconstruction was called *Homo piltdownensis*, the word *homo* reflecting its nearer proximity to *Homo erectus*.

While searching the gravel pit in August 1913, Dawson, Woodward and a Jesuit priest called Teilhard de Chardin found a canine tooth that fit the jaw. Teilhard soon left to return to France and never again participated in the discoveries, a fact which struck some as suspicious at the time.

The canine seemed to fit perfectly with the jawbone, but its discovery raised further questions. Keith pointed out that human molars are meant for lateral movement, to grind food when chewing. The canine now integrated into the Piltdown jaw made no evolutionary sense, because its verticality meant that it would get in the way of the lateral movement that the molars required. The molars on the jawbone were worn down, meaning that they had been used extensively, but the canine that Dawson had added would, essentially, have blocked this creature from eating. Something was not right.

In 1913 David Waterson of King's College London solved the mystery of the Piltdown man hoax. In *Nature* magazine, he wrote that he believed the bones to be a combination of an ape's mandible with a human skull. French paleontologist Marcellin Boule published the

same conclusion in 1915, as did an American zoologist, Gerrit Smith Miller. In 1923, Franz Weidenreich noted that the skull was simply a human cranium and that the mandible was from an orangutan whose teeth had been filed-down. But it would take decades before this explanation was conclusively proven and believed.

In 1915 Dawson claimed to have found fragments of another skull, two miles from the gravel pit. This was referred to as 'Piltdown II' or 'the Sheffield Park find'. But now Dawson refused to reveal the exact location, even to his friend, Woodward of the British Museum. Many suspected that this was another fraudulent find.

Dawson died in August 1916, at which point Woodward presented the new Piltdown Man II discovery as if he had found them himself. President of the American Museum of Natural History, Henry Fairfield Osborn, declared that the two finds, Piltdown and Piltdown II, belonged together 'without question'. The second Piltdown fragments seemed to confirm the authenticity of the first ones, at least for the majority of interested observers reading the newspapers. But now Dawson, the only man who knew the truth, was dead.

Scientists, however, were not so convinced. Piltdown Man did not fit with other fossil and evolutionary discoveries. Either this was some strange mutation of the ape-to-man continuum, or it was a fake.

The hoax was definitively proven in *Time* magazine, but not until 1953. Evidence gathered from a wide array of renowned scientists proved that the Piltdown Man bones came from three distinct species: a medieval human skull, a five-hundred year-old lower mandible of a Sarawak orangutan and the fossilized teeth of a chimpanzee. The skull was the only piece of bone that had actually been discovered at Piltdown. All fragments had been 'aged' by being bathed in iron and chromic acid. Microscopic examination showed that the molars had been filed down with a metal file, to make the chimpanzee teeth look more human.

The forger has never been identified, although Charles Dawson is the main suspect. Woodward at the British Museum and the French Jesuit Teilhard were also possibly involved in the conspiracy. A later examination of Dawson's once-renowned natural history collection found thirty-eight certain fakes, including other species 'discovered' by Dawson, such as *Plagiaulax dawsoni*, teeth from a purported hybrid mammal/reptile. Other fakes and frauds included the Pevensey bricks, which were supposedly the last datable discovery from Roman Britain; flint from the Lavant Caves, a fake mine; the Beauport Park statuette,

a fake Roman-era iron statue; the Brighton 'Toad in the Hole', a real toad inside a piece of flint; and a fake Chinese bronze vase. Dawson was thought to have been behind all of them, motivated by his renown as a collector and amateur scientist, and by the attention that accompanied the discoveries.[24] The greatest harm caused by the fraud was that, for several decades, scientists wasted time investigating a step on the evolutionary ladder that did not actually exist.

The archaeoraptor fossil seen under ultraviolet light to make the fossilized bones more visible

A similar fraud was perpetrated in 1999. A fossil found in China was featured in *National Geographic*, which described it as a missing link that showed an evolutionary bridge between birds and terrestrial dinosaurs.[25] Only recently have palaeontologists determined that dinosaurs have more in common with birds than with lizards, after which they were named (dinosaur means 'terrible lizard'). But although scientists agreed that birds are the most direct descendants of dinosaurs, the Chinese fossil offered definitive proof. That made it a major coup – but sadly, also a false one. A team of scientists in 2002 published verification that the 'archaeoraptor fossil', as it became known, was a fake.[26] Like Dawson's Piltdown Man, it had been constructed, Frankenstein-like, from pieces of real fossils from different species. The tail was that of a winged dromaeosaur; the body was that of a prehistoric bird, Yanornis; the legs and feet belong to an unidentified dinosaur of a different species.[27]

The scandal certainly hurt reputations, not least that of the storied *National Geographic* magazine, but it also brought to light a lively trade in illegally-excavated or forged fossils coming out of China. The forgery was not even particularly adept – in retrospect it seemed evident to palaeontologists that this 'missing link' was in fact a cobbled-together jigsaw of other fossils. But the hunger to find tangible proof for 'missing link' theories allowed the archaeoraptor fossil and the Piltdown Man skull to enjoy the authentication of experts and considerable success, before they were ultimately found out.

DIGITAL TECHNOLOGY: THE FORGER'S ALLY AND ENEMY

Digital technology is changing the landscape of forgery and authentication, making life both easier and more difficult for forgers. On the one hand, the low cost and high quality of digital printers, and the manipulative abilities of software like Adobe Photoshop, mean that computers can be used to forge certain types of art. Works on paper, especially prints (with twentieth-century lithographs the most-frequently forged type of art), can be extremely difficult to distinguish from matted and framed computer printouts.

Vernon Rapley and his team at Scotland Yard's Arts and Antiques Unit once confiscated a forged Banksy, made using modern spray-paint, thick modern paper and a stencil. It was selling online for tens of thousands of pounds.[28] As an experiment, Rapley's team attempted to reproduce the forgery, buying all of the necessary materials from a local DIY shop. The total cost of materials was about £6. The stencil was made simply by using Adobe Photoshop to trace an image of the Banksy painting found online and render it the correct size to match the originals. The result was what may be the ideal object to forge: one that demonstrates just how easy some of these are to make; not necessarily requiring the craft and ingenuity of the master forgers.

The experiment proved particularly interesting because it was scientifically impossible to distinguish the forged Banksy spray-painting from an original. Materially, it was identical, made from precisely what Banksy would have used. To the eye it was also identical – after all, these works were made by stencil. And it was an intelligent object to forge, because the works were produced in multiples – not on a massive scale, but with enough copies out there to make them relatively affordable and not so rare as to raise suspicions should one come on the market.

The Internet has also aided fraudsters as a market for art. For every high-profile forger such as Ely Sakhai or John Myatt, there are dozens if not hundreds of smaller-time forgers, like the makers of the Banksy, who approach their art in a more basic manner – often without artistic skill or elaborate provenance – but who are nevertheless remarkably successful. These are the forgers who do not make the headlines, who are not artist-magicians, but simple, pragmatic criminals. They rely on small galleries, car boot sales, wayward antiques markets and that anonymous criminal playground called the Internet.

Log on to an online auction website on any given day, and you may well come across something labelled as 'Roman coin' or 'Pre-Columbian figurine.' These works are, almost without exception, either looted or fake. This is a reasonable assumption because any genuine Roman coin or Pre-Columbian figurine would fetch a far higher price were it sold through a gallery or auction house. Online sales are ripe for criminal activity because the object for sale cannot be examined in person, the buyer forced to rely on images and a description that may or may not correspond to the actual object. Sellers may remain anonymous, therefore mitigating risk.

But while the digital universe has made life easier for forgers, it also has the potential to make their work difficult, if not altogether impossible. The cost of forensic testing has fallen to the point at which it is not unreasonable to expect a set of forensic tests to accompany any important object put up for sale. It is largely out of habit and the inertia of tradition that the art trade still relies first on connoisseurship and the opinion of experts. It need not be this way, and any buyer serious about protecting an investment would do well to insist on forensic tests (which reputable dealers and auction houses should perhaps supply automatically for works valued, say, above six figures). More casual forgers might be dissuaded from testing the market, if they know that a battery of scientific tests inevitably awaits. Eric Hebborn's forgeries *would* defeat most scientific tests, but he is the exception. John Myatt, Shaun Greenhalgh, Ely Sakhai: none of their works would have withstood basic tests, but they were never subjected to them because they looked good enough and they employed the provenance trap so successfully that it never occurred to anyone to bother with scientific tests.

Elaborate, hi-tech approaches to examining art have been available for years and are constantly improving, but they tend to be used infrequently, and mostly in conservation efforts. Engineers

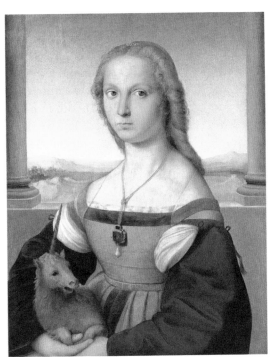

Raphael, *Lady with
a Unicorn*, c. 1506,
oil on panel, 67.8 × 53 cm
(26 ⅝ × 20 ⅞ in),
Galleria Borghese, Rome

such as Maurizio Seracini look to solve art-historical mysteries through science, for instance using infrared spectrometry to look behind the surface of famous paintings like Leonardo da Vinci's *Adoration of the Magi*, where it was discovered that someone hundreds of years ago had painted over a detail by Leonardo of a church being built out of the ruins of a pagan temple – a nod to the fact that Christianity is largely based on pre-existing pagan religion.[29] Such thinking would have been considered heretical in Leonardo's time, so someone painted over the detail, either in outrage or to protect Leonardo's reputation. Seracini likewise unveiled the fact that Raphael's *Lady with a Unicorn* was not originally painted with a unicorn at all. Raphael's original had no pet in the lady's lap.[30] Someone later added a lap dog cradled in her arm, and someone later still added a horn to the dog to transform it into a unicorn. Art historians studying the painting for centuries have thought that the unicorn was an indication that the lady in the portrait was a virgin, for legend has it that only virgins can approach a unicorn without it fleeing. All of the careful iconographic analysis was undone, and the painting must be reconsidered, thanks to this discovery.

Conservation and technology firms like Factum Arte employ elaborate two-and-three-dimensional scanning systems to provide noncontact image recordings of artworks. They have developed technological innovations to deal with specific problems that conservators might encounter, for instance making a scanner that can capture images from delicate rare books when the books are open less than 90 degrees and a three-dimensional scanner that captured the entirety of Tutankhamun's tomb in Egypt. Scans of sufficient quality preserve art that may physically deteriorate and make it accessible to students and enthusiasts who cannot necessarily see the works in person.

High resolution scans can also reveal unnoticed clues, as in the discovery of a laughing figure in the background of Jan van Eyck's *Adoration of the Mystic Lamb*, perhaps meant to be Satan, which seems to have eluded centuries of art historians. Displayed in an over-sized protective glass case, one cannot physically get close enough to the painting to see this figure with the naked eye. But when the Getty Conservation Institute began a restoration of the altarpiece, it produced a billion-pixel image, as well as infrared, ultraviolet, and x-ray images of every panel of the altarpiece, available online that led to the discovery.[31] This technological investigation was also able to confirm that Jef van der Veken's copy of the stolen 'Righteous Judges' panel is, indeed, a copy, and not the stolen and painted-over original, as some had thought (see p. 53).

Factum Arte takes its scanning capabilities a step further and employs specialized printers alongside hands-on artists to create facsimile artworks and artefacts for conservation and research purposes, as well as for museum exhibitions. These grand (and expensive) projects are undertaken in collaboration with national ministries of culture and museums, and include creating pinpoint accurate reproductions of relief sculptures, including the entire eastern end of the throne room of Ashurnasirpal II, based on an original at the British Museum; a full-size scan and reproduction of Veronese's colossal painting, *Wedding at Cana*; a facsimile of an entire room in the tomb of Thutmose III; and a gilded bronze lion, based on a lead copy that had stood for centuries in place of the original, which was lost in a fire at the Alcázar in Madrid. Pixel-perfect, these facsimiles go further than the works of generations of artist/copyists before them (see p. 15) in challenging our assumptions of authenticity. However, one can see how such advances in scanning and printing, in two- and three-dimensions, could be used, in the wrong hands and with the criminal intent, to forge and deceive.

Factum Arte team scanning Veronese's *The Wedding at Cana*, at the Louvre, Paris in November – December 2006. A facsimile from the scans was created in the monastery of San Giorgio Maggiore, Venice, the painting's original home

New digital technology is available that could deter forgers against schemes to steal a work and swap it for a forgery (as in the case of the Matisse *Odalisque*, see p. 153), and also allows owners to identify a work as their own if it is ever stolen and recovered. A team led by Dutch engineer and conservator Dr Bill Wei, of the Netherlands Institute for Cultural Heritage, have developed a system for 'art fingerprinting', a means of identifying a unique object. Called 'Fing-Art-Printing', the system uses an extremely powerful digital camera to photograph a miniscule section of an object, as small as a 3.5 mm square.[32] The area photographed is known only to the technician and the object's owner. The photograph is then processed through software that measures tribology, the roughness of the photographed surface, down to one micron (one one-thousandth of a millimetre). Although colour might change over time, roughness is less likely to alter, and so matching the rough-to-smooth ratio of an object's surface is the most reliable means of identifying it. The technology is so precise that it can map textures even in surfaces that seem not to have any visible texture, such as glazed ceramics, silver-gelatin photographic prints or even bullets.[33]

The tribology is translated into a colour map (in which blue is used for low, smooth sections and red for high, rough ones), and software can compare this to another photograph taken using the same technology. This art fingerprinting is non-destructive and non-contact, and it is also inexpensive, requiring only the software, the camera and a mechanical arm to position the camera precisely. It could certainly be a staple of any significant museum's conservation study. Matisse's *Odalisque* would have been found out immediately. There is no forger on earth who would be able to reproduce, down to one micron, the texture of an original, even if they knew the tiny spot photographed for testing. However, someone would first have needed to notice that something looked odd about the *Odalisque* in order to think to have it tested. While digital technology might have the capability to defeat forgers it is, at the end of the day, down to a fallible person, an expert, to prompt a closer look.

Standardized forensic testing, the strategic use of powerful new digital imaging technology and the independent testing of the provenance attached to an object could well bring about an end to high-end forgeries. It is up to buyers, collectively, to insist upon such services – and perhaps to pay for them, for the art trade is not likely to volunteer.

CONCLUSION

...SO LET IT BE DECEIVED

The art of telling lies skilfully...
– Aristotle

Having journeyed through the history of forgery, and into the minds, motivations and methods of individual forgers, we might now step outside the inner psychology of the forgers and into the social context within which they operate.

Art forgery appears to be an unthreatening and victimless crime – or rather, one that affects only wealthy individuals and faceless institutions. But this is a media construct, of course, and we have seen why it is important to the preservation of pure and true history to curb forgers and identify forgeries. There is also a general indulgence toward forgers on the part of the general public, and so there is little popular pressure on law enforcement bodies to dedicate resources to fighting them – so police tend not to take forgery seriously.[1]

Similarly, there is a distinct lack of disincentives for potential criminals to try their hand at forgery. This is perhaps most obvious

Wolfgang and Helene Beltracchi at the premiere of the German film made about their story – *Beltracchi: Art of Forgery*, 2014, a clear demonstration on the promise of fame that may await art forgers

in the cases of John Myatt and Wolfgang Beltracchi, both of whom served a minimal amount of time in minimum-security prisons, and both of whom enjoyed lucrative careers following their exposure. The prison sentences for forgers tend to be so slight, and the popular interest in them so great, that it may seem well worth a year or two in a minimum-security prison to then emerge as a sort of folk hero with a rewarding career. It may not make sense for forgers to be locked away for extended periods of time – excessive prison sentences have not been proven to dissuade even serious criminals[2] – but with such potential rewards, and even a career in the limelight if you are caught, there is little reason not to give forgery a go.

If anything, the media fascination with forgers provides an active incentive for those considering forgery. If the media collectively sternly condemned forgers rather than applauding their exploits, it would be a step in the right direction. Likewise, if the media agreed not to publish the names or photographs of forgers, nor images of their handiwork – the publication of which offers forgers a route to celebrity – it would have a similarly dissuasive effect.[3] Such a collective agreement on the part of major media players remains highly unlikely, however.

Similarly most countries have no laws to prevent a convicted forger from profiting from his work, which would be a powerful disincentive. It would discourage many of the amateur artists seeking glory from fraud if they knew that getting caught would mean that they could no longer sell any of their art, regardless of whether or not they signed their own name to it. This promises to offer a more effective disincentive than short prison sentences.

Given that most art today is authenticated by provenance, and that the provenance trap is the way so many forgeries are passed off as originals, provenance itself requires closer scrutiny.[4] Middlemen tend to search for provenance when they encounter a new object, because the more information they can find about the background of an object, the better: it will likely sell for more if buyers are comfortable with both its authenticity and its legitimacy of ownership. But we have seen that provenance traps are built precisely to exploit this attitude of 'the more provenance the better'. One must be careful to check that provenance associated with an object is both authentic (as in *not* forged, as was the provenance in the Myatt and Drewe affair) and that it actually corresponds to the object in question (and was not appropriated from some other authentic objects, as in the provenance traps of Ely Sakhai and the Greenhalgh family). Perhaps what is needed is an independent,

objective provenance researcher to investigate the provenance associated with an object with a critical eye? The key would be for the provenance researcher to have no vested interest in the sale of any object, unlike dealers and auctioneers, who benefit from finding that an object in question is authentic. This, as we have seen, can encourage them – if only subconsciously – to *wish* the object authentic, and therefore to skim over its questionable attributes. An independent provenance researcher, approaching each piece of provenance with professional scepticism, would be shielded against the allure of the treasure hunt that ensnares so many enthusiastic experts. This would go some way to impeding future provenance traps, making life more difficult for forgers.

The piece of fake provenance that eventually led to the discovery of the Beltracchi forgery ring – a purported label from the Collection Flechtheim, but it was known that the collector Alfred Flechtheim never placed labels on his artworks

Consider, for a moment, the content of this book. All of it is carefully researched, but what if one of the forgers in this book were fictitious? What if I had taken a note from the narrative trick used by Orson Welles in his film, *F for Fake*, in which one part of the otherwise truthful film was an intentionally-inserted piece of fake history? We tend to accept what we read as fact, and in a cited, edited book written by a professor specializing in a field and published by a publishing house, it is fair to assume that everything presented in the book is true (don't worry – at least in this case, it is). But does this not sound suspiciously like the very sort of thinking through which buyers convince themselves to rely on expert opinion and acquire

a work of art that may or may not be authentic? Swap out 'publishing house' and insert 'auction house', and swap out 'professor' and insert 'art historian', and the point makes itself. In the world of books and academia, citations function like pieces of provenance, lending bonafides to ideas and backing up stated facts. But someone must check to ensure that the cited sources do indeed relate to the facts they purport to support, just as provenance must be checked to make sure that it corresponds to the object to which it has been attached. Over-reliance on the word of others can mislead.

In addition to independent provenance research, another idea to protect buyers, if not curb forgers, is 'art authenticity insurance'. If a buyer could take out insurance on a potential purchase that would guarantee reimbursement if the object turns out to differ from an expert's estimation – whether because it is a forgery or it was simply misattributed – then at least the buyer would be able to defend his or her investment. Such an insurer would send their own evaluator to examine the object prior to agreeing to insure it. That independent expert would have to concur with the attribution of the seller, in order to risk insuring the object. If at some future point the insured object were proven to be other than was believed, the insurance company would reimburse the buyer for the difference between the perceived and actual value of the object. This would have a similar effect to the provenance researcher, by squelching over-enthusiastic attributions and defeating provenance traps through the examination of a third party who is not financially bound to the sale of the object in question. The key is for an object to be evaluated by someone with no financial interest and for the provenance itself to be scrutinized with a critical eye rather than gratefully grasped, as so often happens within the art trade.

Ultimately, it is the buyer who provides a market for forgeries. The middlemen – auction houses, galleries, dealers, specialists – should know better and theoretically act as a filter, separating out the good art from the fake. But in practice, middlemen make mistakes and can profit even from selling forgeries. It is up to buyers to arm themselves with knowledge, get multiple opinions on any work and learn as much as they can about the sort of art they buy. Through greater knowledge of how forgers have succeeded, buyers can fortify themselves against future frauds. The shift should be from *caveat emptor* to *emptor scire*, from 'buyer beware' to 'buyer aware'.

There is, without doubt, an art to forgery, just as there is an art of a different sort to the confidence tricks and deceptions that so

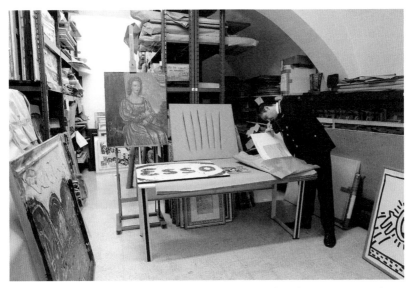

The bunker archive of the Carabinieri Department for Cultural Heritage Protection in Trastevere – the art crime unit of the Italian police force – where all fake and authentic artworks recovered from the black market are kept, Rome, 2013

often pass off art as greater than it actually is. But forgers are largely failed artists who are missing one component of greatness. It is inevitably the confidence trick that marks the moment when a crime is actually committed, and that most often passes off an object which, examined in a vacuum, would fool few. Greater defence against provenance traps, plus deterrents for artists against trying their hand at forgery, seem better ways forward than the hit-or-miss attempts of experts to identify forgeries through connoisseurship. While forgeries and misattributions are frequently revealed and corrected, forgers themselves are rarely caught – and so many who are caught seem to wish to be. By understanding the motives and confidence tricks of forgers and their accomplices, we might hunt out the source of the forgeries, rather than chasing the fruits of their labours.

Let no one doubt that forgeries can have serious consequences. The cases in this book show the power of attempting to rewrite history. Although the objects involved in these frauds have been clearly shown to be forgeries, belief in them endures. Regardless of the proof that they have always been fraudulent, many people refuse to believe that they are anything but authentic, and of huge importance. Even forgeries that are found out have the ongoing power to change history – just as the forgers had hoped.

NOTES

GLOSSARY OF
SCIENTIFIC METHODS
OF AUTHENTICATION

SELECTED BIBLIOGRAPHY

INDEX

ACKNOWLEDGEMENTS

NOTES

INTRODUCTION

1. For more information on Dürer's career and forgeries of his work, including the copies by Marcantonio Raimondi, see Lisa Pon, *Raphael, Dürer, and Marcantonio Raimondi: Copying and the Italian Renaissance Print* (New Haven, 2004).

2. Raimondi prepared the prints for what is considered the first pornographic book, *I Modi* (*The Positions*) with text by Pietro Aretino (first published in 1524). In addition to this saucy work, he is best known as having legally made prints after the paintings of Raphael, the dissemination of which helped to bring Raphael international renown, beyond the scope of those who had seen his paintings in person, in Rome and Urbino.

3. Interview with Jane Ginsburg, 25 January 2012.

4. For more on other categories of art crime, see Noah Charney, ed., *Art & Crime: Exploring the Dark Side of the Art World* (Santa Barbara, 2009).

5. When the Roman Republican army sacked the Hellenistic city of Siracusa (modern Syracuse, in Sicily) in 212 BC, it launched a craze among wealthy Romans for collecting Hellenic art. The plunder from that city, in the form of sculpture and vases, became the talk of Rome. All of a sudden, it was a sign of great taste to decorate one's home with Hellenic art, and so a lively trade rose up to feed this demand. Some of this was fueled by war booty, some by theft, some by legal market transactions, and some by means of deceit.

6. Tradition held that the Crown had been part of the collection of the emperors of Byzantium since at least the sixth century, when Justinian sent a single thorn from it as a gift to Saint Germain, the bishop of Paris. When Saint Louis bought the Crown during the eighth crusade, it was part of the treasury of the cash-strapped Baldwin II, the Latin Emperor of Constantinople.

7. Jennifer Osterhage, 'Relics of Saints a Blessing to Basilica', *Notre Dame Magazine* (Spring 2004).

8. The cult of artists, collecting drawings, and how we conceive of art, its history

and how museums function is largely based on Giorgio Vasari's (1511–1574) ideas and writing on those subjects. For more, see Ingrid Rowland and Noah Charney, *The Collector of Lives: Giorgio Vasari and the Invention of Art* (New York, 2015).

9. There are only two documents that refer to a painting by Giorgione, both are now lost. One was dated to 1507 and was once in the Ducal Palace in Venice, the other from 1508 regarding frescoes he and Titian painted on the outside of the Fondaco dei Tedeschi in Venice, but which quickly deteriorated due to Venice's humidity. Other than a death date sometime in October 1510, there is no primary source documentary evidence that Giorgione existed – just references to him in texts such as Vasari's *Lives of the Most Eminent Painters, Sculptors and Architects* (1550). The idea that he might never have existed is not taken very seriously, but it demonstrates how little we know about some of the most important artists in history. For more, see Enrico Maria dal Pozzolo, *Giorgione* (Milan, 2009).

10. The most thorough account of the various debates over Van Gogh authenticity, including a detailed description of the Wacker trial, may be found in Henk Tromp, *A Real Van Gogh* (Amsterdam, 2010). Another good source is Modris Eksteins, *Solar Dance: Van Gogh, Forgery, and the Eclipse of Certainty* (Cambridge, MA, 2012).

11. Tromp (2010), p.43.

12. De Wild's biography is available online in Dutch: http://www.scribd.com/doc/27700781/Dr-Ir-Angenitus-Martinus-de-Wild-1899-1969

13. Quoted in Graeme Wood, 'Artful Lies', *The American Scholar* (Summer 2012)

14. One such 'forensic trap' is detailed in David Grann, 'Mark of a Masterpiece', *New Yorker* (10 July 2010). It involves the alleged planting of fingerprints and DNA evidence by Peter Paul Biro onto questionable artworks, as a means of establishing their authenticity. Biro sued the *New Yorker* for defamation without success, and the case was dismissed in 2013. The judge noted in his opinion that the article 'appears to be the product of an enormous amount of careful and diligent research'. See Mary Elizabeth Williams, 'Peter Paul Biro's Libel Case Against Conde Nast Dismissed', *Center for Art Law* (11 August 2013), available at http://itsartlaw.com/2013/08/11/peter-paul-biros-libel-case-against-conde-nast-dismissed/.

15. For example, we mentioned Giorgione's known oeuvre, which consists of twelve paintings and one drawing – of these thirteen works, only five are extant, meaning two-thirds are categorized as 'lost'. The term 'lost' is a catch-all for any works the location of which is unknown. This includes works known to have been destroyed, stolen works, or those literally misplaced or perhaps misattributed.

16. See Elisabetta Povoledo, 'Yes, It's Beautiful, the Italians All Say, but Is It a Michelangelo', *The New York Times* (21 April 2009).

17. An example of a latterly corrected misattribution can be found in the collection of Albert Barnes, which contains numerous Old Master paintings. Purchased in the first half of the twentieth century, Barnes relied on the advice of expert consultants for the Old Masters, whereas the majority of his collection, early twentieth century paintings, were made by artists whom he knew personally. All of the modern works in his collection stand up to their attributions, whereas most of the Old Master paintings were re-attributed only recently, and many have been down-sized from, for example, works 'by Rembrandt' to 'school of Rembrandt' or 'attributed to Rembrandt', because modern scholars could not be certain of their attribution.

18. Marjorie E. Wieseman, *A Closer Look: Deceptions and Discoveries* (London, 2010), p.12. The technical summaries in this book are largely drawn from Wieseman (2010) and then checked against Paul Craddock, ed., *Scientific Investigation of Copies, Fakes, and Forgeries* (New York, 2009) and other sources.

19. Wieseman (2010), p.20.

GENIUS

1. Ascanio Condivi, *Life of Michelangelo* translated by Alice Sedgwick Wohl, edited by Hellmut Wohl, (University Park, PA, 1999), notes on p. 128.

2. Ibid., p.21.

3. Giorgio Vasari, *Le vite dei piu eccellenti pittori scultori e architetti* (1568, ed. C. Ragghianti, 4 vols, Milan, 1942), vol. 3, p. 404.

4. This story appears in Frank Arnau, *The Art of the Faker: 3000 Years of Deception in Art and Antiques* translated by J. Maxwell Brownjohn (London, 1961); also in Victor Ginsburgh and David Throsby, eds., *Handbook of the Economics of Art and Culture*, vol. 1 (Amsterdam, 2006), p.276, and in various Luca Giordano biographies.

5. Information on the *Rospigliosi Cup* may be found in Joseph Allsop, 'The Faker's Art', *New York Review of Books* (18 December 1986); Russell, John 'As Long as Men Make Art, the Artful Faker will be with Us' in *The New York Times* (12 February 1984); and C. Truman, 'Reinhold Vasters, The Last of the Goldsmiths', *Connoisseur*, vol. 199, March, 1979, pp. 154–61. Information on Vasters may be found in Yvonne Hackenbroch, 'Reinhold Vasters, Goldsmith', *Metropolitan Museum Journal* (1984–85).

6. Information on Vasters' biography and Frederic Spitzer may be found in Christie's catalogue for the sale 6407, lot 37.

7. Information on André may be found in R. Distelberger, et al., *Western Decorative Arts, Part I Medieval, Renaissance and Historicizing Styles including Metalwork, Enamels, and Ceramics* (Washington, DC, 1993), pp. 282-304.

8. Quoted in Leslie Bennets, '45 Met Museum Artworks Found to be Forgeries', *The New York Times* (12 January 1984).

9. For more on this period in forgery, see Gianni Mazzoni, *Quadri antichi del Novecento* (Vicenza, 2001).

10. Icilio Federico Joni, edited by Gianni Mazzoni, *Le memorie di un pittore di quadri antichi* (Siena, 2004).

11. This is described by Joni in his memoir, the published 1936 English version of which had large sections expunged, including every reference to Bernard Berenson.

Joseph Duveen took the precaution of buying and destroying as many copies as he could, to minimize the spread of knowledge of the extent of forgeries coming out of Siena at the time. Copies of Joni's memoir, particularly the first 1932 Italian edition, are now rarer than his paintings, which hang in many major museums. For more, see Roderick Conway Morris, 'Masters of the Art of Forgery', *The New York Times* (31 July 2004).

12. Wieseman (2010), pp. 36–37.

13. The exhibition, 'Falsi d'Autore', was accompanied by a catalogue: Gianni Mazzoni, ed., *Falsi d'autore. Icilio Federico Joni e la cultura del falso tra Otto e Novecento* (Siena, 2004). The exhibition also has a website: http://falsidautore.siena.it/falsidautore/home.html.

14. Some of the material on Van der Veken may be found in Thierry Lenain, *Art Forgery: The History of a Modern Obsession* (London, 2011).

15. For more on art theft during World War II, Van der Veken and the complete story of *The Ghent Altarpiece*, see Noah Charney *Stealing the Mystic Lamb: The True Story of the World's Most Coveted Masterpiece* (New York, 2010).

16. For more detail on the stolen panel affair, see Charney (2010).

17. This translation differs from that originally published in Charney (2010), and represents an improved translation after consultation with Flemish sources.

PRIDE

1. This case is detailed in Wieseman, (2010). Many of the descriptions of scientific testing methods listed in this section and the glossary were adapted from this book and other sources.

2. Noah Charney, 'The Lost Leonardo' in *LA Times* (6 November 2011).

3. Martin Kemp, *La Bella Principessa: The Story of a New Masterpiece by Leonardo da Vinci* (London, 2010).

4. For further details, see Grann (2010) and note 14 in Introduction.

5. For a very good and complete account of this case, see John Brewer, *The American Leonardo: A Tale of Obsession, Art and Money* (New York/Oxford, 2009).

6. 'Expert Declares Hahn Picture Copy' in *The New York Times* (5 September 1923). This was one of a series of articles in *The New York Times* covering this court case in much detail.

7. 'Sotheby's to Offer Painting that Sparked Debate and Controversy' in *Art Daily*, available online at http://artdaily.com/news/35567/Sotheby-s-to-Offer-Painting-that-Sparked-Debate-and-Controversy.

8. For more on Dalí and Pitxot, see Stan Lauryssens, *Dalí & I: The Surreal Story* (New York, 2008).

9. Jason Edward Kaufman, 'De faux Dalí échappent au pilon: plutôt vendre des contrefacons que les détruire', *Journals des Arts* (March 1996).

10. This is according to statistics kept by the Art Loss Register, available through their organization by request.

11. For more on this, see Lauryssens (2008).

12. Karina Sainz Borgo, 'Dalí ese al que Breton llamo Avida Dollars', *Tendencias del Mercado del Arte* (18 April 2013).

13. For more on Basquiat's life and work, see Jordana Moore Saggese, *Reading Basquiat: Exploring Ambivalence in American Art* (Berkeley, 2014).

14. Grace Glueck, 'The Basquiat Touch Survives the Artist in Shows and Courts', *The New York Times* (22 July 1991).

15. Nora Sophie, 'How to Fake a Piece of Art: by Artist Alfredo Martinez' in *InEnArt* (22 November 2013), available at http://www.inenart.eu/?p=12787, and Anthony Haden-Guest, 'The Hunger Artist: A Jailed Basquiat Faker Goes Without Food so that He Can Make (and Sell) Art', *New York Magazine* (12 January 2004), viewable at http://nymag.com/nymetro/news/people/columns/intelligencer/n_9717/.

16. These two cases are detailed in Phoebe Hoban, *Basquiat: A Quick Killing in Art* (New York, 1999).

17. One of the rare sources of information on this case is Liza Ghorbani, 'The Devil on the Door', *New York Magazine* (18 September 2011), from which the main facts presented here are drawn. See also 'Lasting Legacy: Could Artist Jean-Michel Basquiat's Final Painting be on a Drug Dealer's Store Front?', *Daily Mail* (19 September 2011).

18. The Basquiat expert committee disbanded in January 2012, and some have wondered whether the debate over the door, just a few months prior, contributed to this decision. See Benjamin Sutton, 'Group that Authenticates Jean-Michel Basquiat Paintings to Disband' in *L Magazine* (18 January 2012).

19. Information on this case may be found in Richard Dorment, 'What is an Andy Warhol?', *New York Review of Books* (22 October 2009). This thorough article sparked a hot debate, printed in a series of letters and responses in the *New York Review of Books*, including a follow-up article published on 17 December 2009, and letters and responses published on 25 February 2010.

20. Rainer Crone, *Andy Warhol* (New York, 1970).

21. Dorment (2009).

22. This took place in the midst of the 'red scare', when the early days of the Cold War prompted witch hunts for suspected communists, led most famously by Senator Joseph McCarthy.

23. Michael Kimmelman 'The World's Richest Museum', *The New York Times* (23 October 1988).

24. Kimmelman (1988).

25. Thomas Hoving, *False Impressions, the Hunt for Big-Time Art Fakes* (New York,

1997), and various issues of *Connoisseur* magazine, which was published from 1901–1992 and edited by Hoving from 1981 to 1991, at which point it merged with the magazine, *Town & Country*. Other books have been written about Getty curators who knowingly purchased looted antiquities including Peter Watson and Cecila Todeschini, *The Medici Conspiracy: The Illicit Journey of Looted Antiques from Italy's Tomb Raiders to the World's Greatest Museums* (New York, 2007) and Vernon Silver, *The Lost Chalice: The Epic Hunt for a Priceless Masterpiece* (New York, 2010), to name but a couple.

26. Hoving (1997).

27. This story was popularized in the best-selling book, Malcolm Gladwell, *Blink: The Power of Thinking without Thinking* (New York, 2005).

28. William Poundstone, 'The Best Classical Sculpture in the World', *ArtInfo* (9 April 2013).

29. For more details on the authenticity debate from the Getty's perspective, see Ilse Kleemann, 'On the Authenticity of the Getty Kouros', *The Getty Kouros Colloquium* (1993). Hoving says that the price was $7 million, while an article in *The New York Times Magazine* states that it was between $9-12 million: Peter Landesman, 'A Crisis of Fakes: The Getty Forgeries', *The New York Times Magazine* (18 March 2001).

30. The most complete version of the criminal career of Gianfranco Becchina is detailed in Fabio Isman, *I Predatori dell'Arte Perduta* (Milan, 2010).

31. Neil Brodie 'The Getty Kouros', *Trafficking Culture* (20 August 2012), available at: http://traffickingculture.org/ encyclopedia/case-studies/getty-kouros/.

32. Geraldine Norman and Thomas Hoving, 'It Was Bigger than They Knew', *Connoisseur* (August 1987), pp. 73–78, and detailed in Hoving (1997).

33. Jeffrey Spier, 'Blinded by Science: The Abuse of Science in the Detection of False Antiquities', *Burlington Magazine*, vol. 132, no. 1050 (September 1990), pp. 623–631.

34. Quoted in Michael Kimmelman 'Absolutely Real? Absolutely Fake?', *The New York Times* (4 August 1991).

35. Thanks go to Peter Landesman's article, 'A Crisis of Fakes', *The New York Times Magazine* (18 March 2001), from which most of the factual information regarding the Getty drawings scandal is derived.

36. Peter Silverman and Catherine Whitney, *Leonardo's Lost Princess: One Man's Quest to Authenticate an Unknown Portrait by Leonardo da Vinci* (New York, 2011).

37. Landesman (2001).

38. For more on this, see John Evangelist Walsh, *The Bones of Saint Peter* (Bedford, NH, 2011).

39. Landesman (2001)

40. Ibid.

41. For more on this case, see Peter Watson 'How Forgeries Corrupt our Top Museums', *New Statemsan* (25 December 2000) and Bo Lawergren 'A "Cycladic" Harpist in the Metropolitan Museum of Art', *Source: Notes in the History of Art,* vol. xx, no. 1 (Fall 2000).

REVENGE

1. Most of the information on Van Meegeren may be found in Jonathan Lopez, *The Man Who Made Vermeers* (New York, 2009) and Edward Dolnick, *The Forger's Spell: A True Story of Vermeer, Nazis, and the Greatest Art Hoax of the Twentieth Century* (New York, 2009). There are many books on Van Meegeren, but Lopez' is the most complete and scholarly source.

2. For more on Göring's art collection, see Charney (2010) or Kenneth Alford, *Hermann Göring and the Nazi Art Collection* (Jefferson, 2012).

3. Serena Davies, 'The Forger Who Fooled the World' *Telegraph* (5 August 2006). This article provides a summary of another good book on Van Meegeren, Frank Wynne, *I Was Vermeer: the Legend of the Forger Who Swindled the Nazis* (London, 2006).

4. Davies (2006).

5. Abraham Bredius, 'A New Vermeer', *Burlington Magazine 71* (November 1937), pp. 210–211; 'An Unpublished Vermeer', *Burlington Magazine 61* (October 1932), p. 145.

6. Quoted in Davies (2006).

7. Quoted in Davies (2006).

8. Peter Schjeldahl, 'Dutch Master', *New Yorker* (27 October 2008).

9. Most of the information available on Eric Hebborn comes from his own books: Eric Hebborn, *The Art Forger's Handbook* (New York, 1996) and his autobiography, *Drawn to Trouble* (Edinburgh, 1991).

10. Information in this section, covering Hebborn's processes, comes from Hebborn, (1996).

11. Aristotle, *On Poetics*, translated by S. H. Butcher, available online at http://www2.hn.psu.edu/faculty/jmanis/aristotl/poetics.pdf, p. 34.

12. For the tendency in the media to praise forgers, consider Blake Gopnik, 'In Praise of Art Forgeries', *The New York Times* (2 November 2013), which prompted vituperative reader responses on 6 November 2013; or Jonathon Keats, *Forged: Why Fakes are the Great Art of Our Age* (Oxford, 2012).

13. Most of the information on this case comes from interviews conducted over several years by the author with Vernon Rapley, the former head of Scotland Yard's Art and Antiques Unit, and the man responsible for the arrest of the Greenhalgh family. There are numerous articles that detail the case, including David Ward, 'How Garden Shed Fakers Fooled the Art World', *Guardian* (17 November 2007) and Carol Vogel, 'Work Believed a Gauguin Turns Out to Be a Forgery', *The New York Times* (13 December 2007).

14. As told to by Shaun Greenhalgh to Vernon Rapley.

15. Deborah Linton, 'Humble Council House was Home to 10m Swindle', *Manchester Evening News* (17 November 2007).

16. As related by Vernon Rapley in conversation with the author.

17. This estimation is in terms of percentage of reported art crime cases that were resolved, with either the works recovered, criminals prosecuted, or both. The statistics on the recovery of art stolen in London are particularly noteworthy, as the next best statistics of which I am aware come from the Carabinieri in Italy, which nationally recover between 10–30 percent of art reported stolen.

18. Interviews with Rapley over the course of several years provide information on his work, as well as public lectures he has given.

19. The Metropolitan Police news online (20 October 2008), available at: http://content.met.police.uk/News/ArtBeat-Specials-hit-the-streets/1260267556420/1257246745756.

20. The facts of Keating's life are drawn largely from Keating's autobiography: Tom Keating, Geraldine Norman and Frank Norman, *The Fake's Progress: The Tom Keating Story* (London, 1977). A later article also covers the story, Donald MacGillivray, 'Whis is a Fake not a Fake? When It's a Genuine Forgery', *Guardian* (2 July 2005).

FAME

1. There are relatively few reliable sources on Malskat's career, so much of the factual information in this section comes from Arnau (1961), pp. 265–277; and Guy Isnard, *Les pirates de la peinture* (Paris, 1955).

2. Biographies of Elmyr are difficult to trust, as most of the stories of his early life came from him directly. Most of Elmyr's full story comes from Clifford Irving, *Fake! The Story of Elmyr de Hory: The Greatest Art Forger of Our Time* (New York, 1969), and articles that refer to it, and so the unreliability of the source is clear when we learn that Irving would later fake an entire biography – of a living person. A more reliable and recent book is the aptly-named Mark Forgy, *The Forger's Apprentice: Life with the World's Most Notorious Artist* (2012) and the documentary film, *Masterpiece or Forgery? The Story of Elmyr de Hory* (2006). Other sources include Ken Talbot, *Enigma! The New Story of Elmyr de Hory, The Most Successful Art Forger of Our Time* (1991), and a re-examination of his work may be found in Jesse Hamlin, 'Master (Con) Artist / Painting Forger Elmyr de Hory's Copies are Like the Real Thing', *San Francisco Chronicle* (29 July 1999).

3. Fraud definition may be found on dictionary.com.

4. Quoted in 'The Fabulous Hoax of Clifford Irving' in *Time* (21 February 1972). More on the story may be found in Stephen Fay, Lewis Chester and Magnus Linklater, *Hoax: The Inside Story of the Howard Hughes-Clifford Irving Affair* (London, 1972).

5. The majority of the information about Perenyi comes from his memoir, Ken Perenyi, *Caveat Emptor: The Secret Story of an American Art Forger* (New York, 2012), reviews of his memoir and the author's interview with him.

6. Colette Bancroft, 'Art Forger Lived High Life by Mastering Fakes to Foist on Collectors', *Tampa Times* (14 September 2012).

7. Patricia Cohen, 'Forgeries? Perhaps Faux Masterpieces', *The New York Times* (18 July 2012).

8. Quotations and this background story come from an interview that the author made with Perenyi in 2012.

9. Dalya Alberge, 'Master Forger Comes Clean About Tricks that Fooled Art World for Four Decades', *Guardian* (7 July 2012).

10. 'An Art Forger Tells All', interview on CBS News (3 March 2013), available at: http://www.cbsnews.com/news/a-forger-of-art-tells-all-03-03-2013/.

11. Quoted in Alberge (2012).

12. Quoted in CBS News interview (3 March 2013).

13. This quote appears on Perenyi's personal website: http://www.kenperenyi.com/, accessed August 2014.

14. An earlier version of this section was published as Noah Charney and Matthew Leininger, 'Not In It for the Money', *New Orleans Magazine* (October 2012).

15. Because this is such a recent case, there is no book as yet published on Landis. The best four summaries of the case are: Randy Kennedy, 'Elusive Forger, Giving but Never Stealing', *The New York Times* (11 January 2011); Helen Stoilas, ' "Jesuit Priest" Donates Fraudulent Work' *Art Newspaper*, Issue 218 (November 2010); John Gapper, 'The Forger's Story', *Financial Times* (21 January 2011); and Jesse Hyde, 'Art Forger Mark Landis', *Maxim* online: http://www.maxim.com/amg/stuff/Articles/Art+Forger+Mark+Landis. It is largely from these articles that this section is drawn.

16. I am most grateful to Matthew Leininger for his help with this section, for which he was interviewed by the author (17 January 2012). He is preparing a book on Landis which was not available to read at the time of writing, but the content of which he kindly shared with the author.

17. Stoilas (2010).

18. Gapper (2011).

19. Ibid.

20. Alec Wilkinson, 'The Giveaway', *New Yorker* (26 August 2013).

CRIME

1. Karl Decker, 'Why and How the *Mona Lisa* was Stolen', *Saturday Evening Post* (1932).
2. Simon Kuper, 'Who Stole the *Mona Lisa*?', *Financial Times* (5 August 2011).
3. In 1897 the Hearst Corporation sent the young Karl Decker to Cuba, as a reporter for the *Journal*, to help a woman who had been held for a year without charges, Evangelina Cisneros, break out of prison. Decker not only wrote a story but claimed to have been integral in bringing about the prison break. But suspicions arose shortly after Decker's account was published in the *Journal* that the escape was a hoax, or at least Decker's account of it was a hoax. For more, see W. Joseph Campbell, 'Not a Hoax: New Evidence in the New York Journal's Rescue of Evangelina Cisneros' in *American Journalism*, Issue 19 (Fall 2002).
4. For the complete story of the theft of the *Mona Lisa*, see Noah Charney, *The Thefts of the Mona Lisa* (2012).
5. Hugh McLeave, *Rogues in the Gallery: The Modern Plague of Art Thefts* (Raleigh, 2003), pp. 68–70.
6. http://www.museum-security.org/00/165. html.
7. http://www.newpolandexpress.pl/polish_ news_story-1641-stolen_monet_found.php (15 January 2010).
8. Monika Scislowska, 'Stolen Monet, "Beach in Pourville", Found in Poland After 10 Years', *Huffington Post* (18 March 2010).
9. As noted by Marianela Balbi and William Neuman 'Topless Woman Found. Details Sketchy', *The New York Times* (19 July 2012).
10. A good summary of this case may be found in Jonathan Jones, 'Matisse: Can You Spot the Fake?', *Guardian* (8 July 2014). A book on the case is also available: Marianela Balbi, *El rapto de la Odalisca* (Caracas, 2009).
11. Jones (2014).
12. Michael Sontheimer, 'A Cheerful Prisoner: Art Forger All Smiles After Guilty Plea Seals the Deal', *Spiegel Online*, (27 October 2011).
13. Lothar Gorris and Sven Robel 'Confessions of a Genius Art Forger', *Der Spiegel* (9 March 2012).
14. Joshua Hammer, 'The Greatest Fake-Art Scam in History?' *Vanity Fair* (10 October 2012). The German Federation of Art Auctioneers (*Bundesverband Deutscher Kunstversteigerer*) maintains a database of forgeries identified as by Beltracchi, purported to be from the fictional Jager Collection: http://service. kunstversteigerer.de/bdk/de/dkw/ katalog.pdf.
15. Sontheimer (2011).
16. Julia Michalska, 'Werner Spies Rehabilitated with Max Ernst Show in Vienna', *Art Newspaper* (28 January 2013); and http://artnews.org/ kwberlin/?exi=19126&&.
17. 'Ernst Expert Werner Spies Fined', Art Media Agency (20 June 2013): http:// www.artmediaagency.com/en/68077/ ernst-expert-werner-spies-fined/.
18. Michalska (2013).
19. Harry Bellet, 'L'historien d'art Werner Spies condamne pour avoir mal authentifie une toile de Max Ernst', *Le Monde* (27 May 2013).
20. Michalska (2013).
21. This information comes from an interview between Saskia Hufnagel and an investigator with the lka in Berlin, undertaken on 23 March 2012 and cited in Duncan Chappell and Saskia Hufnagel, 'A Comment on the "Most Spectacular" German Art Forgery Case in Recent Times', *Journal of Art Crime* (Spring 2012).
22. Art dealer Wolfgang Henze, who acquired a Beltracchi forgery, told the *Art Newspaper* that he was astonished that the public had fallen for Beltracchi's 'Albrecht Durer Christ act', which he considered 'disgusting': Julia Michalska, 'Sympathy Grows for Alleged Forgers', *Art Newspaper*, Issue 229, (November 2011).
23. 'Steve Martin Swindled: German Art Forgery Scandal Reaches Hollywood' *Spiegel Online* (30 May 2011).
24. Quoted in Michalska (2013).
25. A small industry has risen out of the Beltracchi case, including an investigative book on the case: Stefan Koldehoff, and Tobias Timm, *Falsche Bilder Echtes Geld: Der Falschungscoup des Jahrhunderts* (Berlin, 2012); a documentary film,

Beltracchi-Die Kunst der Falschung (2014) by Arne Birkenstock, whose father was the Beltracchis' lawyer; and a pair of memoirs by Wolfgang and Helene Beltracchi, one an autobiography (*Selbstportrat*, Reinbek, 2014) and the other their collected letters sent from prison (*Einschluss mit Engeln: Gefangnisbriefe vom 31.8.2010 bis 27.10.2011*, Reinbek, 2014).

26. Laura Gilbert, 'US Attorney's Office Hints at More Criminal Charges in Knoedler Case', *Art Newspaper* (11 September 2013).

27. Judith H. Dobrzynski, 'Knoedler Gallery Reveals Its Tales – At The Getty' (31 July 2013): http://www.artsjournal.com/realcleararts/2013/07/knoedler-gallery-reveals-its-tales-at-the-getty.html.

28. Quoted in Michael Schnayerson, 'The Knoedler's Meltdown: Inside the Forgery Scandal and Federal Investigations', *Vanity Fair* (6 April 2012).

29. According to Schnayerson, Knoedler claimed to have been planning to close its door for some time, and that the decision was not directly related to the lawsuit threat, but the timing is hard to dismiss as coincidence.

30. Patricia Cohen and William K. Rashbaum, 'Art Dealer Admits to Role in Fraud', *The New York Times* (16 September 2013).

31. Patricia Cohen, 'New Details Emerge About Tainted Gallery' in *The New York Times* online(3 November 2013): http://www.nytimes.com/2013/11/04/arts/design/knoedler-gallery-faces-another-forgery-complaint.html.

OPPORTUNISM

1. For more on art theft and the history of art in war, see Charney (2010).

2. Much of the material on Dossena may be found in Arnau (1961); David Sox, *Unmasking the Forger: The Dossena Deception* (London 1987); and Keats (2012).

3. See Drew N. Lanier, 'Protecting Art Purchasers: Analysis and Application of Warranties of Quality', *Cardozo Arts and Entertainment Law Journal*, vol. 3 (2003) and Patty Gerstenblith, 'Picture Imperfect: Attempted Regulation of the Art Market', *William and Mary Law Review*, vol. 29, Issue 3 (1988).

4. See Barnett Hollander, *International Law of Art* (Cambridge, 1959).

5. This may be found in the German magazine *International Art Review* from the year 1930, and is also described in Adolph Donath, *How Forgers Work* (1937).

6. Jonathan Keats, 'Almost Too Good', *Art and Antiques* online: http://www.artandantiquesmag.com/2011/11/almost-too-good/.

7. Hans Curlis, *Der Bildhauer Alceo Dossena: Aus Dem Filmzyklus 'Schaffende Hande'*, a book developed from the film, directed by Curlis, *Scha ende Hande*, about Dossena's career, and produced by the Institute of Cultural Research in Berlin. The book is out of print (originally published in Berlin, 1930), but is available through the Getty Books digital archive: https://archive.org/stream/derbildhaueralceo00curl#page/n3/mode/2up.

8. These include Geert Jan Jansen, Ken Perenyi, John Myatt and Elmyr de Hory amongst others.

9. For a basic summary of the theory, see J. Robert Lilly, Francis T. Cullen, and Richard A. Ball, *Criminological Theory: Context and Consequences* (London, 2007). The original authors revisited their 'Broken Windows' theory in James Q. Wilson and George L. Kelling, 'A Quarter Century of Broken Windows', *American Interest* (September/October 2006). George L. Kelling had previously updated the theory in George L. Kelling and Catherine Coles, *Fixing Broken*

Windows: Restoring Order and Reducing Crime in Our Communities (New York, 1998).

10. The complete story of John Drewe and John Myatt is told in Laney Salisbury and Aly Sujo, *Provenance: How a Con Man and a Forger Rewrote the History of Modern Art* (London, 2010).

11. This information was related in a talk given by the Victorial and Albert Museum librarian at a conference organized by the Victoria and Albert and ARCA (Association for Research into Crimes against Art) in November 2013.

12. For the complete criminal and art historical story of the *Mona Lisa*, see Noah Charney, *The Thefts of the Mona Lisa: On Stealing the World's Most Famous Painting* (London, 2011).

13. A good summary of this case may be found in Clive Thompson, 'How to Make a Fake', *New York Magazine* (21 May 2005). Other sources include press releases from the United States Attorney Southern District of New York, available online at http://www.justice.gov/usao/nys/pressreleases/June04/sakhaiandsandjabyartrelease.pdf and http://www.justice.gov/usao/nys/pressreleases/July05/sakhaisentence.pdf, as well as Julia Preston, 'Art Gallery Owner Pleads Guilty in Forgery Found by Coincidence', *The New York Times* (14 December 2004) and Barry FitzGerald and Caroline Overington, 'FBI Says the Oils May Not Be Oils', *The Age* (1 December 2004).

14. US Department of Justice sentencing announcement: http://www.justice.gov/usao/nys/pressreleases/July05/sakhaisentence.pdf.

MONEY

1. Material on Jansen's life and career comes from the following sources: his own website, http://geertjanjansen.nl/; Geert Jan Jansen, *Magenta* (Amsterdam, 2004); Ard Huiberts and Sander Kooistra, *Zelf Kunst Kopen* (Amsterdam, 2004); and Kester Freriks, *Geert Jan Jansen* (Venlo, 2006); and a variety of articles and interviews with him.

2. Information on Sykes may be found in Charney, *Stealing the Mystic Lamb* (2011) and in Jenny Graham, *Inventing van Eyck* (London, 2007).

3. The Jefferson Lafite story is told thoroughly in Benjamin Wallace, *The Billionaire's Vinegar* (New York, 2007), and also in Patrick Radden Keefe, 'The Jefferson Bottles: How Could One Collector Find So Much Rare Fine Wine?', *New Yorker* (3 September 2007). Most material in this section comes from one of these two sources. For more on wine forgery, see also, Noah Charney and Stuart George, *The Wine Forger's Handbook* (2013). Special thanks to Stuart George for his input on these cases.

4. Kate Connolly, 'Fake Warriors "Art Crime of the Decade", say German critics', *Guardian* (13 December 2007).

5. Joel Martinsen, 'Who's to Blame for Hamburg's Fake Terracotta Warriors?', *Danwei (*29 December 2007).

6. Ron Gluckman, 'Remade in China', *Travel & Leisure* (December 1999).

7. For more, see Laura Barnes, et al, *Chinese Ceramics: from the Paleolothic Period through the Qing Dynasty* (New Haven, CT, 2010).

8. See, for instance, Michael Sullivan, *TheArts of China* (Berkeley, CA, 2009).

9. See Judith G. Smith and Wen C. Fong, eds., *Issues of Authenticity in Chinese Painting* (New York, 1999).

10. An earlier version of this section appeared as a feature article written by the author: Noah Charney, 'Phoney Warriors', *Tatler* (September, 2008).

POWER

1. Valla's own text is available in translation in Lorenzo Valla, *The Treatise of Lorenzo Valla on the Donation of Constantine,* translated by Christopher B. Coleman (Toronto, 1993) and in Lorenzo Valla and G. W. Bowersock, *On the Donation of Constantine* (Cambridge, MA, 2008), both of which contain the facts of Valla's life and annotations on his work. Further analysis may be found in Salvatore I. Camporeale, Christopher S. Celenza and Patrick Baker, eds., *Christianity, Latinity and Culture: Two Studies on Lorenzo Valla* (Leiden, 2013).

2. Books that examine and dismantle the myth around this text include Will Eisner (with foreword by Umberto Eco), *The Plot: The Secret Story of the Protocols of the Elders of Zion* (New York, 2006); Lucien Wolf, *The Myth of the Jewish Menace in World Affairs or, The Truth about the Forged Protocols of the Elders of Zion* (2011); Steven L. Jacobs and Mark Weitzman, *Dismantling the Big Life: The Protocols of the Elders of Zion* (Jersey City, NJ, 2003); and Theodore Ziolkowski, *Lure of the Arcane: the Literature of Cult and Conspiracy* (Baltimore, MD, 2013).

3. There are numerous articles related to the Priory of Sion hoax, including Daniel Schorn, 'The Priory of Sion: Secret Organization Fact or Fiction' on *60 Minutes* (CBS television, 27 April 2006) available at http://www.cbsnews.com/news/the-priory-of-sion/; Ronald H. Fritze, *Invented Knowledge: False History, Fake Science and Pseudo-Religions* (London, 2009); Laura Miller, 'The Last Word: The Da Vinci Con', *The New York Times* (22 February 2004); and Damian Thompson, *Counterknowledge: How We Surrendered to Conspiracy Theories, Quack Medicine, Bogus Science and Fake History* (London, 2008).

4. There are very few reliable sources available on the Dacian lead plates. Most of the factual information presented here comes from Aurora Petan, 'A Possible Dacian Royal Archive on Lead Plates', *Antiquity,* vol. 79, no. 303, (March 2005) as well as websites including: http://romanianhistoryandculture.webs.com/dacianleadtablets.htm.

5. For more on this case, see Ion Grumeza, *Dacia: Land of Transylvania, Cornerstone of Ancient Eastern Europe* (Lanham, MD, 2009); 'Din Tainele istorei – Misterul tabitelor de plumb' *Formula As,* no. 649 (2005); Dan Romalo, *Cronica geta apocrifa pe placi de plumb* (2005); and 'Aurora Petan despre tablitele de plumb de la Sinaia, o misterioasa arhiva regala dacica', *Observator Orul* (6 March 2005).

6. Information on Chatterton and his forgeries may be found in G. Gregory, *The Life of Thomas Chatterton, with Criticism on His Genius and Writings and a Concise View of the Controversy Concerning Rowley's Poems* (Cambridge, 2014); Daniel Cook, *Thomas Chatterton and Neglected Genius, 1760-1830* (New York, 2013); and Donald S. Taylor, *Thomas Chatterton's Art: Experiments in Imagined History* (Princeton, NJ, 1979).

7. Magnus Magnusson, *Fakers, Forgers, and Phoneys* (Edinburgh, 2006), p. 340.

8. For more on this debate, see Howard Gaskill, ed., *The Reception of Ossian in Europe* (London, 2004).

9. See Margaret Russett, *Fictions and Fakes: Forging Romantic Authenticity, 1760–1845* (Cambridge, 2006), which addresses Ossian and the Shakespeare forgeries.

10. The story of William Henry Ireland may be found in Doug Stewart, *The Boy Who Would Be Shakespeare: A Tale of Forgery and Folly* (Boston, MA, 2010) and Patricia Pierce, *The Great Shakespeare Fraud: The Strange, True Story of William-Henry Ireland* (Shroud, 2004).

11. Quoted from William Shakespeare *Macbeth* (Act 5, Scene 5).

12. See Adam Sisman, *An Honourable Englishman: The Life of Hugh Trevor-Roper* (New York, 2011).

13. Rendell's comments on this and other cases may be found in: Kenneth W. Rendell, *Forging History: The Detection of Fake Letters and Documents* (Norman, OK, 1994).

14. The story of the Hitler Diaries is told in Robert Harris, *Selling Hitler: The Story of the Hitler Diaries* (London, 1986).

15. R.A. Skelton, et al., *The Vinland Map and Tartar Relation* (New Haven, CT, 1995), p. 140.

16. Paul Saenger, 'Review Article Vinland Re-Read', *Imago Mundi,* vol. 50 (1998), p. 201.

17. For a thorough examination of the Vinland Map controversy, see John Yates, 'Vinlandsaga', *The Journal of Art Crime,* vol. 2 (Fall 2009).

18. Thanks go to Martin Kemp, who provides many of the facts in this section in Martin Kemp, *Christ to Coke: How Image Becomes Icon* (Oxford, 2011). See also Mark Oxley, *The Challenge of the Shroud: History, Science, and the Shroud of Turin* (2010); and Walter C. McCrone, *Judgment Day for the Shroud of Turin* (New York, 1999).

19. A. Lemaire and the Biblical Archaeology Society, *Burial Box of James, the Brother of Jesus: Earliest Archaeological Evidence of Jesus Found in Jerusalem* (Washington, DC, 2002).

20. These also include the 'Jehoash tablet', purported to be from the nineth century BC, among many others. See Matti Friedman, 'Oded Golan is Not Guilty of Forgery. So is the James Ossuary for Real?', *Times of Israel* (14 March 2012).

21. For more on this case, see J. Magness, 'Ossuaries and the Burials of Jesus and James', *Journal of Biblical Literature,* vol. 124, no. 1 (April, 2005), pp. 121–154; and M. Rose, 'Ossuary Tales', *Archeology: A Publication of the Archeological Institute of America,* vol. 56, no. 1 (January, 2003).

22. Friedman (2012).

23. R. J. W. Evans, *Rudolf II and His World: A Study of Intellectual History 1576–1612* (London, 1997); and Peter Marshall, *The Magic Circle of Rudolf II* (London, 2006).

24. For more, see Charles Blinderman, *The Piltdown Inquest* (New York, 1986); and Miles Russell, *Piltdown Man: The Secret Life of Charles Dawson and the World's Greatest Archaeological Hoax* (Shroud, 2003).

25. The article in question was Christopher P. Sloan, 'Feathers for T. Rex?', *National Geographic* (November 1999). For more see Hillary Mayell, 'Dino Hoax was Mainly Made of Ancient Bird, Study Says', *National Geographic News* (20 November 2002); and Bert Thompson and Brad Harrub, 'National Geographic Shoots Itself in the Foot – Again', *True Origin* (November 2004).

26. Zhou Zhonghe, Julia A. Clarke and Zhang Fucheng. 'Archaeoraptor's Better Half', *Nature,* vol. 420 (21 November 2002), pp. 285.

27. See Helen Briggs, 'Piltdown Bird Fake Explained', BBC *News,* 29 March 2001.

28. As told to the author in one of many interviews with Rapley over several years.

29. Melinda Henneberger, 'The Leonardo Cover-Up', *The New York Times* (21 April 2002).

30. See the TED talk by Maurizio Seracini, entitled 'The Secret Lives of Paintings,' given in 2012 and available online at http://www.ted.com/talks/ maurizio_seracini_the_secret_lives_of_ paintings?language=en.

31. See the research project, 'Closer to Van Eyck: Rediscovering the Ghent Altarpiece' online at: http://closertovaneyck5. universumdigitalis.com/.

32. Some of the facts in this section on 'art fingerprinting' appeared in Noah Charney, 'Authentication Start-Up Fig-Art-Print Promises to Defeat Art Forgers with Microscopic 3D Mapping', *Art+Auction* (13 July 2012).

33. This technology was used by the Dutch police to uniquely identify a single bullet, as related by Dr Wei in a talk he gave at the ARCA Conference in Amelia, Italy (June 2012). Other details in this section likewise come from Dr Wei's talk.

CONCLUSION

1. This is perhaps fair enough – one should not shift limited resources away from crimes in which people are in physical danger – but there should surely be a point of balance, wherein law enforcement agencies can train officers in investigating art crime, so that each new head of an arts unit is not obliged to start from scratch and learn on the job. As of writing there is no specialized training in investigating forgeries, beyond rare one-off courses, like the one I teach every summer on the ARCA Postgraduate Program in Art Crime and Cultural Heritage Protection.

2. See, for example, *Sentencing Advisory Council Australia, Sentencing Matters: Does Imprisonment Deter? A Review of the Evidence* (April 2011), available online at: http://www.abc.net.au/mediawatch/transcripts/1128_sac.pdf.

3. At professional sporting events, television producers consciously refuse to show 'pitch invaders', unruly fans who run onto the field and disrupt the game. This decision is meant to discourage seekers of a fleeting moment on camera, and it seems to have worked. For further information, see, Aaron Gordon, 'Idiot Ruins Game? Brief Interviews With Not-So-Hideous Pitch Invaders', *Grantland* (3 September 2014).

4. At the time of writing, there is no firm or specialist researcher whose job is to check provenance rather than just to look for provenance that had already been linked to an object. Some people now propose that there should be an occupation for provenance researchers – investigators of the provenance associated with an object to be certain that the provenance itself is authentic and not forged, and that the provenance does in fact belong to the object in question and was not appropriated from another source. This would keep dealers honest, and could curb the provenance traps discussed in this book.

GLOSSARY OF SCIENTIFIC METHODS OF AUTHENTICATION

ART 'FINGERPRINTING'

At the time of writing, not widely available, the system uses extremely detailed but very inexpensive, digital photographs of a tiny portion of the surface of an artwork, which is then mapped for roughness using a measurement called tribology. This technology, invented and developed by Dr Bill Wei and the Netherlands Institute for Cultural Heritage, shows promise as a method for art in extant collections to be uniquely identified.

CHROMATOGRAPHY & MASS SPECTROMETER

To determine exactly what organic components make up any given paint requires breaking the components apart. This may be done using chromatography, in which a paint sample is dissolved and the gas it releases is trapped and analysed. The gas is further broken down in a heated column that causes the molecular components to separate. A mass spectrometer attached to the chromatograph then records the composition of each molecular component, resulting in a GC-MS analysis (GC for 'gas chromatography' and MS for 'mass spectrometer').

DENDROCHRONOLOGY

The study of the age of wood is one that does not require hi-tech tests. The growth rings of a tree can be measured, sometimes with the naked eye, and then compared to computerized databases of spacing between growth rings in various woods. When a match is found, the number and spacing of growth rings can determine the age of the tree from which the panel was cut. This works best with trees like oaks, often used for panels in northern Europe. The preferred poplar wood of Italian panel paintings (a favourite because it resists insects) does not form regular rings, and therefore is not easy to date using this method. See Wieseman (2010), p. 12.

ENERGY DISPERSIVE X-RAY (EDX)

EDX follows up on the results of a scanning electron microscope (SEM) examination (see below). It allows scientists to analyse the SEM data to determine the elemental composition of a layer within a cross-section. While it cannot tell us exactly what each layer is, it can identify what elements a layer contains (lead, copper, iron, etc). It is then up to the scientist to determine whether those elements make sense and what the sum total of those elements would equal in terms of pigments and varnishes.

FINGERPRINT & DNA ANALYSIS

Considering artworks as physical objects that will have been handled over the years, it makes sense that fingerprints or DNA sample analysis might be employed to determine who handled the work in question. This is a rather recent addition to the investigator's arsenal, at least applying these techniques to art. But as with a crime scene, artworks can be tampered with. Investigators describe suspected instances of fingerprints or DNA material being placed by forgers for scientists to discover – an elaborate incarnation of a 'forensic trap'.

FOURIER TRANSFORM INFRARED SPECTROSCOPY (FTIR)

FTIR shoots beams of infrared radiation into paint samples. Because materials absorb this radiation at different wavelengths, a record of the resulting wavelengths can be used to identify materials. Paints are almost always composed of multiple pigments and binders, making them less-than-straightforward to analyse. Further, every artist until the nineteenth century mixed their own paints and had their own 'recipes' for their preferred colours, specific combinations of pigments in varying proportions. Guercino used an instantly-recognizable slate-infused dark blue, for example, and Yves Klein famously designed his own cobalt blue, which he patented, and which can be purchased today at any paint shop. FTIR microscopy is helpful in identifying binders, like egg or linseed oil, and also can spot unexpected materials that are grounds for suspicion, such as shellac, that should not be in an authentic painting.

INFRARED RADIATION (IR)

Using a section of the electromagnetic spectrum that is beyond what we can see without scientific assistance, IR can show layers hidden beneath the surface of a painting. Underdrawings and *pentimenti* (changes or alterations to a work that are not visible at the work's surface but may be seen through scientific examination) may be revealed because pigments which are opaque in visible light become transparent in the infrared region of the spectrum. This is best for locating carbon black, used frequently for underdrawings, since it absorbs infrared radiation and therefore looks dark in IR images. This method may be used with infrared-sensitive photographic film or with infrared reflectography (IRR), which uses a special digital camera to photograph this extended portion of the spectrum.

HIGH PERFORMANCE LIQUID CHROMATOGRAPHY (HPLC)

HPLC uses liquid to draw a sample through a porous material that draws out and separates the components of the sample. This is used primarily to identify organic dyes.

RADIOCARBON DATING

Also called Carbon-14 Dating, this is probably the best-known of the techniques discussed. A tiny sample of an organic (carbon-based) substance is destroyed and the resulting gases captured. It works only for organisms that took in carbon from the air (such as plants and animals). The amount of radiation in radioisotope carbon-14 (an element that appears in all organic matter) that was in the sample is then recorded by a computer, and can be used to calculate the age of the organic substance when it died, or ceased to continue to grow. As soon as the organic material stops growing or dies, the amount of radiation in the carbon-14 begins to lessen, in a process called radioactive decay. Since scientists know how much radiation should be present in carbon-14, and they know the rate at which it decays (the radiocarbon half-life, or how long it would take for half of the radiation to disappear), if they can determine the amount of radiation left in the carbon-14 of a sample, they can calculate when the decay started.

This technique was invented in 1949 and may be used for organic materials up to c. 50,000 years old (as materials older than that do not have enough carbon-14 remaining to analyze), for which it usually has a plus-minus 200-year level of accuracy. It is therefore far better at determining whether an archaeological object, a mummy for instance, is from 500 BC or 200 BC, than trying to determine whether a wooden sculpture is truly by Donatello in 1415. Organic material from 1950 or later adheres to a different set of rules thanks to the radiation after nuclear testing, and can often be aged accurately within one year. Yet even these tests can be fooled – it was noted that forgers in China would inject a radioactive isotope into forged vases, so that the vases would carbon-date to the correct age, even though they were made in the modern era.

RAMAN MICROSCOPY

Low-intensity laser beams are used to identify the molecular structure of both organic and inorganic pigments. By comparing with a database the way that the laser wavelengths (called the Raman spectrum) are scattered by the pigments they encounter, the pigments can be identified.

SCANNING ELECTRON MICROSCOPE (SEM)

To really get close in an examination, conservators can turn to a SEM. This microscope shoots high-energy electrons into a sample and records how they interact with the particles just below the surface, showing the topography of the surface (think of the texture of a Van Gogh painting), and even the chemical composition of pigments. A SEM can magnify up to 100,000x – quite a difference when compared to a normal binocular microscope, which magnifies 50x.

ULTRAVIOLET FLUORESCENCE & POLARIZED LIGHT MICROSCOPY

Conservators may want to look at cross-sections, tiny slices from a painting that show each layer of pigment, much as a geologist might look at layers of earth, seen from the side, so that each layer is evident. These cross-sections should show the ground (gesso), pigments, and varnish on top of a painting, and can be subjected to further scientific tests. UV light applied to the cross-section helps to identify the materials in the cross-section. Polarized light microscopy uses a special microscope with a polarizing light filter to look at the crystalline structure of pigment samples, which tells scientists which pigments are present, much like looking at a blood sample can identify the pathogens in the bloodstream.

ULTRAVIOLET LIGHT (UV LIGHT)

Using UV light on a painting causes some materials to fluoresce. This is particularly useful to identify where paintings have been retouched by past restorers. The natural resin used as a varnish in most Old Master paintings tends to fluoresce a pale green colour. If a portion of the painting does not fluoresce in this colour, it suggests that it was painted over the original varnish, and is therefore younger than the painting.

X-RADIOGRAPHY

While we associate x-rays with medical examination of bones, they were used on paintings almost as soon as they were invented, back in 1896. X-ray sensitive film sheets are placed on the surface of an object, and x-rays are then beamed through the object from behind or beneath. The resulting x-ray imprints onto the film after having passed through the object. Most materials used in painting are fairly transparent to x-rays, which means that the more absorptive materials, like lead white, will show up darker on the x-ray and therefore more prominently. This technique is particularly helpful for finding underdrawings and underpaintings that demonstrate the creative process as the artist experimented with the positioning of figures and objects in the final painting.

X-RAY DIFFRACTION (XRD)

XRD uses a type of x-ray that scatters in a 'fingerprint' pattern when it encounters the crystalline structure of pigments. By analysing the scatter pattern (like a criminal investigator might examine blood spatter from a gunshot wound), materials and pigments may be identified.

X-RAY FLUORESCENCE ANALYSIS

Some of the techniques listed here require the invasion or destruction of a small portion of the material in question in order to analyse it. It is of course preferable to use non-invasive, non-destructive analytical techniques whenever possible. X-ray fluorescence analysis examines the elements present in the surface and layers just beneath without damaging the material. Other techniques are borrowed from medical science, like optical coherence tomography (OCT), which examines art the way doctors examine patients using a CT scan.

SELECTED BIBLIOGRAPHY

Dalya Alberge, 'Master Forger Comes Clean about Tricks that Fooled Art World for Four Decades', *Guardian* (7 July 2012)

Kenneth Alford, *Hermann Göring and the Nazi Art Collection* (McFarland & Co, 2012)

Joseph Allsop, 'The Faker's Art', *New York Review of Books* (18 December 1986)

Frank Arnau, *The Art of the Faker: 3000 Years of Deception in Art and Antiques*, translated by J. Maxwell Brownjohn (London, 1961)

Jaromir Audy, 'An Experimental Investigation of Counterfeit Coins and Forgeries', *Journal of Manufacturing Engineering*, vol. 7 (2008) pp. 45–51

—

Michael Baigent, Richard Leigh and Henry Lincoln, *Holy Blood, Holy Grail* (New York, 2005 illustrated edition)

Marianela Balbi, *El rapto de la Odalisca* (Caracas, 2009)

Marianela Balbi and William Neuman 'Topless Woman Found. Details Sketchy', *The New York Times* (19 July 2012)

Colette Bancroft, 'Art Forger Lived High Life by Mastering Fakes to Foist on Collectors' *Tampa Times* (14 September 2012)

Laura Barnes, et al, *Chinese Ceramics: from the Paleolothic Period through the Qing Dynasty* (New Haven, CT, 2010)

Julie Belcove, 'The Bazaar World of Dalí', *Harper's Bazaar* (19 December 2012)

Harry Bellet, 'L'historien d'art Werner Spies condamne pour avoir mal authentifie une toile de Max Ernst', *Le Monde* (27 May 2013)

Wolfgang Beltracchi and Helene Beltracchi, *Selbstportrat* (Reinbek, 2014)

Wolfgang Beltracchi and Helene Beltracchi, *Einschluss mit Engeln: Gefangnisbriefe vom 31.8.2010 bis 27.10.2011* (Reinbek, 2014)

Walter Benjamin, *The Work of Art in the Age of Mechanical Reproduction* (Scottsdale, AZ, 2012)

Leslie Bennets, '45 Met Museum Artworks Found to be Forgeries', *The New York Times* (12 January 1984)

Sidney E. Berger, 'Forgeries and Their Detection in the Rare Book World', *Libraries and Culture*, vol. 27, no. 1 (Winter 1992), pp. 59–69

Charles Blinderman, *The Piltdown Inquest* (New York, 1986)

Karina Sainz Borgo, 'Dalí ese al que Breton llamo Avida Dollars', *Tendencias del Mercado del Arte* (18 April 2013)

Cesare Brandi, 'Theory of Restoration (1963)' in N. Stanley Price, M.K. Talley Jr, and A.M. Vaccaro, eds., *Historical and Philosophical Issues in the Conservation of Cultural Heritage*, (Los Angeles, 1996)

Abraham Bredius, 'An Unpublished Vermeer', *Burlington Magazine*, vol. 61 (October 1932), p. 145

Abraham Bredius, 'A New Vermeer', *Burlington Magazine*, vol. 71 (November 1937), pp. 210–211

John Brewer, *The American Leonardo: A Tale of Obsession, Art and Money* (Oxford/New York, 2009)

Helen Briggs, 'Piltdown Bird Fake Explained, *bbc News* (29 March 2001)

Neil Brodie, 'The Getty Kouros', *Trafficking Culture* (20 August 2012)

Dan Brown, *The Da Vinci Code* (New York, 2003)

—

W. Joseph Campbell, 'Not a Hoax: New Evidence in the New York Journal's Rescue of Evangelina Cisneros', *American Journalism*, vol. 19 (Fall 2002)

Roberto Careaga, 'Las oscuras rutas de la red trafico de arte', *La Tercera Reportajes* (17 February 2008)

Duncan Chappell and Saskia Hufnagel, 'A Comment on the "Most Spectacular" German Art Forgery Case in Recent Times', *Journal of Art Crime* (Spring 2012)

Noah Charney, *The Art Thief* (New York, 2007)

Noah Charney, 'Phoney Warriors', *Tatler* (September, 2008)

Noah Charney, ed., *Art & Crime: Exploring the Dark Side of the Art World* (Santa Barbara, 2009)

Noah Charney, 'The Lost Leonardo', *LA Times* (6 November 2011)

Noah Charney, *Stealing the Mystic Lamb: The True Story of the World's Most Coveted Masterpiece* (New York, 2011)

Noah Charney, *The Thefts of the Mona Lisa: On Stealing the World's Most Famous Painting* (London, 2011)

Noah Charney and Matthew Leininger 'Not in It for the Money', *New Orleans Magazine* (October 2012)

Noah Charney, 'Authentication Start-Up Fing-Art-Print Promises to Defeat Art Forgers with Microscopic 3D Mapping', *Art+Auction* (13 July 2012)

Noah Charney and Stuart George, *The Wine Forger's Handbook* (published digitally, 2013)

Patricia Cohen and William K. Rashbaum, 'Art Dealer Admits to Role in Fraud', *The New York Times* (16 September 2013)

Patricia Cohen, 'New Details Emerge About Tainted Gallery', *The New York Times* (3 November 2013)

Ascanio Condivi, *Life of Michelangelo*, translated by Alice Sedgwick Wohl, edited by Hellmut Wohl, (University Park, PA, 1999)

Kate Connolly, 'Fake Warriors "Art Crime of the Decade", say German Critics' *Guardian* (13 December 2007)

Daniel Cook, *Thomas Chatterton and Neglected Genius, 1760–1830* (New York, 2013)

P. B. Coremans, *Van Meegeren's Faked Vermeers and De Hooghs*, translated by A. Hardy and C. Hutt (London, 1949)

Paul Craddock, ed., *Scientific Investigation of Copies, Fakes, and Forgeries* (New York, 2009)

David Crystal-Kirk, 'Forgery Reforged: Art-Faking and Commercial Passing-Off Since 1981', *Modern Law Review*, vol. 49, issue 5 (September 1986), pp. 608–616

Rainer Crone, *Andy Warhol* (New York, 1970)

Hans Curlis, *Der Bildhauer Alceo Dossena: Aus Dem Filmzyklus 'Schaffende Hande'* (Berlin, 1930)

—

Serena Davies, 'The Forger Who Fooled the World' *Telegraph* (5 August 2006)

Karl Decker, 'Why and How the Mona Lisa was Stolen', *Saturday Evening Post* (1932)

R. Distelberger, et al., *Western Decorative Arts, Part I Medieval, Renaissance and Historicizing Styles including Metalwork, Enamels, and Ceramics*, (Washington, DC, 1993), pp. 282–304

Robert Dodsley, *London and Its Environs Described* (London, 1761)

Edward Dolnick, *The Forger's Spell: A True Story of Vermeer, Nazis, and the Greatest Art Hoax of the Twentieth Century* (New York, 2009)

Adolph Donath, *Wie die Kunstfälscher arbeiten* [How Art Forgers Work] (1937)

Richard Dorment, 'What is an Andy Warhol?' *New York Review of Books* (22 October 2009)

Denis Dutton, ed., *The Forger's Art: Forgery and the Philosophy of Art* (Berkeley, 1983)

—

Will Eisner (with foreword by Umberto Eco), *The Plot: The Secret Story of the Protocols of the Elders of Zion* (New York, 2006)

R. J. W. Evans, *Rudolf II and his World: A Study of Intellectual History 1576–1612* (London, 1997)
—

Stephen Fay, Lewis Chester and Magnus Linklater, *Hoax: The Inside Story of the Howard Hughes-Clifford Irving Affair* (London, 1972)

Walter Feilchenfeldt, 'Van Gogh fakes: The Wacker affair with an Illustrated Catalogue of the Forgeries', *Simiolus: Netherlands Quarterly for the History of Art*, vol. 19, no. 4 (1989) pp. 289–316

Stuart Fleming, 'Art Forgery: Some Scientific Defenses', *Proceedings of the American Philosophical Society*, vol. 130 (1986) pp. 175–195

Mark Forgy, *The Forger's Apprentice: Life with the World's Most Notorious Artist* (2012)

Kester Freriks, *Geert Jan Jansen* (Venlo, 2006)

Ronald H. Fritze, *Invented Knowledge: False History, Fake Science and Pseudo-Religions* (London, 2009)
—

Howard Gaskill, ed., *The Reception of Ossian in Europe* (London, 2004)

Melanie Gerlis, and Javier Pes, 'Recovery Rate for Stolen Art as Low as 1.5%', *Art Newspaper* (27 November 2013)

Patty Gerstenblith, 'Picture Imperfect: Attempted Regulation of the Art Market', *William and Mary Law Review,* vol. 29, issue 3 (1988)

Liza Ghorbani, 'The Devil on the Door' *New York Magazine* (18 September 2011)

Laura Gilbert, 'US Attorney's Office Hints at More Criminal Charges in Knoedler Case' *Art Newspaper* (11 September 2013)

Victor Ginsburgh, and David Throsby, eds., *Handbook of the Economics of Art and Culture*, vol. 1 (Amsterdam, 2006)

Malcolm Gladwell, *Blink: The Power of Thinking without Thinking* (New York, 2005)

Ron Gluckman, 'Remade in China', *Travel & Leisure* (December 1999)

Grace Glueck, 'The Basquiat Touch Survives the Artist in Shows and Courts', *The New York Times* (22 July 1991)

John Godley, *Van Meegeren, Master Forger* (New York, 1967)

Aaron Gordon, 'Idiot Ruins Game? Brief Interviews With Not-So-Hideous Pitch Invaders', *Grantland* (3 September 2014)

Lothar Gorris and Sven Robel, 'Confessions of a Genius Art Forger', *Der Spiegel* (9 March 2012)

Jenny Graham, *Inventing van Eyck* (London, 2007)

David Grann, 'The Mark of a Masterpiece', *New Yorker* (10 July 2010)

G. Gregory, *The Life of Thomas Chatterton, with Criticism on His Genius and Writings and a Concise View of the Controversy Concerning Rowley's Poems* (Cambridge, 2014)

Ion Grumeza, *Dacia: Land of Transylvania, Cornerstone of Ancient Eastern Europe* (Lanham, MD, 2009)
—

Yvonne Hackenbroch, 'Reinhold Vasters, Goldsmith', *Metropolitan Museum Journal* (1984–85)

Anthony Haden-Guest, 'The Hunger Artist: A Jailed Basquiat Faker Goes without Food so that He can Make (and Sell) Art', *New York Magazine* (12 January 2004), viewable online at http://nymag.com/nymetro/news/people/columns/intelligencer/n_9717/

Jesse Hamlin, 'Master (Con) Artist/Painting Forger Elmyr de Hory's Copies are Like the Real Thing', *San Francisco Chronicle* (29 July 1999)

Joshua Hammer, 'The Greatest Fake-Art Scam in History?', *Vanity Fair* (10 October 2012)

Robert Harris, *Selling Hitler: The Story of the Hitler Diaries* (London, 1986)

Eric Hebborn, *Drawn To Trouble: The Forging of an Artist, an Autobiography* (Edinburgh, 1991)

Eric Hebborn, *The Art Forger's Handbook* (New York, 1996)

Phoebe Hoban, *Basquiat: A Quick Killing in Art* (New York, 1999)

Barnett Hollander, *International Law of Art* (Cambridge, 1959)

Thomas Hoving, *False Impressions, The Hunt for Big-Time Art Fakes,* (New York, 1997)

Ard Huiberts, *Zelf Kunst Kopen* (Amsterdam, 2004)
—

Fabio Isman, *I Predatori dell'Arte Perduta* (Milan, 2010)

Guy Isnard, *Les pirates de la peinture* (Paris, 1955)

Clifford Irving, *Fake: The Story of Elmyr de Hory: The Greatest Art Forger of Our Time* (New York, 1969)
—

Steven L. Jacobs, and Mark Weitzman,
*Dismantling the Big Life: The Protocols of the
Elders of Zion* (Jersey City, NJ, 2003)
Geert Jan Jansen, *Magenta* (Amsterdam, 2004)
Jonathan Jones, 'Matisse: Can You Spot the
Fake?', *Guardian* (8 July 2014)
Mark Jones, ed., *Fake? The Art of Detection*
(Berkeley, CA, 1990)
Icilio Federico Joni, *Le memorie di un pittore di
quadri antichi. A cura di Gianni Mazzoni, con testo
inglese a fronte* (Siena, 2004)

—

Jason Edward Kaufman, 'De faux Dali
échappent au pilon: plutôt vendre des
contrefacons que les détruire' *Journals des Arts*
(March 1996)
Sidney Kasfir, 'African Art and Authenticity:
A Text with Shadows', *African Arts*, vol. 35
(2006), pp. 45–62
Tom Keating, Geraldine Norman and Frank
Norman, *The Fake's Progress: The Tom Keating
Story* (London, 1977)
Jonathan Keats, *Forged: Why Fakes are the Great
Art of Our Age* (Oxford, 2012)
George L. Kelling and Catherine Coles,
*Fixing Broken Windows: Restoring Order and
Reducing Crime in Our Communities*
(New York, 1998)
Martin Kemp, *La Bella Principessa: The Story
of a New Masterpiece by Leonardo da Vinci*
(London, 2010)
Martin Kemp, *Christ to Coke: How Image Becomes
Icon* (Oxford, 2011)
W. E. Kennick, 'Art and Inauthenticity', *Journal
of Aesthetics and Art Criticism*, vol. 44 (1985)
pp. 3–12
Michael Kimmelman, 'The World's Richest
Museum' *The New York Times* (23 October
1988)
Michael Kimmelman, 'Absolutely Real?
Absolutely Fake?' *The New York Times*
(4 August 1991)
Ilse Kleemann, 'On the Authenticity of the
Getty Kouros', *Getty Kouros Colloquium*, 1993
Stefan Koldehoff and Tobias Timm, *Falsche
Bilder Echtes Geld: Der Falschungscoup des
Jahrhunderts* (Berlin, 2012)
Tomas Kulka, 'The Artistic and Aesthetic
Status of Forgeries', *Leonardo*, vol. 15 (1982),
pp. 115–117
Simon Kuper, 'Who Stole the Mona Lisa?',
Financial Times (5 August 2011)

—

Peter Landesman, 'A Crisis of Fakes' *The New
York Times Magazine* (18 March 2001)
Drew N. Lanier, 'Protecting Art Purchasers:
Analysis and Application of Warranties of
Quality' *Cardozo Arts and Entertainment Law
Journal*, vol. 3, (2003)
Stan Lauryssens, *Dalí and I: The Surreal Story*
(New York, 2008)
Bo Lawergren, 'A "Cycladic" Harpist in
the Metropolitan Museum of Art' *Source:
Notes in the History of Art*, vol. 20, no. 1
(Fall 2000)
A. Lemaire and the Biblical Archaeology
Society, *Burial Box of James, the Brother of
Jesus: Earliest Archaeological Evidence of Jesus
Found in Jerusalem* (Washington, DC, 2002)
Thierry Lenain, *Art Forgery: The History
of a Modern Obsession* (London, 2011)
Alfred Lessing, 'What is Wrong with
a Forgery?', *Journal of Aesthetics and Art
Criticism*, vol. 23 (1965), pp. 461–471
J. Robert Lilly, Francis T. Cullen, and
Richard A. Ball, *Criminological Theory:
Context and Consequences* (London, 2007)
Deborah Linton, 'Humble Council House was
Home to 10m Swindle', *Manchester Evening
News* (17 November 2007)
Jonathan Lopez, *The Man Who Made Vermeers*
(New York, 2009)
David Lowenthal, 'Counterfeit Art: Authentic
Fakes?', *International Journal of Cultural Property*,
vol. 1 (1992), pp. 79–104

—

Donald MacGillivray, 'When is a Fake not
a Fake? When It's a Genuine Forgery',
Guardian (2 July 2005)
J. Magness, 'Ossuaries and the Burials of
Jesus and James', *Journal of Biblical Literature*,
vol. 124, no. 1 (April 2005), pp. 121–154
Magnus Magnusson, *Fakers, Forgers and Phoneys*
(Edinburgh, 2006)
Peter Marshall, *The Magic Circle of Rudolf II*
(London, 2006)
Joel Martinsen, 'Who's to Blame for
Hamburg's Fake Terracotta Warriors?',
Danwei (29 December 2007)
Hillary Mayell, 'Dino Hoax was Mainly
Made of Ancient Bird, Study Says', *National
Geographic News* (20 November 2002)
Gianni Mazzoni, *Quadri antichi del Novecento*
(Vicenza, 2001)

Gianni Mazzoni, *Falsi d'autore. Icilio Federico Joni e la cultura del falso tra Otto e Novecento. Catalogo della mostra* (Siena, 2004)

Walter C. McCrone, *Judgment Day for the Shroud of Turin* (New York, 1999)

Julia Michalska, 'Werner Spies Rehabilitated with Max Ernst Show in Vienna', *Art Newspaper* (28 January 2013)

Laura Miller, 'The Last Word; The Da Vinci Con', *The New York Times* (22 February 2004)

Tom Mueller, 'To Sketch a Thief', *The New York Times Magazine* (17 December 2006)

Tom Mueller, *Extra Virginity: The Sublime and Scandalous World of Olive Oil* (New York, 2011)

Werner Muensterberger, *Collecting: An Unruly Passion* (New Haven, CT, 1994)

Oscar White Muscarella, 'The Veracity of "Scientific" Testing by Conservators', *Original – Copy – Fake?* (Mainz, 2008), pp. 9–18

—

Geraldine Norman and Thomas Hoving, 'It Was Bigger Than They Knew', *Connoisseur* (August, 1987)

—

Jennifer Osterhage, 'Relics of Saints a Blessing to Basilica', *Notre Dame Magazine* (Spring 2004)

Mark Oxley, *The Challenge of the Shroud: History, Science, and the Shroud of Turin* (Milton Keynes, 2010)

—

Clara Passi, 'As pessoas amam ler sobre crimes de arte', *Jornal do Brasil* (24 August 2008)

Esther Pasztory, 'Truth in Forgery', RES: *Anthropology and Aesthetics*, vol. 42 (2002), pp. 159–165

Ken Perenyi, *Caveat Emptor: The Secret Story of an American Art Forger* (New York, 2012)

Aurora Petan, 'A Possible Dacian Royal Archive on Lead Plates', *Antiquity,* vol. 79, no. 303, (March 2005)

Paul Philippot, 'Historic Preservation: Philosophy, Criteria, Guidelines', in N. Stanley Price, M.K. Talley Jr, and A. M. Vaccaro, eds., *Historical and Philosophical Issues in the Conservation of Cultural Heritage* (Los Angeles, 1996)

Patricia Pierce, *The Great Shakespeare Fraud: The Strange, True Story of William-Henry Ireland* (Shroud, 2004)

Lisa Pon, *Raphael, Dürer, and Marcantonio Raimondi: Copying and the Italian Renaissance Print* (New Haven, CT 2004)

William Poundstone, 'The Best Classical Sculpture in the World', *ArtInfo* (9 April 2013)

Elisabetta Povoledo, 'Yes, It's Beautiful, the Italians All Say, but Is It a Michelangelo', *The New York Times* (21 April 2009)

Elizabeth Povoledo, 'A Masters in Art Crime (No Cloak and Dagger)', *The New York Times* (21 July 2009)

Enrico Maria dal Pozzolo, *Giorgione* (Milan, 2009)

—

Colin Radford, 'Fakes', *Mind*, vol. 87, no. 345 (1978), pp. 66–76

Kenneth W. Rendell, *Forging History: The Detection of Fake Letters and Documents* (Norman, OK, 1994)

Dan Romalo, *Cronica geta apocrifa pe placi de plumb* (Oras, 2005)

M. Rose, 'Ossuary Tales', *Archeology: A Publication of the Archeological Institute of America*, vol. 56, no. 1 (January 2003)

Ingrid Rowland and Noah Charney, *The Collector of Lives: Giorgio Vasari and the Invention of Art* (New York, 2015)

John Russell, 'As Long as Men Make Art, the Artful Faker will be with Us', *The New York Times* (12 February 1984)

Miles Russell, *Piltdown Man: The Secret Life of Charles Dawson and the World's Greatest Archaeological Hoax* (Shroud, 2003)

—

Paul Saenger, 'Review Article Vinland Re-Read,' *Imago Mundi*, vol 50 (1998), p. 210

Jordana Moore Saggese, *Reading Basquiat: Exploring Ambivalence in American Art* (Berkeley, CA, 2014)

Laney Salisbury and Aly Sujo, *Provenance: How a Con Man and a Forger Rewrote the History of Modern Art* (London, 2010)

Peter Schjeldahl, 'Dutch Master', *New Yorker* (27 October 2008)

Michael Schnayerson, 'The Knoedler's Meltdown: Inside the Forgery Scandal and Federal Investigations', *Vanity Fair* (6 April 2012)

Daniel Schorn, 'The Priory of Sion: Secret Organization Fact or Fiction', broadcast on *60 Minutes* (CBS television, 27 April 2006)

Peter Silverman and Catherine Whitney, *Leonardo's Lost Princess: One Man's Quest to Authenticate an Unknown Portrait by Leonardo da Vinci* (New York, 2011)

Adam Sisman, *An Honourable Englishman: The Life of Hugh Trevor-Roper* (New York, 2011)

R. A. Skelton, et al., *The Vinland Map and Tartar Relation* (New Haven, CT, 1995)

Christopher P. Sloan, 'Feathers for T. Rex?', *National Geographic* (November 1999)

Judith G. Smith and Wen C. Fong, eds., *Issues of Authenticity in Chinese Painting* (New York, 1999)

Michael Sontheimer, 'A Cheerful Prisoner: Art Forger All Smiles After Guilty Plea Seals the Deal', *Spiegel Online* (27 October 2011)

Nora Sophie, 'How to Fake a Piece of Art: by Artist Alfredo Martinez', in *InEnArt* (22 November 2013), available online at http://www.inenart.eu/?p=12787

David Sox, *Unmasking the Forger: The Dossena Deception* (London, 1987).

Jeffrey Spier, 'Blinded by Science: The Abuse of Science in the Detection of False Antiquities', *Burlington Magazine*, vol. 132, no. 1050 (September, 1990), pp. 623–631

Hunter Steele, 'Fakes and Forgeries', *British Journal of Aesthetics*, vol. 17 (1977), pp. 254–258

Doug Stewart, *The Boy Who Would Be Shakespeare: A Tale of Forgery and Folly* (Boston, MA, 2010)

Michael Sullivan, *The Arts of China* (Berkeley, CA, 2009)

Benjamin Sutton, 'Group that Authenticates Jean-Michel Basquiat Paintings to Disband', *L Magazine* (18 January 2012)

—

Ken Talbot, *Enigma!: The New Story of Elmyr de Hory, the Most Successful Art Forger of Our Time* (London, 1991)

Donald S. Taylor, *Thomas Chatterton's Art: Experiments in Imagined History* (Princeton, NJ, 1979)

Bert Thompson and Brad Harrub, 'National Geographic Shoots Itself in the Foot – Again', *True Origin* (November 2004)

Clive Thompson, 'How to Make a Fake', *New York Magazine* (21 May 2005)

Damian Thompson, *Counterknowledge: How We Surrendered to Conspiracy Theories, Quack Medicine, Bogus Science and Fake History* (London, 2008)

Hans Tietze, *Genuine and False: Imitations, Copies, Forgeries* (London, 1948)

Henk Tromp, *A Real Van Gogh: How the Art World Struggles with Truth* (Amsterdam, 2010)

C. Truman, 'Reinhold Vasters, The Last of the Goldsmiths', *Connoisseur*, vol. 199 (March, 1979), pp. 154–61

—

Giorgio Vasari, *Lives of the Most Eminent Painters, Sculptors and Architects* (1550)

Giorgio Vasari, *Le vite dei piu eccellenti pittori scultori e architetti* (originally published in Italian in 1568), edited by C. Ragghianti, 4 vols (Milan, 1942)

Carol Vogel, 'Work Believed a Gauguin Turns Out to Be a Forgery', *The New York Times* (13 December 2007)

—

Benjamin Wallace, *The Billionaire's Vinegar* (New York, 2007)

Benjamin Wallace, 'Hints of Berry, Oak, and Scandal', *Washington Post* (25 November 2007)

Horace Walpole, *Anecdotes* (London, 1762)

John Evangelist Walsh, *The Bones of Saint Peter* (Bedford, NH, 2011)

David Ward, 'How Garden Shed Fakers Fooled the Art World', *Guardian* (17 November 2007)

Peter Watson, 'How Forgeries Corrupt Our Top Museums', *New Statemsan* (25 December 2000)

Marjorie E. Wieseman, *A Closer Look: Deceptions and Discoveries* (London, 2010)

Mary Elizabeth Williams, 'Peter Paul Biro's Libel Case Against Conde Nast Dismissed', *Center for Art Law* (11 August 2013)

James Q. Wilson and George L. Kelling, 'A Quarter Century of Broken Windows', *American Interest* (September/October 2006)

Lucien Wolf, *The Myth of the Jewish Menace in World Affairs or, The Truth about the Forged Protocols of the Elders of Zion* (New York, 1921)

Graeme Wood, 'Artful Lies', *American Scholar* (Summer 2012)

Frank Wynne, *I Was Vermeer: The Legend of the Forger Who Swindled the Nazis* (London, 2006)

—

John Yates, 'Vinlandsaga', *Journal of Art Crime*, vol. 2, (Fall 2009)

—

Zhou Zhonghe, Julia A. Clarke and Zhang Fucheng, 'Archaeoraptor's Better Half', *Nature*, vol. 420 (21 November 2002)

Theodore Ziolkowski, *Lure of the Arcane: The Literature of Cult and Conspiracy* (Baltimore, MD, 2013)

INDEX

Numbers in italics
refer to illustrations

ACKNOWLEDGEMENTS

Thanks go out to David Anfam, the brilliant art historian, connoisseur and editor at Phaidon who helped conceive of this book and bring it to print. I was happily assisted by several other fine editors, including Diane Fortenberry and Ellen Christie, and Phaidon's in-house film-maker extraordinaire, Emma Robertson. Thanks go to them, and to Sarah Smithies, the image hunter who found all the esoteric pictures of forgeries, and Steve Bryant, who took care of the production side of the book.

Thanks also to my peer writers, scholars and friends for checking over drafts or chapters of this book, and contributing their experience and wisdom to its lessons: Ingrid Rowland, Martin Kemp, Thierry Lenain, Laetitia Rutherford, John Stubbs, Nathan Dunne, Stuart George, Matthew Leininger, Helen Stoilas, Kate Abbott, Vernon Rapley, Ken Perenyi, Bill Wei, Danielle Carrabino, Ernst Scholler, Stefano Alessandrini, Eleanor Jackson, Graham Smith, Adam Lowe, to the team at ARCA (the Association for Research into Crimes against Art) and to my students over the years on ARCA's Postgraduate Program in Art Crime and Cultural Heritage Protection. My annual course on the history of art crime, and its recent incarnation focusing on the history of art forgery, have been instrumental in developing my ideas on the subject, with the input and clever questions of students helping to shape the final product.

Thanks, most of all, to my family, who support my writing habit with enthusiasm, patience and love. *Vas imam rad kot norec.*

−Dr Noah Charney
Kamnik, Slovenia

PICTURE CREDITS